This book was published on the occasion of the Retrospective dedicated
to Sam Peckinpah organized by the **Festival del Film Locarno** in 2015,
in collaboration with the Cinémathèque suisse and the Cinémathèque française.

68°
Festival del film Locarno
5-15 | 8 | 2015

Edited by Fernando Ganzo

Manager: Thierry Lounas
Managing Editor: Camille Pollas
Editor: Maxime Werner
English version revised by Louisa Dunnigan

Design: Marion Guillaume

Published in English and in French by Capricci, France, June 2015
© Capricci, 979-0-239-0100-9
© Intellect Book for the distribution of the English Edition, 978-1-78320-619-3

 intellect

Special than
Dominique Blin, Christa and Samantha Fuller, Lupita Peckinpah,
José Luis Tolel Marías, Oscar Oliva, Pierre Rissient, Garner Simmons,
isco Javier Urkijo

This work, pu
from the Inst of a program of aid for publication, received support
à la publication ouvrage a bénéficié du soutien des Programmes d'aide
nçais.

Cover: Sam Pec
Previous page: O f *The Ballad of Cable Hogue*.
Dogs.

SAM PECKINPAH

capricci

intellect

THE TRAITOR AND THE HERO

BY FERNANDO GANZO

*"Don't ever ruin your career as a loser
with a shitty success."*

Jorge Oteiza

There is only one thing that can be said about a person as erratic, contradictory, mythomaniac, complex and profound as Sam Peckinpah: here is a director who was made in the image of his characters, those men who belong to a different era, born too late, in a world that opposed all freedom and eccentricity. We like to describe Peckinpah as one of the fathers of New Hollywood, of the baroque aesthetic of the 1970s, as someone who had a primordial and often regrettable influence on that particular style. This is not completely false. However, this tendency to make him into "the man who killed John Ford", someone who ushered in the end of the Western, does not do justice to his true nature: Sam Peckinpah is more like "the man who wanted to *be* John Ford", but in a Hollywood and in an America that had already changed too much. We must think of the commercial success of Sergio Leone's Westerns, made at the same time, which succeeded because of his few, well-chosen fight scenes, his cartoon-like characters, and his lengthy long shots. Luckily for him, Peckinpah had something else to say, or rather something to say differently. Good to know: death is film's ultimate subject. He was the first director to do in Hollywood what Nagisa Oshima did in Japan: look death in the face, because death is the only moment that truly deserves this, as a moment of transcendence, of despair, that puts man in contact with the absolute. Peckinpah accomplished this, starting with his second film, *Ride the High Country*, when the character played by Joel McCrea asks to be left alone with the mountain just before he dies. Similarly, in *Pat Garrett & Billy the Kid*, Katy Jurado keeps a prudent distance, her face covered with tears, when her husband (Slim Pickens) dies while watching the sunset, a smile on his face, to the sound of "Knockin' on Heaven's Door".

For Peckinpah, death always arrives via violence. Violence is a fetish, certainly, but also is the ultimate instrument that determines the history of the United States by populating it with ghosts. Scarred by his time in the army, Peckinpah wanted to show that man does not die easily and that death is not only a rupture, its very spectacle is as well. For him, the cinema was truly death at work. This is the origin of his aggression toward the image and toward the spectator.

It is no coincidence that Peckinpah was obsessed by Resnais' *Last Year at Marienbad*, which he couldn't help going back to time and again, without even knowing if he loved it or hated it. He had discovered that the narrative structure is also a question of perception and of sensorial stimulation: zooms, suffocating slow motion, extremely short shots, and desynchronizations of all kinds. For Peckinpah, all of these gimmicks are the perfect expression of his world, a world of revenants. Take, for example, *Pat Garrett & Billy the Kid* where Garrett, who has just accepted a job as sheriff, finds himself faced with the task of killing his old friend the Kid. The famous first scene of the film shows Garrett, in sepia, being murdered at the dawn of the 20th century. Simultaneously, a parallel montage takes us thirty years earlier, during a scene where Kid and his friends – including Garrett himself – shoot chickens for fun. The montage alternates between these two scenes of gunfire, provoking a strange feeling: it seems to be Billy the Kid who kills Garrett. It's even Garrett who seems to shoot himself. This isn't far from the scene where Tom Doniphon kills Liberty Valance to construct a world where there's no place left for men like him. Except here it is the montage that does the explaining for us. For Peckinpah, at this precise moment of her history, America killed an essential part of herself, the part that represented her liberty and her dignity. From this moment on, the cowboy would necessarily be an outcast, a living corpse. Peckinpah himself played the role of a gravedigger in *Pat Garrett*, his last Western. The next year, he filmed Warren Oates driving around a corpse's head from one end of Mexico to the other, in *Bring Me the Head of Alfredo Garcia*. Dreaming of one last chance of saving his life, the character ploughs directly toward his own grave: once the head is delivered and the reward received, he admits (a bit like the characters of *The Wild Bunch*) that he isn't capable of leaving things as they are, a statement which leads once again to a final violent massacre. Whether through montage or through the script, everything in Peckinpah's films brings us to a destructive force that man cannot seem to detach himself from.

Obsessed soldiers, disappointed cowboys, rodeo stars, math teachers and bank robbers figure among the characters that populate his work.

Peckinpah knew how to put his whole life into his films, without ever speaking directly of himself. As the actress Helen Shaver said during the film shoot for his last film, *The Osterman Weekend*, "We live our lives between the words 'action' and 'cut'. It's the only time when we are truly alive." This is why, despite the many biographical elements present in the literature dedicated to Sam Peckinpah, this book also analyses brief stories from his film shoots. There, we find the same things as in his films: adventures, disputes, and confrontations

(which, far from avoiding, Peckinpah seemed to want to provoke). This destructive force applied to his own film-making made each film shoot an adventure and a moment where everything could be improvised: from the lighting, to the lines, to the décor. Everything to maintain a sense of danger.

Yet the genius of Sam Peckinpah also resides in the work of his actors. All the great actors he directed brought him the best acting of their careers. Accordingly, it is difficult to think of a Charlton Heston who is more complex than he was in the skin of the marginal, obsessive Major Dundee; or a Steve McQueen more pure than he was in the role of Junior Bonner; or of a Jason Robards more touching than he was as Cable Hogue, looking at the prostitute that he loved; or a James Coburn more compelling than when Pat Garrett shot his own reflection, unable to stand what he had become. Why? Because Peckinpah was one of them. At the price of an infinite succession of disputes and battles – often lost – with his producers, his collaborators and his friends. Indeed, this points to a paradox that Peckinpah shares with Orson Welles: both director-editors were considered authors, despite the fact that they not only never had the right to the final cut of their films, but quite often suffered the modification, mutilation and massacre of their work at the hands of their producers. This also came at the price of his health, destroyed by alcohol, drugs, and work. Sam Peckinpah will remain the director that taught us that defeat is, forever, the most brilliant of all victories.

On the film set of *The Wild Bunch*

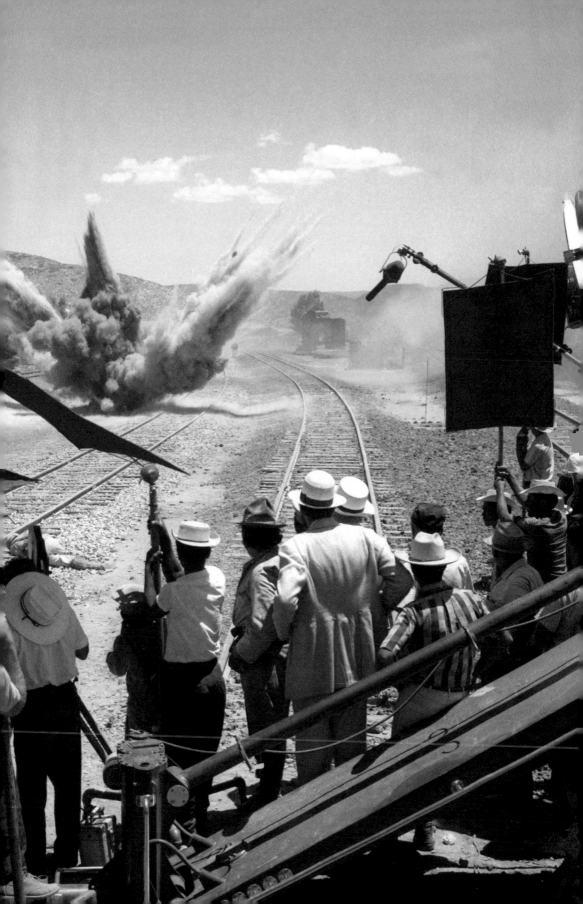

IN CONVERSATION WITH SAM PECKINPAH

MOVIETONE NEWS,
Nº 60-61, FEBRUARY 1979

Sam Peckinpah visited Seattle for several days in July, 1978, under the joint auspices of the Seattle Film Society and the Academy of Motion Picture Arts and Sciences. On the evening of July 19 he appeared at the Seattle Concert Theatre to talk with an audience that had just seen, and warmly responded to, his comedy-western *The Ballad of Cable Hogue*. The following is a slightly edited transcript of that dialogue. For fluency of reading we have kept the '[Laughter]' notations to a minimum, but the fact is that laughter punctuated the discussion with considerable frequency. Questions, in bold, were mostly from members of the audience. Richard T. Jameson was moderator.

Cable Hogue, even though Cable died at the end, was a very upbeat film, which is different from all the other [Peckinpah] films that I've seen. Was there a reason that in 1970 or 1969 you made a movie that does not – to me, at any rate – fit very easily with all the rest of your work?

I think it fits very well. I should mention one thing that seems to confuse people: I've made three, or maybe I could say four, films that were my own projects; the rest I have done because that was the job that was offered. I don't really pick and choose. On *Cable*, Warren [Oates] had given me the property to read, I liked it, I bought it on time, I tried to get together with Van Heflin to make it for around $700,000, and could not do it. And Ken Hyman, who was the president of Warner Brothers at that time, loved *The Wild Bunch*, and I conned him into taking *Cable Hogue* because I wanted to make the film. And that's it.

I have a question about *The Wild Bunch*. The first print that was shown in Seattle lasted about seven days. Then it was changed – another print was substituted. Some things were cut, deleted, mainly to conform with some criticisms that *Time* had about the movie. Who was responsible for the cuts?

Well, *Time* magazine was not responsible. I was cutting *Cable* at the time. I got a call from [producer Phil] Feldman; he said they wanted to try it out in one theater – a shorter version. I said "Fine – in one theater." Next thing I knew, it had been cut to pieces all over the country. So you can thank Mr. Feldman for doing it. And a man named Weintraub, who also was very active at Warner Brothers at the time.

Does an intact print still exist?

Uh… not as much as I would like. But the European version does exist, and I think that's shown in 16 mm.

Yes, we showed it here.

I think it's two hours and twenty-seven minutes, something like that. I think right now it's down to a three-minute short.

Is there an intact print of *Pat Garrett & Billy the Kid*? [Question followed by conspiratorial laughter in the audience]

Oho! Rumors! *[Pause]* Somebody said there was a print stolen. *[Pause]* Let you know next year. *[General laughter]* Something about redubbing it.

I have a question about *One Eyed Jacks* **[Marlon Brando, 1961], which this filmography says you worked on. I understand the movie ran about four hours and then was cut. Does a print of the four-hour-long version still exist?**

It was written for [producer] Frank Rosenberg who gave me a book called *The Authentic Death of Hendry Jones* [by Charles Neider, 1956]. I did the script, and we had some problems. It was a damn good script. Which I threw at him, by the way; and it was not bound, so it was all over his livingroom – it was really one of my last great moves. I told him to send it to Brando. And damned if he didn't, and Brando bought it. I worked with Marlon for three and a half weeks before he fired me. I was asked to come back on the show, but I was directing at that time, and passed. There's very little of Mr. Neider's work or mine. There's two scenes of mine in the picture and I did not receive credit for it.

You also did not receive credit for at least two films on that sheet we handed out, which to my shame I noticed earlier today. I don't know exactly when you wrote the scripts but in the mid-Sixties there were two films you had a screenplay credit on that you did not direct, *The Glory Guys* **[Arnold Laven] about 1965…**

A real winner! *[Laughter]* Good script!

Should I mention *Villa Rides* **[Buzz Kulik, 1968]?**

Well, *Villa Rides* and *The Glory Guys* were interesting because… Again, grist-for-the-mill for any writer or director or would-be direc-

tor is that they all became part of *The Wild Bunch*. On *Major Dundee* all the slow-motion, special effects, dealing with time, etc., etc., etc., had a chance, thanks to Ken Hyman, to come to some kind of fruition with *The Wild Bunch*. So if you do lose, you don't really lose: you use it for the next picture. It's a learning process. If you stop learning, you're dead.

I've seen almost all of your pictures and I particularly like the secondary characters – Warren Oates, L.Q. Jones, Strother Martin… Do you cast those roles?

Yes. I did, until it became impossible to cast some of the people I wanted because of their salaries. On the last picture [*Convoy*] I was working with a producer named Robert Sherman, and no matter who I cast, he managed to fuck up the deal so I couldn't get them in the picture – Mort Sahl and… *ad nauseam* on *Convoy*. But I usually cast every single role, do the wardrobe, etc.

How does someone contact you if they're an actor and they want to work with you? Because you do such great things with heavies. How does someone get to you? Do they need an agent or can, uh… *[General laughter]*

Send money! No, the whole thing is watching, is first watching films. And if you don't have films, get some. Use a video camera – you can make it with all kinds of things. I like to look at films first. I saw Bo Hopkins in some sort of 16 mm number and *yeah*. Warren just happened to show up one day and was dumb enough to like working with me, and I liked working with him. Ben Johnson knows how to ride pretty good – he can hold the horses. I got *lucky*. I can't afford any of them anymore.

Since the movie moguls and producers seem to like to chop your movies up, would you say

Junior Bonner

there is something in your personal philosophy that leads to this?

Well... I suffer fools badly and they take it personally.

I'd like to know what you think of Sergio Leone's movies, like *Once upon a Time in the West* [1968]. And also, what western movies do you personally like?

I like Leone's movies and I like *him*. They're always too long but they're fun to watch. A marvelous man to talk to, and I think he does really interesting things. Western movies? Uh – what was the last Hoot Gibson I saw? No, I really loved *Red River* [Howard Hawk, Arthur Rosson, 1948] until the ending – the phony arrow in the chest, and the chick. Ford did a great western with Fonda and Victor Mature, *My Darling Clementine* [1946]. I recall, uh... a *lot* of good films. The best western I've ever

seen is – I think it was a serial I saw one Saturday morning on TV in Fresno, California, when I was eleven; I forget the name of it.

For a while it seemed that you were going to form a stock company of actors much the way John Ford did, and maybe just make your own projects. Was that a dream and are you unhappy that it didn't materialize that way?

Yes!

Yes, or yes yes?

Yes yes *yes*! As I said, they got too expensive.

If somebody were to give you a production company and say, "OK, go back to that desire," would you now, at ten years' remove from when that was happening, go back and do it that way?

Nnnnnnoooooooo, ya don't know, because

you change. I never consciously evaluate the style *per se*, only the people who are working. What happened – that's interesting, because what happened on *Convoy* was that people I'd worked for, and with, for years, back of the camera and in front of it, turned out only to be interested in… retirement plans. I went to Rome to do a one-day bit in an Italian western with Warren (had a marvelous time doing it – was an *actor*) and I had the privilege of spending a great deal of time with Fellini. And the problems I'm talking about now are the same things we talked about then – he felt the same way. People don't want to *work* anymore. And to me, it's a *privilege* to work in films; it always has been, it always will be. And I'm sick to death of the Hollywood attitude and that's why I don't live there or work there anymore.

When you're looking at a film you made ten years ago, and now your perspective has changed, do you ever wish you could go back and…
[*Sharp bark of laughter from Peckinpah*] I want to reshoot, recut, rescore, redub *everything*. No, not really. There's about two or three things in *Cable* I'd like to change, but that's my picture and I'll let it stand. The marvelous thing about film as opposed to theater is that it doesn't lie. You see it a year later (this is my year of reseeing all my films and a lot of other films)…
[*Interruption as the would-be Peckinpah heavy rushes down from the balcony to offer his Coke can as an ashtray; subject irrevocably changed*]

Do you think you'd ever do another war film?
I hope not.

When you made *Cross of Iron* what were some of the things you encountered as problems?
Germans. [*Laughter*] Gerrrrmannnsssss!

The actors?
No, *groovy* actors. The German producer was a mini-nazi. Which I could talk about for years – the porno king of Munich. Kept asking why I didn't get a close-up when his wife bit the joint off Art Brauss. Well, I think that speaks for itself. Then we had two great entrepreneurs, Arlene Sellers and Alex Winitsky, who were financing or sub-financing the picture, and that became a disaster. There was one person who made the picture finally get finished and done right, and that's Nat Cohen from England. I missed him on my last picture, very definitely.

What kind of stories do you like? What do you look for when looking at a script and thinking about whether to make it?
What you see. I turned down *King Kong* to do *Cross of Iron* because I didn't feel I was competent enough to deal with… puppets. *Cross of Iron* was based more than anything else on the Willi Heinrich book, but it was also based on James Jones' sensational book. I think it was actually a pictorial history, but it was some of his best work. I stole outrageously from that.

One of the main criticisms I've heard leveled at your work had to do with your portrayals of women. Do you have any comments on that?
I like 'em. I try to portray them as they are. They're like everybody else: they're human beings. I try to get 'em off a pedestal – not too successfully, but…

Are there any reruns of *The Westerner*?
Gonna have one tomorrow. ["Jeff," the most-discussed episode of the series, was shown in a University of Washington film class along with the hour-long ABC Stage 67 production of "Noon Wine".] I've got four.

The rest – the negatives were burnt up because they didn't want to store them any longer[1]..

I was wondering if you'd thought of toning down the violence in your films.
What violence?.. I just try to portray what I've experienced and what I've seen. I'm concerned with violence because I see so much of it in myself and in people that I know. I'd like to know why and I'd like to channel the positive effects. I suppose I feel that the basic thing is that I feel Robert Ardrey should be required reading for everyone.

I don't understand. Are you saying you do that kind of violence?
No [emphatically]. No, I deny that, I'm not guilty. On occasion. I usually don't make a film about something I don't know about first-hand.

What is the next film you're going to do?
It's a very difficult assignment. Deep Throat Comes Back. Getting the rights is tough.. I'm going to do a Max Evans story, I believe. About a kid, some horses, an old-timer, and growing up in the Twenties.

What do you think about Max Evans's book on this film, or built around you? [Sam Peck-inpah: Master of Violence, an account of the filming of Cable Hogue.]
Very simply, it was done without my knowledge or consent. I think it's an outrageous piece of shit. But Max said he needed the money and his wife put a pistol to his head, so..

Do you have any advice for a new writer with a new script who has no contact with the industry and doesn't know what to do with it?
It depends on what form and who it's for. I think right now it's a writer's market. Look at what is being sold and who is selling and who is buying and what kind of script, and then get the names of who those people are, and lie, cheat, steal, bribe and get in to meet them and con.

Thank you!
That's the only way I could do it. I was a dialogue director and a propman; I became a writer because it was a way to become a director.

In the documentary we saw on the making of Cable Hogue there was a sequence where everybody talked about their childhood and daydreaming and how this led into their acting. I was curious, was this true of you as well? Do you think your childhood, what you daydreamed, what you saw.. did you extend childhood daydreaming into filmmaking?
I was being interviewed for that film, which is strictly the responsibility of Gary Weiss and Gil Dennis. Yes, we restaged and reenacted The Charge of the Light Brigade [Michael Curtiz, 1936] many times. I was very much a loner, very much into what I read and imagined as a kid.

Do you see the whole film in your mind before you make it, or are there parts you're not sure of?
No.. A film can change, it becomes an adventure, it becomes an entity unto itself. You must know enough to let it work along in its own terms, but yet within a certain framework.

You talk about films changing and the fact that only three of your movies were your own projects. I think it sometimes seems to

1-The series episodes do survive and have been seen on the Encore Westerns channel.

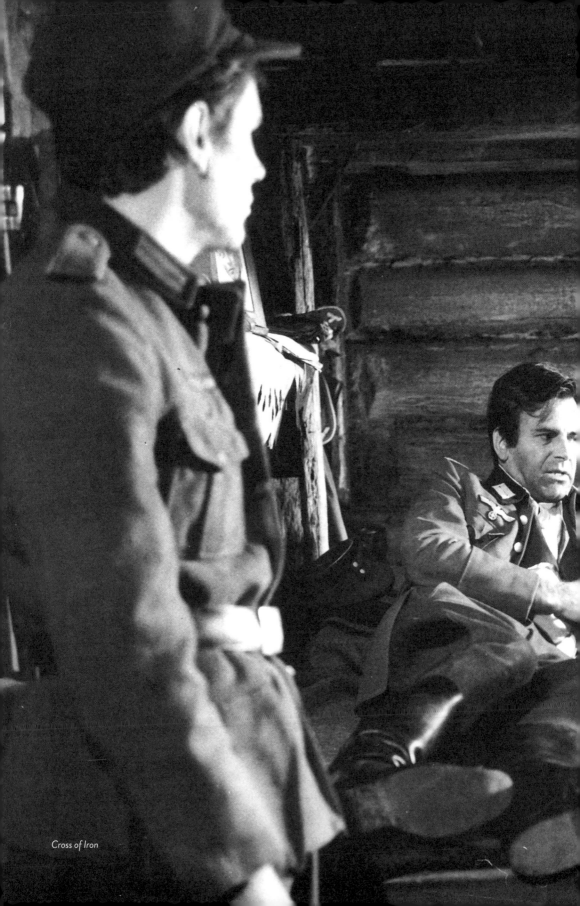

Cross of Iron

us out here… it sounds like a contradiction in terms. You're given a movie to do and yet you essentially have to make it up as you're going along. I guess this question adds up to: how do you go about making one of those assigned projects your own?

Well, it's like *Straw Dogs*. We had a very bad book. I wrote the script with David Goodman, and then [Daniel] Melnick and David went off by themselves without my knowledge and wrote a completely different script. Marty Baum[2] blew his top about that and took it to London and said, "Did you know anything about this?" I said no. He said, "Write the script." So I wrote the script. I had to sign a paper with Mr. Baum stating that I would have a happy ending. But once I'd cast Susan George, I knew that was impossible. I played it down to the end until Dustin Hoffman came up to me and said, "We can't make this ending," and I said, "Well how about *this* one, Dustin?"… So it's always a gamble and it's always a fight and… it's adventure!

Have you ever thought of returning to television?

No.

Was it difficult doing television?

It was great. At Four Star, Dick Powell was in charge of production; working with Mr. Powell unfortunately left a mark on me. We had the best crews, the best staff, and nobody who worked there has ever been able to find people like that since. It was a delight. That's where I learned, thanks to Mr. Powell.

… who unfortunately passed away just when things were getting going.

Just before "The Losers" [1963] came out, yeah.

Partly this question has been asked already, but I'm still wondering how much you chart and plan a film before you start.

We chart and plan *everything*, knowing that everything is going to go wrong. Then you adapt. Within a framework, you adapt.

How about reviewers and film critics? Do you read them, and how do you think they stand in relation to your work?

I think the enormous importance of the reviewer is underestimated because we have so many really *bad* people reviewing films. They're very important to me, and to other directors I know and respect. Not many of them are… I really don't break my heart over Rex Reed anymore. Penelope Gilliat and her boyfriend that writes for *The New York Times* had a big thing to do about *Cross of Iron*, saying "My god, it was so awful because the uniforms, you could hardly tell the difference…" What the *fuck!* That was what it was all *about!*

So it's important to you what they say?

Very. Very. Anything anybody says. I'm part of the audience and that's my job. I'm not doing closet drama.

About the time of *The Killer Elite* most of the negative reviews admitted that you know how to make a movie, to keep things moving, but they can't stand it if you try to put any content in them. They hate it when people talk to one another.

Well, actually *The Killer Elite* was interesting because that was kind of a delightful satire, just kind of a fun-and-games film, and everybody took it so seriously – I couldn't figure that out. How could you believe Ninjas attacking the mothball fleet?! I had a ball making it. I enjoyed it; I don't know why people took it so grim.

About *Junior Bonner*, what debts do you owe to Nicholas Ray and *The Lusty Men* [1952]?

Who?

2-President of ABC Pictures, who had enjoyed the first version of the script presented by Peckinpah.

Ray… *The Lusty Men*…
Nothing. This was Jeb Rosebrook, who lived and worked rodeo, and got the script to Steve [McQueen]; I got the call from Steve and went in and we did two back-to-back: *Junior Bonner* and *Getaway*. None. He's a good director but that was Jeb Rosebrook – a damn fine writer. I don't know what debt *he* owes to Nicholas Ray, but I don't really know the picture you're talking about.

Back to violence: Do you like violence because it enables you to do the sort of action and editing you go in for?
I don't *like* violence. I think that any conflict in drama is necessary. Sometimes it's violence, sometimes it's in words; sometimes the worst thing in the world – as in "Noon Wine" – is the failure of love, the lack of communication. But conflict in one form or another *is* drama.

I've seen Stella Stevens do some good acting and I've seen Stella Stevens do bad acting, and I think you drew a very good performance out of her in this movie we saw tonight. I was wondering, how do you deal with your actors, how much do you control them, how much rehearsal do you do?
The key thing in making a film is the amount of rehearsal time you can spend, because the actors get to know you and you get to know them. Once I did a TV show with Jean Simmons ["The Lady Is My Wife," *Bob Hope Chrysler Theatre*, 1967] and she said "You lied to me!?" – and I did. But it kinda works out. Once she got her makeup off, she was fine.

Sam, the first day that *Cable Hogue* played in a theater, I saw it quite by accident, and two weeks later it wasn't playing in any theater anywhere. And I got angry about that and I called you on the phone and I said: "I'm starting a Cable Hogue society."
[Delighted] Oh I remember that!

… and my idea was to find and gather films that got lost, and get them out, and get the word out to audiences and theater owners and get them to book them. And I still wish that fine films like that could find an audience. I saw *Walkabout* [Nicolas Roeg, 1971] and *The White Dawn* [Philip Kaufman, 1974] and a number of other films that fall inside that Cable Hogue Society category…
Glad to agree with you about *Walkabout* because I saw it and loved the picture, and I just got done acting with Jenny [Agutter]. The thing is that Weintraub and Warner Brothers wrote off *Cable Hogue* after one weekend as a tax loss and that was the end. That's corporate dealings in Hollywood and there's no way to get out of it, unless you buy a print or steal it… Maybe with seven thousand bucks you could dupe them and you'd be set… Grand theft felony.

I'd like to go to the subject of your films that have been cut. I'd like to know why they do it. Is it that you have a conflict or…?
Yeah, *Pat Garrett & Billy the Kid* was strictly a conflict with Melnick. Dundee was strictly Jerry Bresler…

Are their motivations commercial or are they trying to put you in your place?
It's a whole big ego trip. Agents and executives like to be creators and filmmakers – and they're not. But sometimes the damnedest thing happens: they're *right*. Usually it's trying to get a picture down to two hours or less so they can have another chance to sell popcorn. You all watch TV, so you're as guilty as… I am.

I'd like to ask a question about the images you use – for instance, the animals in the film. They're really an excellent counterpoint to the conflict that the people have. Do you

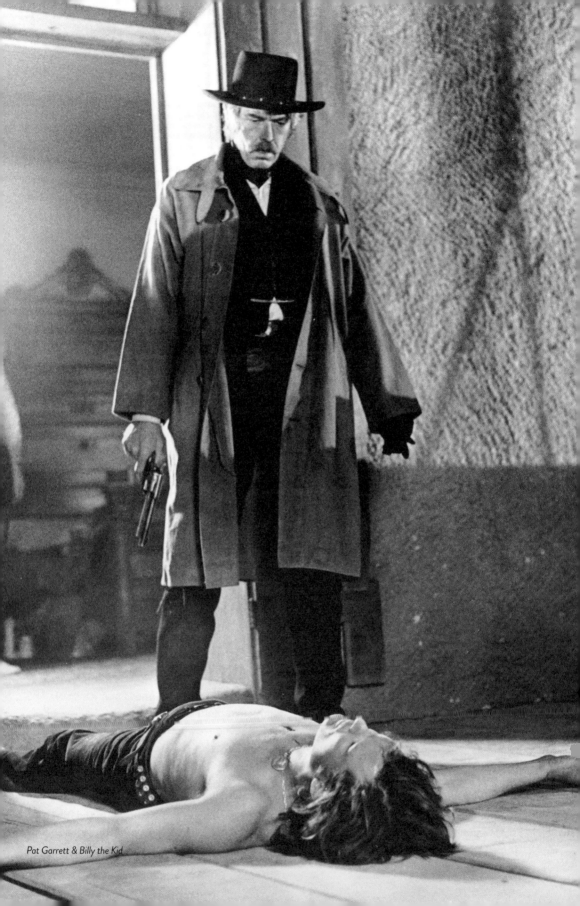

Pat Garrett & Billy the Kid

come to these types of images by instinct or do you have an idea about the images you use to make up a film?

Most of the work I do is instinctive, right or wrong. I do have a background in theory, but mostly it's guts poker. I'm a shit-kicker from way back.

I was impressed on this list of credits with all the shows you worked on in television, and I remember the shows as being worthwhile, and I don't see their quality on TV anymore. What do you think has happened? Why is something like Have Gun - Will Travel **only history?**

I didn't work on *Have Gun*; I worked on *Gunsmoke*, *Trackdown*, *Zane Grey Theatre*, a couple of others, and *Rifleman* I created. What's happening is very simple: you're buying a product – therefore you're the mean average and you ought to be ashamed. You're *buying* the *product*. That's the way these things work. It's the indifference of the people which is responsible for the level of television.

Do you own a TV? Do you watch TV?

Of course. I watch it about five straight days two or three times a year. That's not talking about the World Cup or football season, but… Otherwise I avoid it. I don't even know what shows are on. I really don't like it too much: I really fucking *hate* advertising. I think that if somebody can get together and stop the amount of brainwashing that's going on, stop buying the products, it'd be kinda keen.

Who is your favorite cameraman?

If I answered that, I'd have my head blown off by somebody else. It is *not* the cinematographer on the first part of *Convoy* – I really can't remember his name! [Harry Stradling Jr.] It was really nice and really interesting to find your slow-motion cameras tipped upsidedown; and if you mark a camera to run at 64 and it's running at 16 [frames per second], it's really interesting. Bobby Hauser came in and did three weeks, seven weeks, eight weeks of work. He's one hell of a guy, and great crew; I can't say that for Stradling or any of his people.

You had a very surprising and distinguished second-unit director on that movie [James Coburn]. Maybe you could talk to people about what second-unit directors do and how you work with them, make your thing happen through a second-unit director.

Walter Kelley was very successful during the last part of *Cross of Iron* and he was very unsuccessful doing this picture. Jimmy came in – working to get his director's card – and he came through with a couple really key shots. He was as wild and crazy as he should have been.

How much did Convoy **cost and what do you think about it?**

I don't really think too much about it. We ran eight reels of supposedly the director's cut, my first cut, and that's all I've ever seen. The other four reels I've seen but they weren't shown. My time ran out and the film was taken over by the company [EMI]. I think by the time it's finished with prints and advertising it will make money. In Japan already it's done seven-point-eight in distributor's gross – that's a fifth of the cost in one country alone. I'm selling my interest to the University of Washington so they can do the audit… I'm serious!

I saw Ride the High Country **as a second feature to something like** The Tartars **[Richard Thorpe, Ferdinando Baldi, 1961]. I only saw the last ten minutes and I couldn't see the**

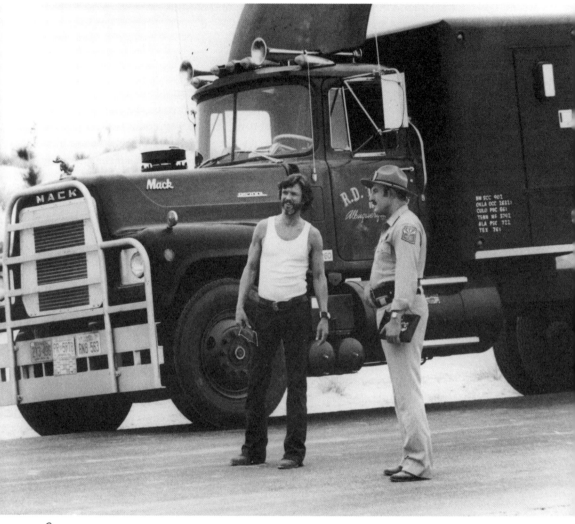

Convoy

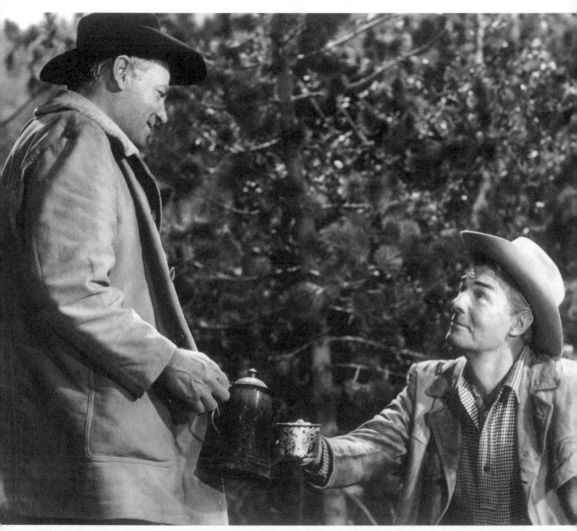

Ride the High Country

movie again for three years. **The fight didn't end after one shot like Matt Dillon[3], but looked as if, with these inaccurate guns they had at the time, they had to keep shooting. It was riveting! Did you think when you made it that somewhere there was a gun freak that would really appreciate the accuracy of that touch...?**
Well, I'd done a good deal of research, and I had a marvelous editor, Frank Santillo, and I spent a good deal of time with Frank Kowalski's father – a great first-assistant director. And we finally got it down using three-frame and two-frame cuts, and it ended up running about 19 seconds.

It seemed longer. I mean that as a compliment!
Frank turned me on – Frank Santillo, who cut the movie you saw tonight [*Cable Hogue*] with Lou Lombardo – he was and is one of the great cutters of all time. He worked with Vorkapich and he knows montage, and he taught me a great deal. I just took it and ran with it. The first time I was conscious of slow motion was the film Friedkin just remade, *Wages of Fear* [1977]; I saw the original of that and was astonished by the effectiveness of slow motion. I started in television using it.

That sequence that we just talked about was essentially ripped off – I don't mean they used the same footage but they used the same setups, the same music score by the same musician, even had Warren Oates in the scene too – in a movie called *Mail Order Bride* [1964] Burt Kennedy made a year or so later. Did you ever see that and what did it do to you?
No, I never saw it. I know Burt very well. He gave me an option to try and get Evans' book [*The Rounders*, 1960] made, which he eventu-

ally made, so I can't say anything about Burt. But I've been ripped off so many times I feel like I was a garment industry.

Jerry Fielding used *The Wild Bunch* score for *The Deadly Trackers* [Barry Shear, 1973]...
No, he didn't, *Warner Brothers* did, and he sued them – and collected. That's Warner Brothers.

There's a piece of that score in John Milius's recent film *Big Wednesday* [1978]; in fact, he's got your General Mapache scene in *The Wind and the Lion* [1975]...
[Laughing] I heard about that!

... and in the new film he turns his surfers into the Wild Bunch in Mexico. Do you know his work?
Only through my own, evidently.

How did you work with Richard Gillis who wrote the songs in *Cable Hogue*?
I was about three days away from going to Las Vegas to be with Jason [Robards] and start rehearsal and look at the Valley of Fire, when Gordon Dawson said I better go to the Olive Branch and listen to Mr. Gillis, and I did, and started rewriting the picture to fit his songs. We're still working together and – he's one fine, fine writer. The Peter Pan of Burbank.

In your pictures over the years you've worked with an array of the most potent actors America has – Coburn and Oates and those guys. How would you visualize, or how would you like to put Clint Eastwood in a movie? Is there a particular way you'd like to portray him?
I've got a script I wrote about two years ago; it's called *Dirty John* – about a San Francisco cop... No, really, he's damn good and I'd love

3-Police officer played by James Arness for twenty years in the series *Gunsmoke*.

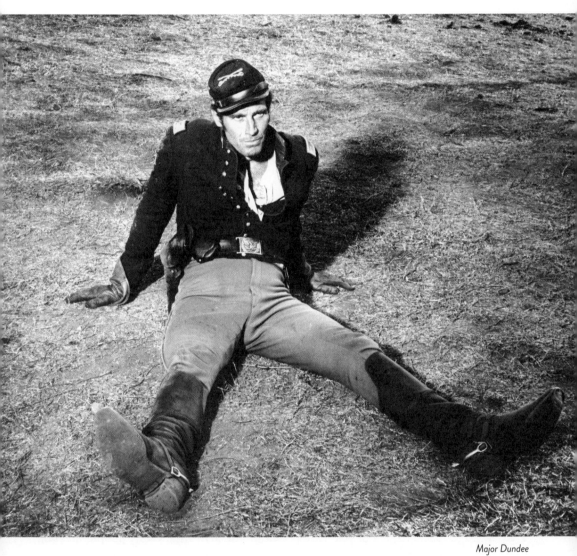

Major Dundee

to work with him. But he's been busy; so have I. He's been busy with Don Siegel, who was my *patron*, got me started in the business.

Do you plan to work again in Hollywood?
I will work with anybody anyplace, but I will not work in Hollywood, in that town.

So you will work with a studio?
I'll work with anything – as long as I don't have to go there anymore. I spent too many nights in Goldwyn's.

***Convoy* stands out to me as quite atypical of your movies that I've seen.**
Well *I* haven't seen it so I can't discuss it. Word-of-honor truth: I have not seen it since I ran those reels.

Well, I'm asking basically about your motivations because it seems so different.
In preparing *Cross of Iron* I kept hearing on Armed Forces radio this song about "We'll hit the gate goin' 98, Let them truckers roll, Ten-Four!" and I said "By God, I'd like to be out on *that* highway!" And so I got out there, but I ended up not being there at all.

In spite of all the cuts I think *Major Dundee* is one of your most powerful and entertaining films. How do you feel about that film?
I wanta kill.

Is there any chance of the cut footage being put back?
They called me back about four years afterward to come in and recut and rescore and redub, and I said no. That really hurt me, that one, because it was a fine film, really a fine film, and I was very proud of it. It was a very personal vendetta with Jerry Bresler.

How do you feel about the footage that remains?
Like a maimed child.

Have you ever considered going underground and making films with less resources, but you can keep your hands on them?
That's what I'm doing now.

This tension between producers and directors fascinates me. The right to final cut – is that decided before the picture's begun, is it negotiated, or…? You mentioned about *The Wild Bunch*, the call to you about trying out a cut version in one theater? Was that a courtesy call or did you have some appeal?
They did exactly what I said don't do. It was Phil Feldman. He could say, "Well, I *called* you." But they changed every print in the United States.

Did you know when that picture began that the end product would be out of your hands?
You usually have a preview cut. I had two preview cuts on the last picture, which I lost because I took too much time. I've never had final cut unless it was given to me or unless I stole it. Judge Learned Hand said that compromise is the soul of integrity. Sometimes I doubt it.

You've been talking a lot about things you made that nobody got a chance to see. I'm a writer and editors do this to me, and I've always figured the solution would be to get big enough so that nobody'd dare screw around with what I wrote. But you're big and you still talk about people messing around with your creations. Is there no solution to that?
Arm yourself. I don't know what the solution is, except: try and definitely get penalty money written into the contract, so that it will cost them money. Otherwise they'll just tear up the contract, do what they want, and say: "sue." So you spend five years suing and they

have all the money and all the lawyers, and you're dead. There is no guarantee whatsoever. Lie, cheat, steal, hold film out, steal it…

Does the producer of a film own the film?

No, the producer's hired. In the case of *Convoy*, Bobby Sherman put the package together, EMI picked it up, and so EMI owns the film. Michael Deely of EMI had the final say. Robert Sherman really had nothing to say except get in the way of everybody.

Is it legally possible to have a print for yourself?

It's legally possible but it takes a lot of doing. As I say, you must have certain penalty clauses. But I have nothing to say against *Convoy* because I completed my job and…

Are you able at this time to command any kind of financial backing that would give you more freedom?

No.

None at all?

If I could command it, I would be doing it. I'm trying to, but… I have had money offered to me, but on such terms that I couldn't accept.

I heard a few years back that you were suing to prevent the release of *Pat Garrett*. What is happening about that now?

Nothing. I was trying to beat 'em down and I failed. They took seventeen minutes out and destroyed the film. I sued them with everything I had, which was very little, and it dribbled away and… lost. Failed.

Have you got something now you'd like to do?

Yeah, I've got about five pictures I'd like to make – about five major pictures and about three smaller pictures I'd like to do before I hang it up.

Would you tell us what you're really about?

About what you see on the screen. It's all up there. Whatever's left… That was the best I could do.

What did you do to get unoffically blacklisted?

I kicked [Martin] Ransohoff off the set [of *The Cincinnati Kid*]. I refused to cast Sharon Tate. She badmouthed Katharine Hepburn and we had a little tussle. Right now I'd be delighted to work with Marty. He always resented that Bresler had first place on *my* blacklist. But… people change, ya know?

With its linking of the Mafia and Richard Nixon, *Bring Me the Head of Alfredo Garcia* seemed more overtly political than your other work. Do you think so?

Politically, possibly. Spiritually, I'd say. We had something going and it was pretty exciting, but – it got cut off at the pass. On the next one, *The Killer Elite*, we had a great line at the end of the picture. It was from Lord Buckley, an old Lord Buckley record: "I *don't* know where we're goin' and I *don't* know where we been, but I *know* that where we is isn't it."

Thank you very much. •

The Wild Bunch

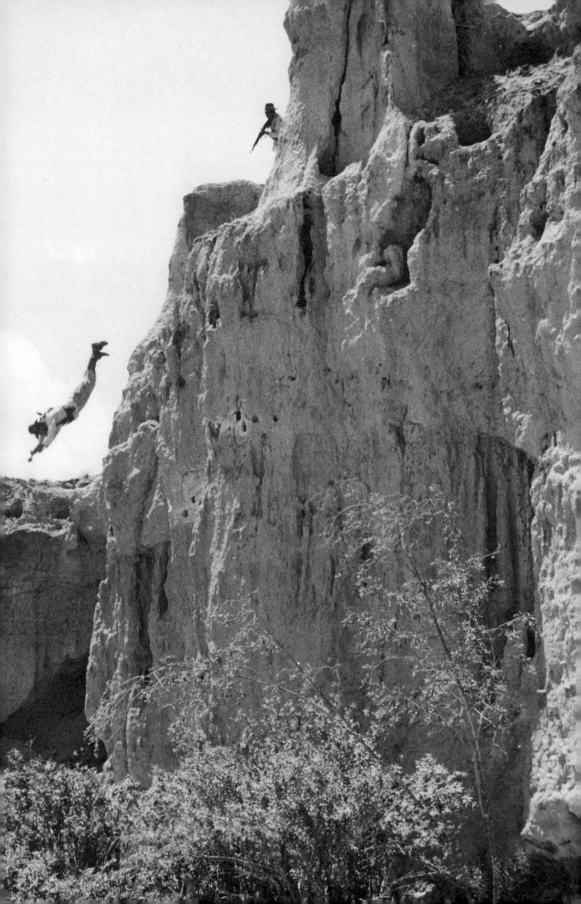

1961-1965

EARLY LATENESS
Sam Peckinpah before
The Wild Bunch

BY CHRIS FUJIWARA

THE DEADLY COMPANIONS (1961)

RIDE THE HIGH COUNTRY (1962)

MAJOR DUNDEE (1965)

THE BODY, THE TRICK

I think regularly of the trick by which John Wayne defeats Christopher George in Howard Hawks's *El Dorado*: an emblematic moment for the whole period, and the whole conception, of late cinema to which Peckinpah belongs. In this period, in order for the Western hero to triumph over his adversary, his skills, knowledge, and strength of character are no longer sufficient: he must resort to deception. Yet the hero is still allowed to remain heroic, despite this trick: it is as if we were allowed to glimpse, in a brief flash, a bankruptcy that is then immediately covered up and forgotten, so that the film can end in a celebratory semblance of continuity with the films of the past.

This Hawksian trick is one answer, perhaps the most rigorous and pragmatic one, to the problem that confronted the filmmakers of classical Hollywood as they attempted to keep going in the 1960s: how do you continue, with aging stars, with an audience that no longer accepts the moral certainty that was supposed to stabilize the old scenarios, with a relaxed censorship system…? For Ford, concerned with his historical themes of the closing of the frontier and the end of the Old West (*Liberty Valance, Cheyenne Autumn*), none of that is a problem. Ford accepts the inevitability of his physical and commercial decline, and that of his stars; he is not at all anxious about remaining up-to-date, about adapting to or responding to the changed situation. (Contrary to received opinion, no film could be less "revisionist" than *Cheyenne Autumn* – the film is in every way consistent with the established Fordian pattern.) But Hawks is anxious; for him, remaining contemporary, or at least negotiating successful terms with the contemporary, is a problem. (And the same goes for Hathaway.)

Near the beginning of *Ride the High Country*, Peckinpah already addresses this 1960s question. In the late West of this film, where the motorcar has made its début, and where the activities of the legendary frontier are matters for sideshow parody, success is revealed, from the beginning, to depend on tricks: young Heck (Ron Starr), riding a camel, bests all his horse-riding opponents in a race down the town's main street; Gil Westrum (Randolph Scott), masquerading as "the Oregon Kid", increases his odds against sharp-shooting challengers at his carnival booth by using a pistol loaded with buckshot. From the very beginning of the film, Peckinpah acknowledges that the Western has become a spectacle, that it is supported by a staging, by ruses. There is no concealing or forgetting this knowledge: the spectacle can henceforth continue only in self-awareness or self-mockery. The subject of *Ride the High Country* is the Hollywood Western itself, as cultural institution and as aesthetic form, and more particularly the conditions for its endurance.

Born in 1925, Peckinpah belongs to the generation after that of Welles, Fuller, Ray, Losey, Aldrich, Fleischer, Mann, Boetticher, Siegel. His relationship to Hollywood is different from theirs. Part of what distinguishes him is that he, unlike they, is a man of television. Though he begins in theatrical films, as dialogue coach and assistant director, it is in television that Peckinpah makes his mark, as the creator of series (the popular *The Rifleman*, then the superior *The Westerner*, which lasted only thirteen episodes). An extension of Hollywood cinema that is also the corruption of Hollywood cinema, television itself resembles the disabled body of John Wayne in *El Dorado*: a way of maintaining life and a career but in a diminished format. This diminishment was felt in the culture of Hollywood. The old cinema people looked down on their young rival. Richard Lyons, the producer of *Ride the High Country*, recalled that MGM "was very class conscious. I mean they just didn't even consider hiring television directors."[1] If Peckinpah has accommodated himself to television, which threatens the old regime of cinema, for him it is still cinema, not television, that is the terrain of predilection.

In a short piece on *The Wild Bunch* in *Cahiers du cinéma*, Serge Daney writes: Peckinpah "comes too late. His problem is that of the generation before him (that of Huston, Ray, or Preminger), who, unable to reflect their relationship with Hollywood, had to convey that inability metaphorically in the themes they handled (failure, derision, entropy of all human enterprise, of every mise-en-scène, etc."[2] Daney thus sees Peckinpah as symptomatic of a kind of cinema now at its end. This cinema is built, Daney writes, "on the presence of the actor… or on the nostalgia for such a presence". But it is in the body of the actor that Peckinpah inscribes his effects. In *Ride the High Country*, as in *El Dorado*, the old gunfighters bear the scars of their violent history. Peckinpah's is explicitly a cinema of the body and its reality, the body as a record of its own past – but this body is doubled by the spectral body of the legend of that past. Thus there is something miraculous in the walk of Randolph Scott and Joel McCrea toward their final showdown: it is a walk of cinema, in which camera movement and musical score participate to produce an effect of terrible and glorious fatefulness.

A lesson on the "reality" of violence, visual and verbal, is given in "Hand on the Gun", an extraordinary episode of *The Westerner*, in which we are shown (by a horse herder played by Michael Ansara) what a bullet actually does to the body (the size of the exit wound is commented on). In the teeth-marks on the hand of Turkey (Chill Wills) at the beginning of *The Deadly Companions*, and in the scar from the scalp knife revealed at last on the forehead of Yellowleg (Brian Keith) at the end of that film, we can see Peckinpah's concern for a history of violence as played out and registered on the body. At the end of *Ride the High*

1-Garner Simmons, *Peckinpah: A Portrait in Montage*, Limelight, 1998.
2-*Cahiers du cinéma* , n° 218, mars 1970, p. 65.

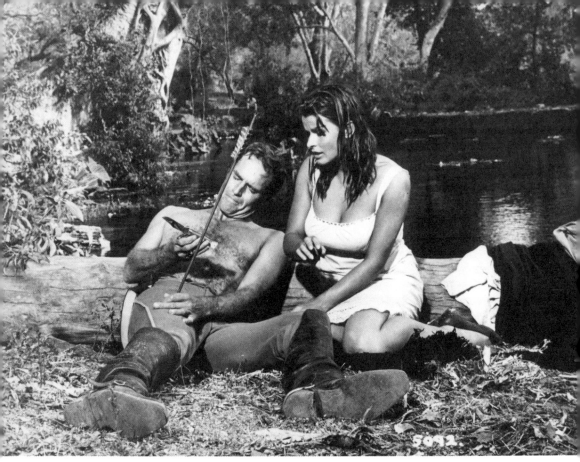

Major Dundee

Country, Steve Judd (McCrea) says that the Hammond brothers all put their bullets in the same spot. These moments are evidently the announcement of a renewal in cinema: henceforth, there will be a new approach that, instead of eliding violence, lingers over its destructive effects, while also making these effects into a kind of writing.

These wounds – Ansara's in "Hand on the Gun", Keith's in *The Deadly Companions*, McCrea's in *Ride the High Country* and one may add, for example, the arrow in Charlton Heston's thigh in *Major Dundee* (which anticipates the crushing of Cable Hogue's legs under the runaway car) – are all, no doubt, "symbolic". The symbolic nature of the wound is, however, part of what Peckinpah fights against. In *The Deadly Companions*, a good deal is made of Yellowleg's disabled right arm. In the script, which Peckinpah disliked, Yellowleg was to wear two guns and was to triumph in a duel with Billy (Steve Cochran) by using his left-hand gun. Peckinpah omitted the left-hand gun and simply had Yellowleg walk up to Billy and shoot him. The producer, outraged, says he had no choice but to recut the sequence so that Turkey appears to shoot Billy in the back.[3]
In any case, what is decisive in the result is that Peckinpah refuses to obey the

3-See Garner Simmons, "The Deadly Companions Revisited," in Michael Bliss, *Peckinpah Today: New Essays on the Films of Sam Peckinpah*, p. 6-35.

script's dramaturgical requirement that the hero overcome the disability of his arm. The script seems to allude to a logic that makes the disabled arm a symptom of moral immaturity, so that in order to function as a full man, Yellowleg must either recover his lost control over his right arm at a crucial moment, or (like John Wayne in *El Dorado*) find some way to compensate for his disability. But Peckinpah prevents this from happening. What does this mean? It means that we are not to celebrate an act of violence – neither to see violence as redemptive (as we would have been led to do if Yellowleg had recovered the use of his arm) nor to see the hero's strategic use of violence (the unexpected, but also predictable, use of the left hand that the script had called for) as existentially necessary. In other words, we are not to understand that the hero is made whole again by the use of violence. James Dodd, in *Violence and Phenomenology*, warns against the ways by which we become "the dupes of violence": "first, there is the tendency to expect *too much* from violence, to look to violence either to express a decisiveness of purpose, or to provide a proof of authenticity that violence cannot in fact sustain."[4] In his attempted revision of *The Deadly Companions* (ultimately frustrated by the producer's re-cutting), Peckinpah tries to prevent the audience from falling into this trap.

Nor does Peckinpah demand that we compare acts of violence on some hierarchical scale. In the script, Yellowleg carries out a good act of violence (killing Billy) but is dissuaded from the bad act of violence (scalping Turkey). In Peckinpah's version, presumably, the killing of Billy is completely unglamorized and robbed of any moral heroism (which is why the producer was outraged by it): it is "a brutal, realistic act".[5] There is no good, redemptive violence, and no bad (selfish or nihilistic) violence: there is just violence, as a possibility, or a dimension, of humanity, as a choice of *how* to act in the world.

INCOHERENCE

The question of violence in Peckinpah is, then, a question of history, of story-telling, of how to narrate a life in such a way that it acquires a significant shape. Peckinpah's lateness in relation to classical Hollywood manifests itself as a willingness to countenance lives that do not reach such a shape, that end abruptly, snapped-off and unredeemed. There is something deeply unsatisfying in the ending of *The Deadly Companions*, the evident failure to resolve the differences between Peckinpah's view of the story and the producer's, a failure to bring together the two main movements of the story (that of Yellowleg and

4-Routledge, 2009, p. 1.
5-Ernest Callenbach, "A Conversation with Sam Peckinpah", *Film Quarterly*, Vol. 17, n° 2, Winter 1963-1964, p. 9.

that of Kit, played by Maureen O'Hara) into a meaningful pattern. Incoherence will also haunt *Major Dundee*, at the end of which it is difficult to affirm that the various historical and personal strands of the story have been brought into a clear relationship. Dundee (Heston) completes his mission and rides on (as do Yellowleg and Kit at the end of *The Deadly Companions*), but he has left behind a map of broken lines, of which one of the most vivid represents the life of Dundee's nemesis, Tyreen (Richard Harris), whose final self-sacrifice is shown in a way that deprives it of nobility and redemptive meaning. For Tyreen, the pattern of life has been disrupted and is never completed.

This is indeed the problem of *Major Dundee* as a whole: the actions of the characters do not conform to a pattern but collapse into insignificance, derailed by the logic of what might be called a purely external chain of cause and effect, amid results that contradict their original intention. "We entered the village to take food and horses," Trooper Ryan's voice-over narration observes, "but instead gave away our own, and everyone was thankful." Narrative movements are broken without ceremony: the Apache warrior Sierra Charriba, object of Dundee's expedition, is finally killed not by Dundee but by Ryan; the long-promised duel between Dundee and Tyreen is interrupted by the sighting of the oncoming French troops, and Tyreen is finally killed by the French, not by Dundee.

The two goals of Dundee's expedition – to capture or kill Charriba and to recover the Rostes boys – are not necessarily contradictory, but their co-presence at any rate creates a certain play, or ambiguity. After the return of the boys, Dundee has the option of returning to the United States; if he instead affirms the necessity of continuing the search for Charriba, it is by an act of personal will as much as out of fidelity to the other half of his originally stated intention. In *Dundee*, motives are constantly muddled (this, too, is a symptom of the lateness of Peckinpah).

Abjuring traditional patternings by which protagonists and antagonists are decisively opposed to each other, Peckinpah's narratives instead plunge all the characters into a world where any one of them may be promoted suddenly into the role of a surrogate protagonist. In *Ride the High Country*, Judd's intention – "to enter his house justified" (by the successful completion of his mission for the bank) must be completed by Gil Westrum. This is because of the accident of Judd's death, which follows from the accident that involved Judd in a feud with the Hammonds. But in another sense you could say that there is no such thing as an accident; no "external logic" that would oppose an "internal logic" – the logic of life being based on the constant mixing of internal and external. Thus the "logic" of Peckinpah's cinema at once is, and is not, a logic of what might be called classicism, if classicism is that which draws only on itself, only on the set of objects that are originally in place.

If Peckinpah's characters fail to complete a pre-designed course, it's also because they have a tendency to act impulsively and wildly, to take fire from chance encounters. The comic narrative of *"The Courting of Libby"*, an episode of *The Westerner*, is built on the passion Dave Blassingame (Brian Keith) conceives for Libby (Joan O'Brien), a passion that erupts spontaneously on a chance encounter and that proceeds in the manner of a pure diversion. This is the role of women in Peckinpah's films: to remove men from their course, to begin an alternate or divergent movement. Kit, in *The Deadly Companions*, diverts Yellowleg from his goal of revenge, a diversion that he sees first as a postponement but that finally becomes a cancellation of his original intention (Kit's revulsion causing him to see himself differently and to give up his revenge).

In *Ride the High Country*, Mariette Hartley's Elsa diverts Heck and morally improves him – and it is possible that Steve countenances this diversion because she reminds him of his lost love, Sarah Truesdale (we can infer this in spite of, or rather on the basis of, his indignant rejection of Gil's suggestion of a similarity), or because he recognizes that the role Elsa is playing in Heck's life is the same one that Sarah played in his own, and that Elsa could then complete, for the new generation, the proper functioning of that role (which in Steve's case had been interrupted). In *Major Dundee*, Teresa (Senta Berger) functions as a distraction for Dundee, offering the momentary glimpse of a different way of life; but their idyll is brutally interrupted twice: first by the thigh wound that puts Dundee out of commission and second by Teresa's sight of the nude back of the Mexican woman who cares for Dundee during his recuperation in Durango. Both times, it is the body (as revelation) that breaks off an incipient impulse in the narrative toward the foundation of the romantic couple, toward a respite from war.

The tendency of Peckinpah's films to move toward chaos and destruction is announced in a light manner in such television works as "Brown", "The Courting of Libby" (which presents pure externality as spectacle, in a sequence of cats being chased by a dog), and "The Losers", before appearing full-blown in the battle sequences of *Major Dundee*. As the denial of a meaningful individual human pattern, and the immersion of the individual within pure destructiveness, chaos is an extension of the normal state of the soldier (as Dundee describes it almost wistfully to Teresa: "it's easy; forget about your problems, responsibilities, just let someone feed you, tell you what to do..." In other words, surrender to the not-self). On the other hand, chaos manifests itself as a kind of inevitable betrayal of military order: the scene in *Dundee* in which Lt. Graham vainly tries to get the soldiers, who are breaking in the wild packhorses, to form ranks, is just a step away from the machine gun out of control, firing randomly, in *The Wild Bunch*.

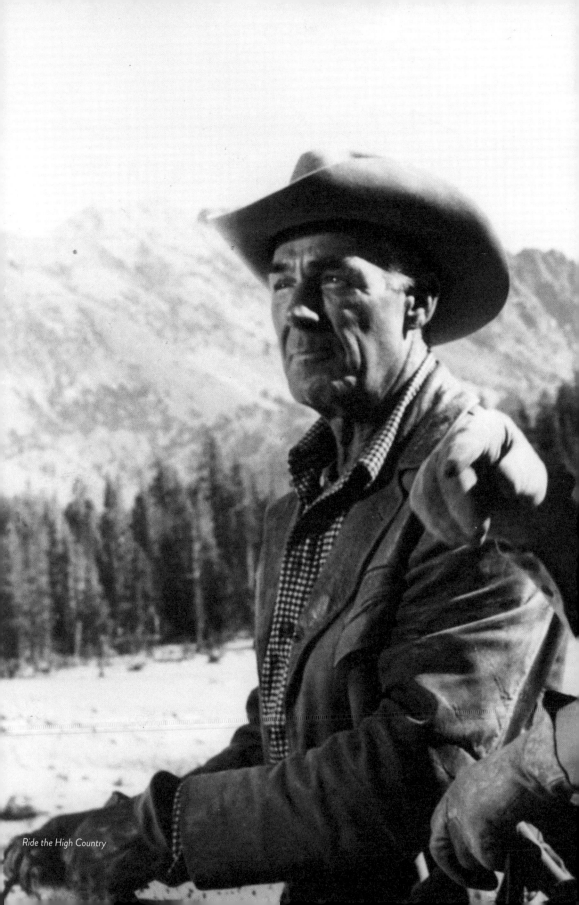

Ride the High Country

Chaos is always within Peckinpah's reach: it is one tendency of his editing, which brings together disparate spaces and characters only to separate them again, leaving them in their mutual inconsequence. Frequently, as if to emphasize the necessarily sundered, severed condition of his protagonists, he lets dialogue from one spatial situation or configuration of characters continue over the image of another, commenting ironically on the new image or claiming a coherence that is simultaneously denied.

Major Dundee is entirely a film of scattered images, moments from the lives of a large and heterogeneous cast of characters. The rhythms of the film are often broken, the transitions abrupt and arbitrary (the externality of production circumstances dictating terms to the internal flow and logic of the film); yet the scattering of the images is not without a dry and elegant purposiveness (in the genre of "Reminiscences of a Cavalry Expedition in Northern Mexico"). Typical of Peckinpah's editing are such moments as the scene of the racist white soldier challenging the black Aesop by ordering him to remove his boots (flurries of shots of soldiers looking on in consternation from different positions), and the night scene in which the Cavalry camp becomes alarmed by the sound of a bird call that sounds like, and proves to be, an Apache signal (shots of soldiers hastily grabbing guns, dousing fires). Peckinpah's procedure in these moments is close to the editing styles of Ray or Aldrich, based on multiplication and dispersion: in Peckinpah's films, durations are compressed so far that they approximate the still frame (a limit reached repeatedly in Peckinpah's films, e.g., "The Losers", *The Wild Bunch*, *Pat Garrett & Billy the Kid*, and *Bring Me the Head of Alfredo Garcia*, in moments that crystallize the elegiac aspect of Peckinpah's lateness). Early in *Major Dundee* there is an excellent example of Peckinpah's editing style. Medium long shot: Potts (the civilian Cavalry scout) and Dundee riding slowly through the Rostes camp after the massacre, approaching a body in the foreground bundled in a blanket. High-angle: the bundle springs to life, an Apache rises and lifts a pistol. Potts, on his horse, shoots down at the Apache. The Apache is struck; immediately another gunshot is heard; the Apache starts to fall. Dundee reloads his rifle, which he has just fired. The Apache, on the ground, collapses dead. This succession of shots has taken less than five seconds.

The fragmentation that is an inescapable characteristic of *The Deadly Companions* (in which it is not always possible to distinguish between the incongruities Peckinpah intended and those that were added by the producer's recutting) reaches a special level of intensity in key moments of the relationship between Yellowleg and Kit, such as the dissolve on a close-up of Kit after she threatens him with a gun when she sees him trying to bury her son's coffin. This is because (or is a symptom of the fact that) their relationship is based on contradiction. Thus: "You killed the only person I loved in this whole world", and then, just two minutes later, "I just wanted to say – thank you." Contradiction

is also a feature of the other relationships in the film, as when Billy takes Yellowleg's gun (in Siringo) and then gives it back to him (so that he can use it against Turkey). Contradictions abound in Peckinpah's cinema. In the Durango sequence of *Major Dundee*, Tyreen, coming upon Dundee, declares: "I've come to rescue you." Dundee: "Why?" "So I can kill you myself." ("That makes sense," replies Dundee.)

If, throughout the period of his work that culminates in *The Wild Bunch*, fragmentation increasingly characterizes Peckinpah's mise en scène, it is countered by an effort, sometimes doomed and desperate, by the characters of his films to assert the continuous presence of a meaningful pattern in their lives. This effort takes the form of a particular kind of movement through time, of which Kit's mission in *The Deadly Companions* may be taken as representative: to vindicate her own life and the legitimacy of the birth of her dead son, she insists on retracing her own course, going backward in time, from Gila City to Siringo. This movement proves to be one toward barrenness and destruction: Siringo is a ghost town, filled with graves. The other main movement in the film, that of Yellowleg, is also a return to the past, as Yellowleg seeks to avenge his near-scalping by Turkey. Siringo becomes the place, then, where both these movements, that of Kit and that of Yellowleg, are annulled in the face of the all-embracing void of the dead town itself, which robs the characters' missions of their significance. Both people are positioned between a past that is a personal myth and a future that is empty and without basis. This is why the ending of the film is so abstract: it doesn't matter that the couple riding off together is a cliché of the Western genre, since what is important is that there is nowhere for the couple to go.

Other Peckinpah characters try to give their lives legitimacy and purpose by conceiving their present and future in relation to the past. In "The Money Gun", an episode of *The Rifleman*, Lucas, who rode once in the past with professional killer King (John Dehner), now feels the urgent need to distinguish himself from King. Shame from the past also weighs on characters in two other *Rifleman* episodes by Peckinpah, "The Marshal" and "The Boarding House". In "Jeff", an episode of *The Westerner*, the past relationship between Dave and the girl he loved, Jeff, is repeated in the present, leading (as in *The Deadly Companions*) to a cancellation or stalemate: unable to resolve their past relationship, the couple have no choice but to separate.

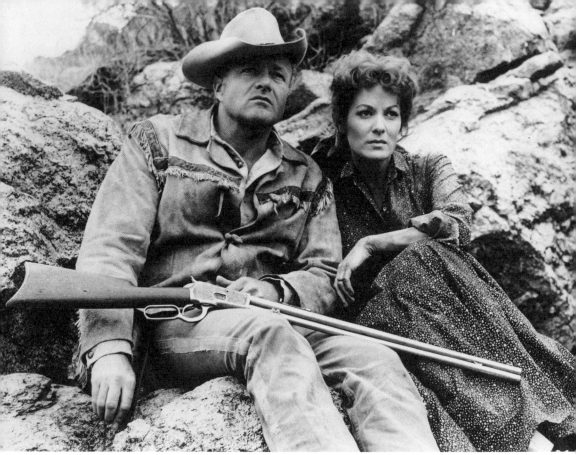

New Mexico

SEEING ONESELF

Throughout *Ride the High Country*, Gil and Steve carry on a running discussion of the past. The past is now more real than the present for them, and it is in terms of the past that they present themselves (Gil's Oregon Kid booth at the town fair) and are seen (the ironic scene of Steve's arrival in town at the beginning of the film). Similarly, in *Major Dundee*, Dundee and Tyreen carry on, intermittently throughout the film, an extended dialogue about their past. It is also a dialogue about their own biographies and their own destiny. "You haven't the temperament to be a liberator, Amos." "Haven't I?" Who are Dundee and Tyreen? This is the problem of the film, and it is never solved. "How exactly do you see yourself, Amos?" Tyreen asks him. The question is not answered. Later in the film, during his Durango purgatory, Dundee stares at himself in a mirror in an upstairs bedroom in a cantina. Then, Dundee asks Tyreen, who has come to rescue him: "Why don't you drink, Lieutenant Tyreen? Don't you ever have any doubts about who you are?" Dundee contradicts himself: as a Southerner who fights for the Union; as a friend who votes for his friend, Tyreen, to be cashiered (for killing another officer in a duel of honor). Whereas Tyreen

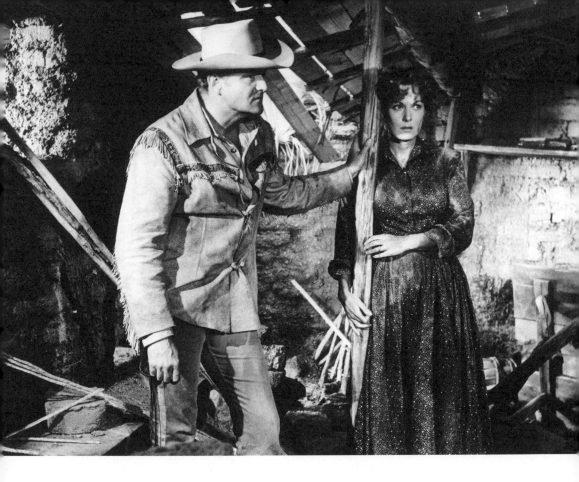

is three men in succession: Irish potato farmer, cashiered Union officer, and Confederate renegade.

Dundee is the modern figure of the two because he is contradictory: a figure of disunity, emblematic of the disunity of his country and of his company, which at the same time he seeks to unify through the force of his will and personality. (He *can*, at least at moments, do it, because, after all, he is embodied by Charlton Heston: this is enough for the film to work, superficially, in a "classical" mode that it repeatedly contradicts.) We are told by the dialogue that Dundee's past was marked by the pursuit of personal goals: "If you try to fight your own war again as you did at Gettsyburg, they'll break you," Dundee is warned by Captain Waller. For Dundee, the pursuit of Charriba represents a chance to redeem himself, to be perceived as a soldier again and no longer as a mere jailer.

This question of how to see oneself is obviously an obsessive one for Peckinpah. As early as the first sequence of *The Deadly Companions* we find the emblematic gesture of the shooting of the self-image in a mirror, an act here relegated to the minor character of Billy. It recurs near the end of *Pat Garrett & Billy the*

Kid – though, according to James Coburn, the actor wanted Garrett to shoot himself in the mirror, and Peckinpah originally tried to argue him out of it, possibly aware that the action was so close to him as to be already a kind of cliché.[6] Coburn also recalled a significant conversation he had with Peckinpah during the production of *Major Dundee*. "I asked him, 'Sam, what is it about the character of Dundee that makes you want to make this film?' I knew I'd get an answer to that one. And Sam said: 'Because he continues. I mean through all the shit, through all the lies, through all the drunkenness and the bullshit that Major Dundee goes through, he survives and continues!' It was brilliant because suddenly I understood the script in the way Sam saw it. Despite everything, Dundee must go on. And from that point on, while the picture was still a hell, I at least understood why I was willing to go through it."[7] So, in the film, Coburn's character, the guide Potts, says to Dundee, about Charriba: "He wants to drag it out. I think he figures on leaving stories about you that will be told around the campfires of his people for a thousand years." This determination to continue, to "drag it out", to draw out a line relentlessly, constantly fascinates Peckinpah. All his work can be seen in terms of this: whether a line is allowed to continue in what would be its own direction, or whether it is diverted or broken.

The truth of *Major Dundee* is that whether Dundee is to be seen as a hero or a villain is something that can be determined only at the end of his expedition, after everything is over; this can also be said of the heroes of *The Wild Bunch* and *Bring Me the Head of Alfredo Garcia*. Similarly, it's in connection with the question of the final word that we should consider the abandonment of revenge in Peckinpah's films (not just *The Deadly Companions* and *The Ballad of Cable Hogue*, but also *Major Dundee*, in which Tyreen renounces his threatened vengeance upon Dundee by choosing to spend his last moments in a solitary charge upon the French troops), and, on the other hand, the hero's relentless, even improbable, completion of the mission of revenge in *Bring Me the Head of Alfredo Garcia*.

In *Major Dundee*, the characters' efforts to test and define themselves through experience puts them in conflict with a regime based on writing, the text, the word. The journal of Trooper Ryan is important because it extends this regime over the narrative (transforming experience into narrative). Some of the soldiers are illiterate (Dundee, selecting volunteers for his expedition, allows them to make their mark in lieu of signing their name). At the tense moment of confrontation over the fate of the Southern soldier (Warren Oates) who has deserted and been brought back, Tyreen implores Dundee: "Forget the book." Yet Dundee knows that Tyreen is, in spite of everything, a man of language, of the word: "I have what I want," says Dundee of Tyreen, "I have his word." Tyreen's

6-David Weddle, *If They Move... Kill 'Em! The Life and Times of Sam Peckinpah*, Grove Press, 1994, p. 479.
7-Simmons, *Peckinpah: A Portrait in Montage*.

"word" is an example of a Peckinpah theme that finds its most celebrated expression, no doubt, in the exchange between William Holden and Ernest Borgnine in *The Wild Bunch*, over Deke Thornton's "word" ("He gave his word." "Gave his word to a railroad!" "It was his word!" "That ain't what counts! It's who you give it to!"). Peckinpah's characters are caught in the contradiction between their longing for freedom and the debt they owe society as beings of language. So it is with Steve Judd, poring over his contract with the bank in *Ride the High Country*, his spectacles betokening his enthrallment to civilization. And so it is that of the two men who are perhaps the "freest" of Peckinpah's heroes (that is, the most childlike, the most at liberty to take pleasure in their wildness), Dave Blassingame in *The Westerner* is illiterate (he starts to learn to read in "Hand on the Gun"), and Cable Hogue has difficulties with the written word. Their illiteracy is the condition of their freedom.

REENACTMENT

Let's look more closely at the sense in which Peckinpah comes "too late" (to take up Daney's words again). It is significant that the two directors under whom he begins in cinema are Don Siegel (*Riot in Cell Block 11*, *Private Hell 36*, *An Annapolis Story*, *Invasion of the Body Snatchers*, *Crime in the Streets*) and Jacques Tourneur (*Wichita*, *Great Day in the Morning*). Tourneur is already the exhaustion of "classical cinema", its turning away from a narrative of "action" in the traditional sense, toward a modern cinema of pure gestures and signs. And if Siegel, trained in the montage department of Warner Bros. (where he invented sequences to be inserted in the middle of films by Raoul Walsh and Michael Curtiz), represents a kind of renewal of classical cinema, it is in the sense of stripping down and stripping away, of a conscious negativity and destructiveness. Peckinpah's apprenticeship takes place, then, not within the heart of classical cinema itself, but at the site of its overturning.[8]

Having gone through this apprenticeship, Peckinpah knows that the old cinema is dead, or has become impossible, and that it falls to him and his generation to find a new justification for cinema. The first feature film Peckinpah directed,

8-The accidental shooting of the boy in *The Deadly Companions* reenacts a moment from *Wichita*. In *Ride the High Country*, Gil's booth is decorated with the names "Dodge City" and "Witchita" [sic], prompting Steve's disingenuous question, "Did you ever run with the Earp boys, Gil?" Note also the presence of Edgar Buchanan from *Wichita* in *Ride the High Country* and of Peter Whitney from *Great Day in the Morning* in *The Ballad of Cable Hogue*. Peckinpah's association with Siegel endured till late in both men's careers, when Siegel invited Peckinpah to direct the second unit of *Jinxed!*, which would be Siegel's last film. Among the actors whom Peckinpah may have first met while working on Siegel's films, and who went on to appear in his own films, were Steve Cochran (*Private Hell 36*) and L. Q. Jones (*An Annapolis Story*). It should be noted, however, that Peckinpah's well-known claim to have made significant revisions to the script of the most famous of the films on which he worked as an assistant, *Invasion of the Body Snatchers*, was forcefully denied (as Pierre Rissient has recalled) not only by the credited writer, Daniel Mainwaring, but also by the director (Siegel) and the producer, Walter Wanger.

however, seems to renounce any positive affirmation in order to place itself firmly in relation to death and mourning. *The Deadly Companions* is a film of exhaustion, in which the vengeful quest of Yellowleg is in effect renounced in advance, and the only possible future dies with the boy who is killed, accidentally, near the beginning of the film. So the narrative movement is basically no more than a mourning for the cutting-off of this possibility. There is no serious business left for the characters other than the working-out and cancellation of the debts they owe to the past. The secondary characters of *Companions* encapsulate this exhausted Zeitgeist: Billy and Turkey are roaming villains without real malice; the feeble-witted Turkey fantasizes about an impossible utopia which is nothing other than a parody of American civilization; the Apache are reduced to playing games of mimesis, re-enacting the derisory conquest of a stagecoach.

This reenactment announces one of the principal modes of *Ride the High Country*, Peckinpah's second film. Gil Westrum is reduced to a figure of mimesis, "the Oregon Kid", fraudulently representing the legendary past of the American frontier. The movement of the narrative at last brings Gil and Steve to the point where they can redeem themselves by playing themselves truly (in contrast to the false playing of Gil's fair booth), though the film also makes it possible to assert that all selfhood is, simply, play and to see the characters as constantly imitating themselves or inventing themselves – this Nietzschean perspective is Peckinpah's major contribution to the Western genre.

The staged, enacted, legendary nature of the final shootout in *Ride the High Country* may be what aroused the antipathy of Margaret Booth, the venerable head of MGM's editing department, who hated the film: something happens that is not, according to the conventions, "real" or "realistic" – the Hammonds are summoned to, and Judd and Westrum enter consciously into, a sort of summation or transcendence. Such moments of staging occur throughout Peckinpah's early work: cf. the church service in the saloon in *Companions*; Dundee's staging of the aborted execution of the Confederates in *Major Dundee*; or, in the same film, Tyreen's conscious assumption of a self-sacrificial role at the river battle. (Throughout the film, Tyreen exemplifies a certain stylization or theatrical presentation of self: in this, he is consciously a "late" character, just as Peckinpah is a "late" director: unable simply to be himself, Tyreen must play himself. Others of this type include Gil as the Oregon Kid in *High Country*, Billy in *Companions* – saluting Kit with a courtly little bow and the doffing of his hat – and John Dehner's Burgundy Smith in episodes of *The Westerner*.)

DURATION
AND IDIOSYNCRASY

The "failure" of *Major Dundee* (cf. Daney: "failure, derision, entropy of all human enterprise, of every mise en scène") is more drastic, more symptomatic, more significant than that of *Companions*: it is the sign of a double impossibility, that a certain kind of filmmaking has become impossible (because false), while, at the same time, a true filmmaking is not yet possible. *Major Dundee* represents both sides of this condition through a journey more metaphorical in form than those of *The Deadly Companions* and *Ride the High Country*: a search for the film itself, which does not exist on the level of the script (which both Peckinpah and the last writer on the project, Oscar Saul, recognized as unsatisfactory) but which only comes into being in the quest for its own form.

This quest necessarily demands a certain unpredictability of duration, and it is in *Major Dundee* that duration comes into its own as a key element of Peckinpah's work. *The Deadly Companions* is a kind of protraction of the television episode, retaining the same principles of dramatic construction.[9] *Ride the High Country* is a fully achieved "feature film", admirable for a unity of construction that can accommodate so much liveliness in the background and among the supporting characters. *Major Dundee*, on the other hand, shows the difficulty in Peckinpah's conception of cinema with regard to duration: the film can only work if it is too long (or, as Blake writes in *The Marriage of Heaven and Hell*, "You never know what is enough unless you know what is more than enough"), and since Columbia won't let it be too long, the film cannot work. *The Wild Bunch* (though it will also be shortened by its studio for release) will present a sort of solution: if the film is too long, it is because the episodes are excessively drawn out, not because (as Peckinpah might have argued concerning *Major Dundee*) the plot or the character development require an extended running time (cf. Daney's comment that the whole of *The Wild Bunch* is already in its title sequence).

In *Major Dundee*, the extended sequence of the celebration in the impoverished Mexican town after the surrender of the French garrison develops a sense of duration that will become increasingly idiosyncratic and increasingly free in Peckinpah's subsequent films (just as interludes such as the sporting fight between Potts and the Apache scout Riago introduce a ludic element that is irrelevant to the movement of the narrative; such scenes could, clearly, be drawn out to any length). It is hard not to associate this sense with the lingering

9-Paul Seydor writes: "*The Deadly Companions* can in many respects be regarded as a kind of two-hour episode of *The Westerner*, its hero an extension of Dave Blassingame. The casting of Brian Keith virtually guarantees this." *Peckinpah: The Western Films - A Reconsideration*, p. 33.

sentimentality (grossly evident in the flashbacks and extended bouts of male laughter in *The Wild Bunch*) and reluctance to let go of the image, which, together with the use of slow motion, become Peckinpah trademarks in *The Wild Bunch* and the subsequent films. Following exactly the reverse tendency of the compression of the twenty-five-minute television episodes with which he began his directing career, Peckinpah's cinema expands, at the risk of becoming increasingly empty. Duration is the principle of *Junior Bonner*, in which the hero's moments of self-projection into action are impossibly extended (the rodeo sequence) and then interspersed with even longer interludes of relaxation (the saloon sequence). *Pat Garrett & Billy the Kid* is nothing but stasis, the extension of a single situation, or the interruption and postponement of the inevitable death of Garrett, just as *The Ballad of Cable Hogue* seems to take place at a single spot in the middle of the desert, where the entire narrative is, perhaps, being dreamed by its dying hero.

It is also through the idiosyncrasy of characterization pursued as a value in itself, without regard for the function fulfilled by a character in the plot, and through a purely eccentric mode of characterization, that Peckinpah asserts himself as a figure who renews classical cinema. This is a matter of giving each character in a film his or her own temporality, which may be at odds with the dominant temporality of the film. The excess of a figure who is subverted from menace into ridicule, without entirely ceasing to be dangerous, can be seen in: Chill Wills in *The Deadly Companions*; Strother Martin in *The Wild Bunch* and *The Ballad of Cable Hogue* (Martin's appearance as the parson in *The Deadly Companions* is less aberrant and freakish than his later ones for Peckinpah, or, indeed, than his performance as Lee Marvin's sidekick in *The Man Who Shot Liberty Valance*); the brothers (notably Warren Oates and John Davis Chandler) in *Ride the High Country*; and the Southerners (especially, again, Oates and Chandler) in *Major Dundee*. Drawn to people who are not normally seen in films, Peckinpah lets us look at them closely, at length: cf. Jason Robards' "white trash" neighbors in "Noon Wine".

Related to the troubling nature of these people, there is something very unusual and original, too, in the inadequacy of Cal (Ben Cooper) in the remarkable "Hand on the Gun": a young tenderfoot who has been lured out West by tales of bravado and gunplay, who accosts strangers while twirling his gun and who seeks, with an insistence that increases until it becomes provocation, to make himself the hero of such a tale. He is an unbearable person, one who embodies an irritating selfishness, that of the "individual" who has a sovereign need to assert himself, always inappropriately – it is impossible for him to be appropriate; he has nothing "proper" in himself. He is a body too much, with "the smell of death on him", a body that must finally be disposed of. Is there not something of him in the soldiers of *Major Dundee*, all of them, too, intolerable bodies that are displaced and that thrust themselves where they don't belong?

Major Dundee

North Americans in Mexico, Dundee's men are greeted as liberators by the Mexican people (who have been suffering under the French), only to be seemingly expelled by the land itself.

THE GROUP, THE COUPLE

During the shooting of *The Deadly Companions*, Peckinpah was forbidden by the producer to speak with Maureen O'Hara, and it does indeed seem as if O'Hara were encased in her own film, separate from the director and the other actors, looked at always from a great psychological distance (even if photographed in close-up). Even so, hers is not necessarily the most extreme and desperate of the solitudes of characters in this film: each of them is solitary, acting in their own private drama that only tangentially relates to the dramas of the other characters. The movement of the early Peckinpah films is a quest to conquer this unconquerable solitude, which is also the condition of Steve Judd (*Ride the High Country*) and of Major Amos Dundee. But it is in "Noon Wine" that the solitariness of Peckinpah's characters reaches its peak: Jason

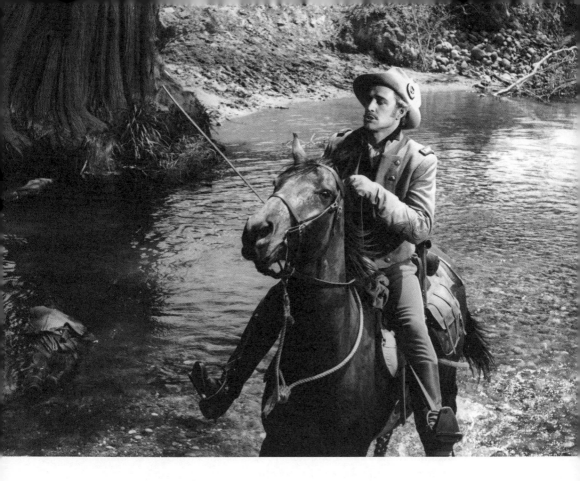

Robards, Per Oscarsson, and Olivia De Havilland are all trapped in their own worlds, in which they are condemned to remain.

Against this solitariness, Peckinpah's cinema offers two major figures: the pair and the group. The pair is usually a pair of men, joined in an uneasy, sometimes antagonistic relationship: Yellowleg and Billy in *The Deadly Companions*; Steve and Gil in *Ride the High Country*; Dundee and Tyreen in *Major Dundee*; in *The Westerner* episodes, Blassingame and Burgundy; and their identically named avatars in "The Losers", played by Lee Marvin and Keenan Wynn. The number two assumes full prominence at the end of *Ride the High Country*, with Gil and Steve walking together, the camera low to the ground, tracking back before them, as they go to fight the Hammonds.[10] The entire beginning section of *Ride the High Country* presents a series of dual rivalries: the embittered defeated horseman vs. the camel-riding Heck; then two boys of identical height, wearing similar suits and hats, who are dragged away by their mother from the spectacle of a midriff-revealing

10-On the significance of the number two, cf. Jean-Claude Biette on Tourneur's *Wichita* ("Revoir Wichita" *Cahiers du cinema*, n°281, octobre 1977, p. 40-43) and Jean-Louis Comolli et François Géré on *Fritz Lang's Hangmen Also Die!* ("Deux fictions de la haine" *Cahiers du cinéma*, n°286, mars 1978, p. 30-47).

female dancer; then another dual rivalry (the gum chewer trying his skill against the Oregon Kid). This series culminates in the meeting between Steve (now deceiving, rather than deceived, pretending to be a silly old man – i.e. parodying the role which he has previously seemed to play for the townspeople) and Gil (whose deception – using a pistol loaded with buckshot in his marksmanship contests – Steve, who is far from silly, exposes). Subsequently, we encounter another pair: the father and son team of Percy Helton and Byron Foulger at the bank: old people who want to use young people and for whom the middle-aged Steve is barely acceptable for the job of guarding the gold miners' bank deposits.

As for the other figure, the group, *The Wild Bunch* and *Pat Garrett & Billy the Kid* both offer important versions of it: if Peckinpah romanticizes the outlaw groups and scattered underground societies of these films, it is because they represent a last-ditch opposition to the civilization built on capital and on moral law, and it is implicitly in these terms also that Peckinpah (following Ford) views the Cavalry in *Major Dundee*. But any group is necessarily an impingement on the individual: Dundee's alcoholic dissipation in Durango permits him, momentarily, to escape the need to see himself as part of a group. The Durango sequence contributes to the complexity of a portrait of a troubled individualism that seeks, paradoxically, to express itself through an institution (and in that sense can be taken as the director's self-portrait).

Throughout Peckinpah's work, the strain of moral severity in American society is criticized, as with the whip-wielding John Dehner character in "The Baby Sitter" (an episode of *The Rifleman*), Elsa's father in *Ride the High Country*, and the deranged jailer in *Pat Garrett & Billy the Kid* (the latter two characters are both played by the same actor, R. G. Armstrong); already there is a deep ambivalence in the character of Lucas McCain (Chuck Connors), the Rifleman, a contradictory figure of morality (a man of peace and a kindly father who unhesitatingly turns to violence when he is forced to defend his town). The tone of moral outrage that sometimes accompanies Lucas (as in "The Money Gun", with its self-righteous horror at "filthy, stinking murder") is reminiscent of Phil Karlson's *The Phenix City Story* in its extremism. Steve Judd in *Ride the High Country* is a softer, milder version of Lucas, but one who suffers more from the responsibility of judging

Peckinpah's narratives typically reach an impasse where "morality" must yield: this is the conclusion of "The Baby Sitter" (in which the remorseless Protestant fundamentalist played by Dehner is simply overpowered and thus made to give up his quest to reclaim the child his estranged wife has taken away from him – a dénouement echoed in another *Rifleman* episode, "The Boarding House", in which the villainous Alan Baxter simply gives up when he loses his knife and is beaten by Lucas), and also the conclusion of "Jeff"

(in which Blassingame gives up his attempt to take Jeff away from her pimp). In *The Deadly Companions*, Kit both rebels against and internalizes the moral condemnation heaped on her by the good people of the communities where she lives. Always quick to assume that others regard her as of little value, she says to Yellowleg: "Five years is a long time to turn your back on, especially for a woman like me. That's what you're thinking, isn't it?"

Perhaps Peckinpah's ultimate statement on morality and judgment is to be found in the lacerating "Noon Wine". The poor farmer played by Jason Robards, like Steve Judd in *High Country*, is seeking to be justified, but he constantly suffers under the judgment of others, and finally of himself. The story turns on the inadequacy of the figure of a father who at one point threatens violence against his sons, a threat that lacks any moral basis, which is why it is so loud and excessive. Robards becomes moral only in siding with someone outside the family: having accepted the itinerant farmhand Per Oscarsson, Robards will defend him against the terrible bounty hunter Hatch, with fatal results. Robards' self-judgment is all the more final and devastating in that it operates in a complete void, that of the bankruptcy of "justice" (represented by the defense lawyer, Robert Emhardt, who merely does a job, doesn't want to listen to his client and refuses to linger with him after the acquittal) and the absence of community (so visible when Robards and de Havilland go to plead their case to the neighbors, who otherwise don't exist in the story, and who are not in sympathy with them).

REDUCTION
OR APOTHEOSIS?

What does Peckinpah represent in Hollywood cinema? It is clear that between *Ride the High Country* and *Major Dundee*, a divergence of viewpoint occurs: *Ride the High Country* views Gil and Steve more or less as they view themselves, espousing a just point of view, anticipating Gil's eventual reformation (as in Steve's line: "Hell, I know that. I always did. You just forgot it for a while, that's all"), and keeping the other characters, especially the two ingénues, at a distance. On the other hand, in *Major Dundee*, the characters are viewed with a mixture of irony, sympathy, and awe, and in this wavering perspective, they never fully come into focus. Dundee and Tyreen are monsters, farthest from us when they are most lucid in their perception of themselves.

In the scaling-down from Gil and Steve, already quasi-mythical figures, to Heck, Elsa, and the Hammond brothers, there is already a reduction from the legendary Old West to a whole implied contemporary reality (including the reality of television, which nurtured Peckinpah himself). Major Dundee, like Steve Judd,

seeks his apotheosis, but he will never find it. The problem is not that Dundee's cause is not just – this was not a problem for John Wayne in Ford's *Rio Grande*, and in the end, Steve's own cause, protecting a bank's money, is less than glorious. The secondary cause of protecting Elsa, which occasions the final gunfight, may be seen as noble or not, but the evidence of the way Elsa is placed in the mise en scène suggests that Peckinpah does not put great weight on it: it is, merely, a cause, i.e. a pretext.

It is because Elsa and what she represents (youth, survival, the future) are merely pretexts that there is no guarantee of apotheosis: the end cannot be predicted in advance, it can be seen only after it *is* an end. The case with *Major Dundee* (finally, a work of pure pragmatism) is similar. Yet Peckinpah's early films, in their openness, their brokenness, and in coming close to the negativity of the later ones (particularly in the compulsive negation of home and of nation that is already so forceful a feature of *The Deadly Companions*), anticipate the conclusions of the later ones, while still retaining, as something more than a hope , the possibility of another trajectory.

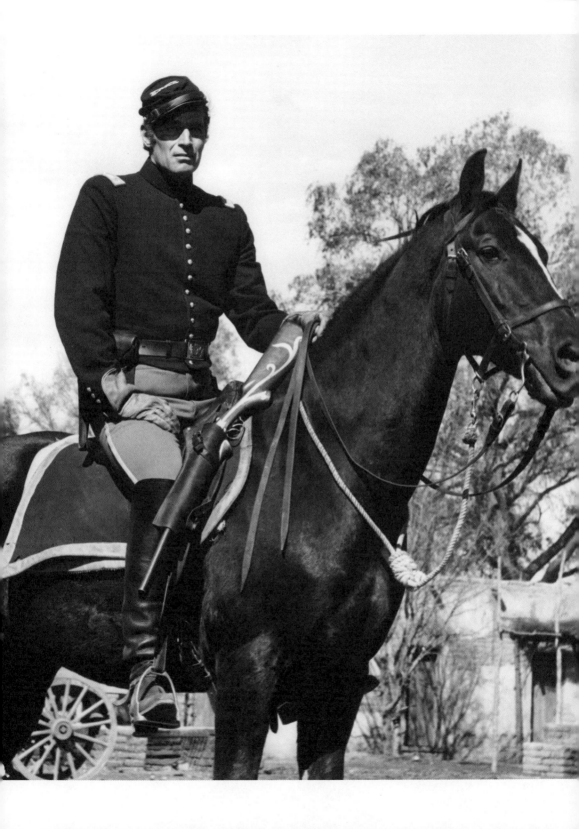

1961-1965

FILM SHOOT
STORIES

The Deadly Companions
(1961)

The year is 1960. Sam Peckinpah is thirty-five years old, and has already gained a small following thanks to the show *The Westerner*, which he produces and runs according to his own rules. He would arrive to work with his scriptwriters, put his feet on the table, lower his hat and almost fall asleep. If one of the screenwriters had a question, Peckinpah would grab the line manager: "Answer this young man's questions, or I'll take you outside and blow all the bones out of your body." The show was such a success that the lead actor, Brian Keith, landed the main role in a western with Maureen O'Hara, produced by her brother, Charles Fitzsimmons. As soon as he'd got the role, Keith brought in Peckinpah as director. But it's difficult to be a novice in Hollywood: Fitzsimmons insisted on a scene that the filmmaker found pointless, and had ultimate control over the final cut. What could be done? Well, there was always mutiny! In secret, and with the help of his actor, Sam Peckinpah changed the lines for his main character during filming. It was a method that he would use for all of his films: the script was no more than a malleable base that could be played with at leisure. As for his private life, the end of filming for *The Deadly Companions* would also mark the end of Peckinpah's first marriage. After thirteen years of living together, a broken jaw and a private detective on her trail Marie Peckinpah finally pushed her husband to divorce amid claims of infidelity. A name was born: in playground fights, his four children would be forevermore insulted as "damn Peckinpah!"

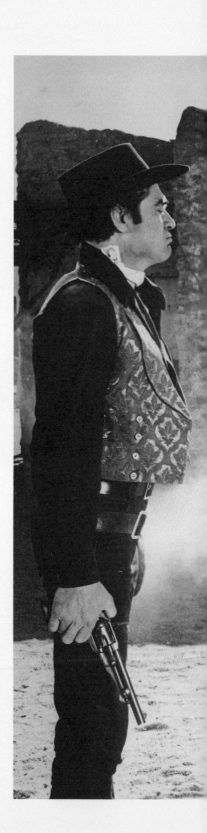

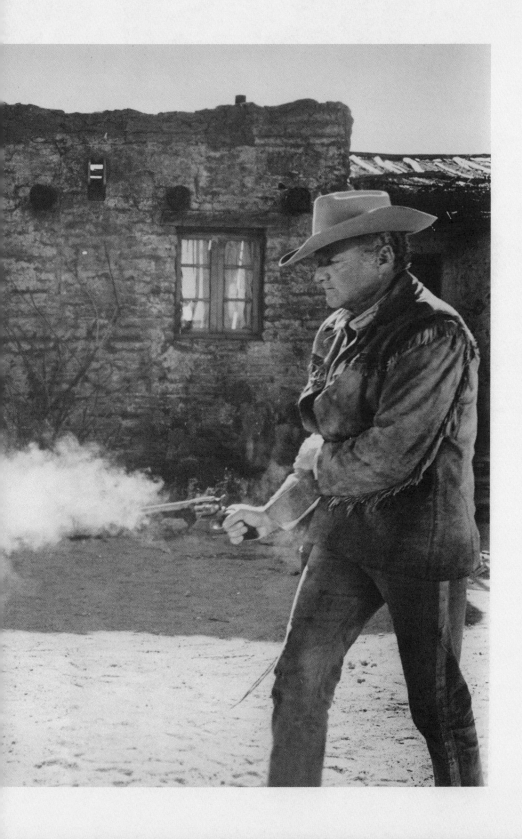

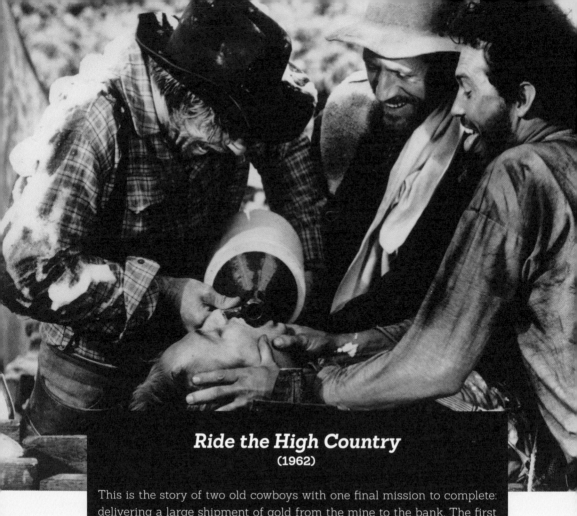

Ride the High Country
(1962)

This is the story of two old cowboys with one final mission to complete: delivering a large shipment of gold from the mine to the bank. The first wants to be an honest man, but the second is tempted by personal gain. Two mythical actors played the duo: Joel McCrea and Randolph Scott. When it was time to film, Peckinpah had two strokes of genius. First, he decided to switch the roles: McCrea would play the incorruptible Steve Judd, whilst Randolph Scott would be the deceitful Gil Westrum. Second, and most radically, he changed the film's ending: it would now be the stalwart that would die and not the traitor. On the filming side, McCrea, the Hollywood Golden Age actor, was becoming less and less accepting of Peckinpah's personality, but little by little, he began to understand the extreme attachment the filmmaker had for his two heroes. The lines that Peckinpah gave Judd, such as the mythical "all I want is to go home with my head held high", were lines taken directly from his own father's mouth, whilst Westrum's character is clearly Sam's alter ego. The story of two old friends is in fact the story of a father and son. When Gestrum tells Judd that he would do all he could to make sure everything goes well after his death, and Judd replies, "I've always known you'd do it, you just lost your way for a while", it's no more and no less than one of the last exchanges between the old Peckinpah and his son.

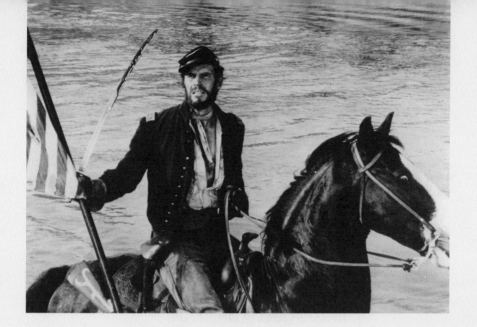

Major Dundee
(1965)

For this film, Peckinpah took Charlton Heston, James Coburn, Warren Oates and the hard-nosed Richard Harris ("He was an Irishman by profession, but not a professional Irishman", Charlton Heston would write in his diary) to Mexico. On top of the extremely difficult filming conditions, everyone was having difficulty dealing with Peckinpah's methods, as he systematically destroyed the screenplay. Everyone was scared of the director, who fired members of the team at the drop of a hat. At one point, he even turned on Charlton Heston himself. The actor was leading his troops on horseback "slowly", following the orders of the director who immediately howled: "This is shit, I told you to go hard!" Heston reminded Peckinpah of what he'd really said, to which he replied: "I never told you that you lying son-of-a-bitch." Charlton Heston cracked, and charged at Peckinpah, who had to throw himself on the ground to dodge the blow. Tensions were at an all-time high. But in spite of everything, it would be the actor who would save the film when the studios (who were angry that the film had gone over budget) decided to put a stop to the project. For his part, Peckinpah had fallen in love with one of the actresses: Begoña Palacios, twenty years his junior. To seduce her, he had yellow roses delivered to her, and even hired a singer to serenade her from below her window. But his passion didn't stop him from continuing to frequent Mexican brothels, where he would get drunk and fight. "One night," he would go on to recall, "I picked up a chair and hurled it across the room and into the great mirror. 'Who wants to test me?' Well, they did. When I woke up, a Mexican whore was reanimating me. They'd pummelled every part of my body, other than my balls. I had a broken rib, too." For better or worse, the film was completed, and though Peckinpah would always view the final edit as treason, *Major Dundee* remains one of the most beautiful depictions of the American Civil War ever created.

INTERVIEW WITH GORDON T. DAWSON

*** * ***

BY MAROUSSIA DUBREUIL

Gordon T. Dawson was Sam Peckinpah's handyman between 1965 and 1974. In five films, from *Major Dundee* to *Bring Me the Head of Alfredo Garcia*, he covered the roles of costume designer, screenwriter, producer and even second-team director.

You started working with Sam Peckinpah in 1965 on *Major Dundee*. What was your first impression of him?

He was a fierce man. He found it hard to explain what he wanted, and believed that everyone should understand what he wanted to happen. If anyone made a mistake, he'd shout: "Bring me the fucking script!" Obviously, the more worked up he was, the more people made mistakes, and Sam got even angrier. Going onto set was like entering hell. I remember one particular time with the camera assistant on *Major Dundee*; Sam had taken a disliking to him, and he was constantly insulting him. If the guy ever cut the frame slightly, Sam would start yelling at him: "Don't you ever cut. Don't ever cut my film!" Sam

shook him up so much that the poor guy couldn't even use his hands. They were trembling so much that he couldn't control the camera any more, and he ended up having to go home. Sam fired a lot of people on *Major Dundee*, but it got worse later. As for me, my first time was pretty good. I was an assistant, working on costumes. On the fourth day of filming in Mexico the actors were wearing beautiful costumes, but the American and Mexican teams had altered them so that they looked more worn-in. Sam went mad; he fired the managers of the department, including my father, and he said: "I want the guy who made the unaltered costumes." So they called me up: "Tomorrow morning, you're going to Mexico." When I arrived, the Mexi-

Sam Peckinpah and Gordon T. Dawson

cans didn't even want to go on set. I've never seen such terror. And I went on to work with Otto Preminger, who could be horrible. But with Peckinpah there in front of me, I was dealing with a monster – because he really was a monster.

What set Sam apart, making him different to other directors?

He was brilliant with actors like Charlton Heston, William Holden and Jason Robards. Usually, the guys would sit down and just watch what Sam did, but the technicians, they were terrified. He was hard on everyone because he felt insecure. He was so worked up that he never prepared before going on set, so he'd jump down from the car and blame the first person he saw. For example, on *The*

Wild Bunch, for the final gunfight, he was stood on the porch and everyone was looking at him: "What should we do?" He didn't have the slightest idea. There were nine cameras in every direction, ready to shoot, and hundreds of extras. We wasted eight days, my God! Luckily, the AD, Cliff Coleman, had worked everything out so that no matter which direction we shot in, it would work. The guy knew where every child was running, every dog, the puniest soldier. He was a genius. Sam knew it too, and he'd often tell everyone that the guy was a master! The gunfight in *The Wild Bunch* was his work. But that didn't stop Sam from firing him from his next film. They were both drunks. Sam once said to me: "I'm going to kill him," and Cliff told me that he wanted to kill Sam too, and then he left. Another example of Peckinpah's methods: when someone asked him what we were going to film the next day, he said: "We're going to film these mountains." Then, in the early hours of the morning, he changed his mind: "We're filming this side", right where all the lorries were parked. Once everything had been moved out of the way, he shouted: "You lot cost me a packet every day!" and he fired two or three of them. On some of the shoots, it was hell from the beginning right up until the end. But on other shoots, like on *The Getaway* (1972), it was brilliant. On that film, where he was the absolute master, the magic was in the editing suite. He'd done more takes than any director on any film. It was a goldmine! And he was communicating with the editors with this amazing instinct. He could see something that no one else could. Even if he had fired a few people, it didn't affect the film.

What do you think explains that passion?
Sam was so demanding. For *The Ballad of Cable Hogue*, we needed an old building. Sam asked me to dismantle an old construction

in Bishop, California, board by board. We put it back together on the Nevada border. If the chief decorator ever tried to make a new building look old, or used new wood, Sam would explode. It was the same with the Native Americans in *Major Dundee*: "These Indians are all too clean! I want you to be able to believe that they've been here for weeks; I want to see the dirt behind their knees." So I took all the extras to the changing-room, and I waited with them there, doing nothing, for half an hour. When he came back, Sam said: "There you go! That's exactly what I wanted!" In that half hour, he'd changed the camera angles, he'd altered the dialogue, and everything was going better... I realised that was how he was. When he was laying into someone, I'd come up behind and say to them: "Don't take it personally, go take a walk for twenty minutes."

On *Major Dundee*, there were some problems with the production – Peckinpah even tried to get himself fired...
Yeah, if Charlton Heston hadn't been there, that definitely would've happened. He said: "If Sam goes, I go." I've heard other versions, where Charlton Heston was even going to hand over his salary, but I don't know about that.

It was on that film that he fell madly in love with a Mexican actress...
Yes, Begoña Palacios. He was always falling in love. And if he targeted one girl, he was awful with anyone who looked at her. On *The Getaway*, he had a secretary, a Japanese girl. The costume guy started to flirt with her and so Sam fired him. Just because they'd got sweet on the same girl.

If he was that difficult, how did you become so close to him?
I don't know. I've always liked working with

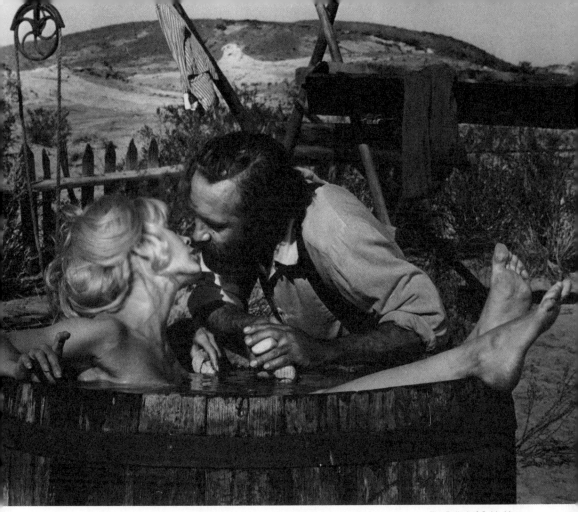

The Ballad of Cable Hogue

difficult people. Once I understood that he was crazy, I understood that I could help him. I felt odd about it, but I respected how he had an eye for film. He had such an air of authenticity and complexity... That's clearest in *The Wild Bunch*, when Agua Verde arrives and a woman is breastfeeding her baby, with her torso bloodied from an ammo-belt. The violence in the nurturing mother...

Did you trust him?
He betrayed a lot of people. On *Pat Garrett & Billy the Kid*, the studio had told him he couldn't film the scene where a guy floats down a river and exchanges fire with James Coburn. It was a little scene that just wasn't necessary. But Sam didn't give a damn, and he asked to shoot it anyway. I went with

James Coburn. When the studio and the producers saw the rushes, I was almost fired. There was a phrase then for firing people. Sam called it "the rope". He'd say: "That guy's on a thread, give him the rope." He was saying that all the guy had left to do was hang himself. I would negotiate matters to try and gain time. I'd give them three chances. Sam would go: "That guy's fired." I'd say to him: "Ok, it's his first warning. Then the second, etc. Sometimes he'd say to me: "No, that was one, two and three, all in one." I fired thirty-six people that way. There was even a guy in charge of giving bus tickets to the guys who were fired. I can tell you, that guy was busy!

And what about with the actors?
From time to time, things would get heated.

After *The Wild Bunch*, I became associate producer on *The Ballad of Cable Hogue*, with Stella Stevens. Sam said to me: "Your main job is to keep Stella Stevens happy. Keep her out of my sight, but make sure that she's happy." The first day of filming, Stella Stevens was late and Sam lashed out: "It's your fault, your woman is late." We waited. Once the make-up and hair were finally done, he said to her: "Come here" and he threw a bucket of water in her face: "Now we can start." The next night, I saw Stella in the hallway getting ready to leave. It was a tough job getting her to stay! I wrote a love letter from her to Sam, and a love letter from Sam to her. And I posted them both. The next morning, they hugged, they kissed, and we could get on with the film. They never knew the truth! But at the end of the film, she was bad again. Sam said: "I can't cope with her anymore! I'll send her to hell! I'm going to punch her in the nose! I'm gonna hit her!" We still had one wide shot to film, but there wasn't any dialogue in it. So Sam said to me: "Find me another woman somewhere." We went to the drama department of UCLA to find a woman that looked like Stella. We found one and said nothing to Stella, who we'd left hanging around in the airport.

Was anyone able to say "no" to Sam?
To say "no" to Sam was like handing in your papers. Anyone who said "no" openly to Sam was a dead man. The studios understood that, and he was in constant battle with them.

He used to say "Anything for the film"
Yeah, one of the episodes that stands out the most is the train episode on *The Wild Bunch*. William Holden really did drive the train. There was an engineer in there with him, but Holden was looking out of the window and had to stop at a specific point. There was a big wagon in front, where we'd put all of the stuff for filming, including the generator for the lights. The train was going along slowly, seeing as it wasn't easy to stop at the drop of a hat. Sam asked Holden: "Could you go faster? Go on, faster! Get a move on!" Holden accelerated and lost all control of the machine. The train overtook the cameras, and crashed into the wagon. Everyone went running. And don't forget that Warren Oates was sat at the front of the locomotive. It was a miracle that no one was hurt.

When did you take the most risks?
Definitely in the Texan prison at the start of *The Getaway*. We weren't laughing then. We'd been warned about the risk of hostage taking. Convicts would surround Steve McQueen every day. In one scene, McQueen had to jump out of a truck and run towards the camera, which was behind the prison gate. There were horses, two armed guards and loads of dogs. When Steve set off, the dogs were released and sent to chase after him. Miraculously, he managed to make it to the gate, and to jump over to our side. He was scared. The dogs were on the other side, trying to get through. Another time, Steve had to leave the prison to go back to where we were staying, but he'd forgotten that it was dangerous, and that he should've been escorted at all times. One of the guards, thinking he'd seen a prisoner trying to escape, tried to shoot him! Steve was like that, a loose canon. We almost had a repeat of that situation quite a few times... it was an odd place, the prison. At the wrap party, all the waiters were black prisoners. A member of the prison staff who was sitting at the table yelled out: "This nigger food is the best thing I've ever eaten – this bastard black cook is good! He got out six years ago, but luckily he stabbed a woman, so now he's back. We've got him for life now!" And the waiter could only respond with "Yes, sir." That's Texas for you.

Did you have trouble convincing insurers?
No. The only problem was with Steve Mc-Queen, the cars, the motorbikes…

Why?
Before we started filming *The Getaway*, we'd learnt that Ali MacGraw didn't know how to drive. But her character had a lot of driving to do in the film. We tried to teach her how to drive in a parking lot. Then Steve turned up, said "Give up this crap!", and got into the car we'd be using the next day. "Once you stop being scared, you're fine." He got in and started fooling about, got onto the motorway, was going forwards and backwards at eighty miles an hour, and Bam! went straight into a wall. It took all night to repair the car. You can't know how many times the police came and asked us: "Could you tell Steve that the main road is one-way?" because every night, he'd drive the wrong way up it. Every night. My god!

Did you ever see Sam Peckinpah genuinely moved?
One night, when we sat down to watch the rushes from the day before, he got emotional and shouted out: "There it is! There's our film!" He did strange things as well. For example, when we were watching the first day of *Pat Garrett & Billy the Kid*. We were watching it with the big boss of the studio. For no reason, Sam got up and took a leak on the screen, making a big letter S. And so, for the rest of the filming, we watched the rushes behind a big "S".

What was your proudest idea?
On *The Wild Bunch*, in front of all of the extras, Sam looked around and said: "Something's not right. I like it, but couldn't you give me something a bit more Hell's Angels?" I went back to the trailer where I had my stuff, and I got an old rosary. I pulled the Jesus off, and I found some ammo to put on the cross. I looked around, and the whole Mexican village was staring at me, with the Jesus on the ground. I said to myself: "They're going to kill me!" I took it to Sam, who said: "That's it!" The actor kisses it in the film. It took me three minutes to make, and now it's a real piece of art!

You also wrote for Peckinpah…
What I really wrote was *Bring Me The Head of Alfredo Garcia*. He was in England shooting *Straw Dogs* and he rang me: "I need a script in ten days", because he didn't want his friend Frank Kowalski to write it anymore. I said: "I'll need ten thousand dollars." And I got to it. I wrote in Peckinpah's style, I had his voice in my head. I even slept on the paper. The way that the character Bennie treats women, that was Peckinpah. Sam was a bad boy! A Hollywood bad boy! Today, no one would hire him. That's how things change. Every time I wrote for him, I did it in ten days. That's Sam for you.

Peckinpah filed for Mexican citizenship. Was he sick of America?
He hated Nixon, that's for sure. He couldn't stand him. So he decided he'd live and make his films in Mexico. The battle with the studios was awful. And it really came to blows with *Pat Garrett & Billy the Kid*. He was a broken man after that film. He left for Mexico because of it. And rather than shout at the American heads of department, he'd fight with the Mexican heads of department. They were totally perplexed.

Why did you stop working with him?
I was beat. On *Pat Garrett*, Billy and his friends shot at chickens, and we see their heads explode on screen. I was director of the second team, so it was me who did the chicken shots. We'd half buried them in the

sand, so that they couldn't move, and so we could have them in the wide shots. But because of the pressure of the sand, their lungs were crushed and they were dead. I went to tell Peckinpah who said: "Don't talk shit. Go wake them up." I had to go round, chicken by chicken, taping their eyes open so they looked alive! Stuff like that, I did thousands of times for Peckinpah… But that ended with *Bring Me The Head of Alfredo Garcia*. At the end of filming, Sam came up to me and said: "You know, I've got an appointment with a girl and I've got to go get her from the airport. Finish the film for me." Then he took the car, left me, and we had to film the scene where Bennie is killed. I did the best I could, but I couldn't believe it: "You finish the film, I'll take the plane!" That's the last time I saw him.

Do you think he destroyed himself?
Of course. The worst was location scouting, because he was always drunk. He'd have loads of ice and beer bottles in the back. You could always hear the bottles clinking. Jesus Christ! And we had to stop at every bar. Yes, he let himself go. He was completely drunk after eight in the evening. And at six in the morning, he'd be taking cocaine. I never tried to stop him.

Is that what his films were about?
I don't know. Whenever people would ask him what the subject of his films was, he'd say he didn't know. So I don't know either. ●

Adapted from French by Zizzy Lugg-Williams.

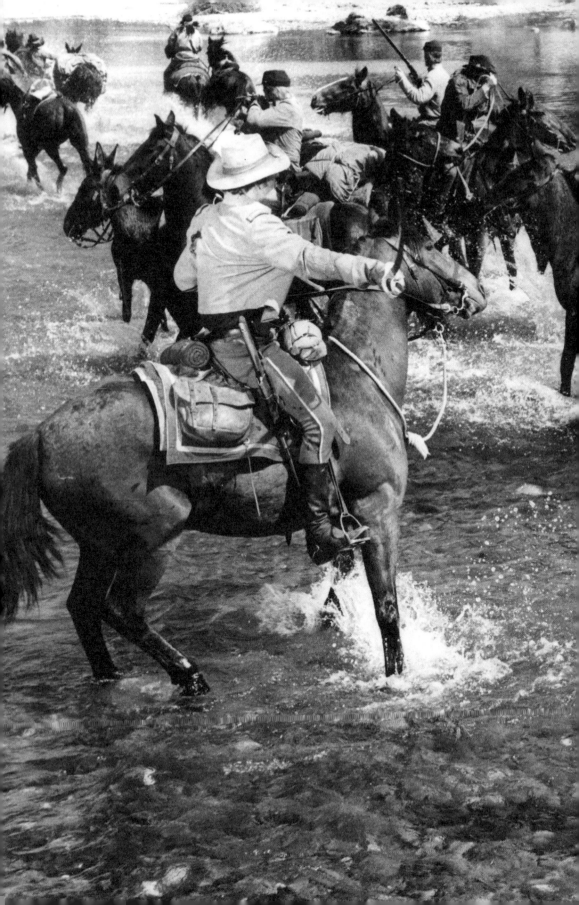

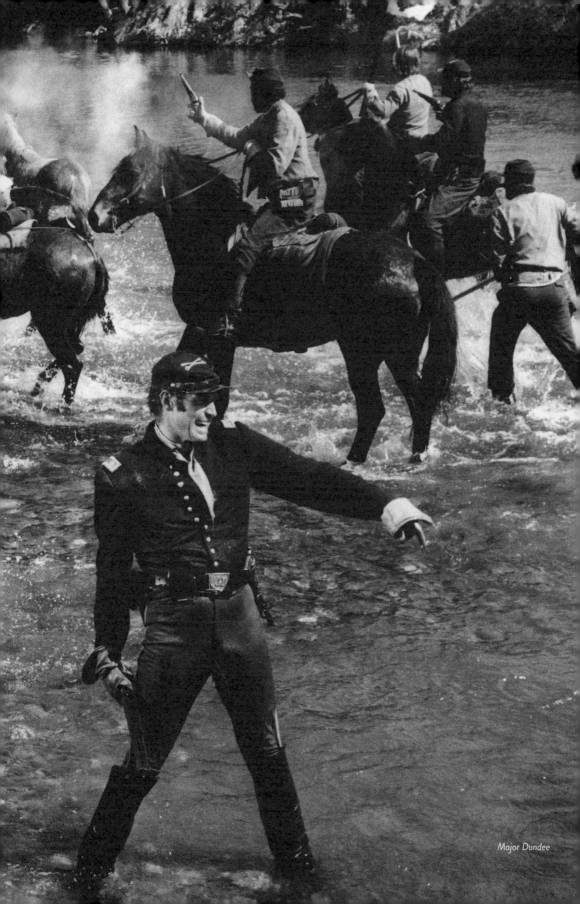

Major Dundee

1969-1973

* * *

SPURS
The Styles
of Sam Peckinpah

* * *

BY EMMANUEL BURDEAU

* * *

THE WILD BUNCH (1969)

THE BALLAD OF CABLE HOGUE (1970)

STRAW DOGS (1971)

JUNIOR BONNER (1972)

THE GETAWAY (1972)

PAT GARRETT & BILLY THE KID (1973)

A sequence of about eight minutes opens *The Getaway*. Its setting is a prison in the state of Ohio where Carter "Doc" McCoy is serving ten years for armed robbery. A series of images explores the interior, and sometimes the exterior. They depict "Doc"'s cell, the hearing where he is refused early release, the comings and goings in the corridors, the work of the prisoners within the walls, and their activities in the surrounding fields. They also offer glimpses, whether memories or premonitions, of "Doc" embracing his wife.

Each of these visual snippets proceeds at its own pace. The whole piece plays out at a variety of rhythms from immobility to furious speed. Immobility: a deer sitting in the stable yard looking toward the camera is changed into a logo by a freeze-frame with the text "First Artists". Furious speed: the machine looms on which "Doc" and the others busy themselves make a racket which continues in the background of scenes which have nothing to do with the work. This deafening noise provides an industrial atmosphere for events only some of which are under the reigning discipline. Inmates enter their cells in synchrony and are lead out to the fields in order, with the guards keeping count as each one passes through a gateway. On the other hand, taking a shower, playing chess, weightlifting in the exercise yard, the attentiveness of the doe: all answer to exterior causes, or to no cause at all. The cadence seems at times military, but there is also a music that comes from the rhythm of the events. "Doc" and a fellow prisoner exchange high fives between two grilles and, conjured as by a snap of the fingers, this salutation brings a new title-over-picture, in white letters, "The Getaway". The film begins.

The eight minutes that introduce this adaptation of the novel by Jim Thompson are among the most accomplished sequences in the work of Sam Peckinpah. Their crescendo culminates in a scene where "Doc" in his cell destroys the bridge which he has built out of matches, one imagines to kill time. The offstage din of the workshop increases while the succession of images becomes even faster. Flashes of Carol, his wife, mingle with clips of men showering, and views of the warders on horseback with those of the prison workshop machinery in action.

This opening plays on two competing meanings of the word "enchain" Enchainment" was a major preoccupation of Sam Peckinpah in these middle years from *The Wild Bunch* to *Pat Garrett & Billy the Kid*. Its first sense: the cinema's capacity to link images and sounds and draw out from them new relationships. And the second: what society does to a man when it locks him away for the length of his sentence. A positive artistic meaning: a negative take on power. Art that liberates by linking things differently contends with the power which oppresses. The first enchainment prepares for, and even accomplishes, emancipation; the second, literally, puts into chains.

The Getaway

Between these two senses, Peckinpah and his film editor Robert J. Wolfe provide a series of linkages and dynamic reverses. These linkages and reverses could have for their controlling force the handle with which "Doc" controls his machine loom. In the midst of a rich and complex montage, this lever provides a direct – or the least indirect – metaphor for the cutting table where one can imagine Peckinpah and Wolfe at work. When "Doc" – that is to say Wolfe, that is to say Peckinpah – pushes the lever, imprisonment reverses, releasing a burst of energy: the rhythm accelerates, the regime is interrupted by a bucolic moment or a sensual vignette. When "Doc" – that is to say Wolfe, that is to say Peckinpah – pulls it back, the visions of liberation collapse under the weight of the law: order returns, a re-establishment of regulation. The reverse is also conceivable: push to lock, pull to release… the metaphor is flexible.

A superb opening. Risky too. A high-wire act. But what's to say that these minutes don't just end up as industrial art, the machinery of the prison taking precedence over the machinery of the cinema? Nothing more than a new imprisonment? For sure, there is no complete protection against such a risk. Always, the liberty conferred by the edit is at risk of suffering the subjugation of Power. But in neither of the senses of the word *enchainment* is the undertaking worthwhile unless in a situation of precarity where humanity and the cinema are both in a state of need. So what to do? It is necessary not only to create the conditions of liberty, but also to liberate from the (same) conditions. Not to pick sides on the meaning of the word, but to release the construct and its interpretation. To enchain and to "disenchain" is not enough: it is as important to unchain, and never mind if everything collapses like a card-house.

Such "disenchainments" appear again and again. In his white prison garb, "Doc" has a severely neutral appearance, with all the impassiveness that Steve McQueen carries off so well, at once fearless and self-contained – not wanting to be misunderstood again. When he expresses his frustration with being confined, it's with a cold, wordless rage: here he crushes the matchstick bridge, there he knocks over the pieces on the chessboard during a match with another prisoner. These miniatures epitomise the sequence: Peckinpah constructs a mosaic with one hand and destroys it with the other; he carefully lays out the pieces which he will soon send flying; he builds bridges between gestures and images only to blow them up a second later. (There are castles and bridges of less symbolic import destroyed in other works, for example in *The Wild Bunch*; one can always find in them the simulacra of montages, of enchainment, of "disenchainment" and of unchainment.)

The alternation of scenes is so fast and varied that the impression of a finely-tuned mechanism competes on equal terms with that of a mishmash. Peckinpah

and Wolfe offer us the spectacle of a closed world, where the clangour of the gates, the guards high in their watchtowers, the constriction of the cells, the perfectly regimented column of prisoners all work together – and all keep in time. A logical circuit where everything is related to everything else, inescapably. Peckinpah and Wolfe reveal at the same time the panorama of a world that has lost its head. It's all a dance: links are energised which lack any proper causal relationship. A doe rhymes with a watchtower. There are so many entrances and exits from the cells that one loses count. An extreme close-up of Carol stroking "Doc"'s forehead arrives like an interruption: here is not disorder subdued by order, but order and peace and love coming to the relief of the mental chaos suffered by the detainee. Strange connections which flip the inside and the outside, the before and the after, the loss of liberty and its reclamation. Connections without any logic other than that of wanting to destroy the logic that reigns in this place and to increase, in this pressure-cooker, "Doc"'s fury.

As often is the case in Peckinpah's work, here the machine and the animal are at two extremes. The machine loom stands for activity and regulation. It represents the movement and the authority which proclaim themselves universal. As for the animal, it is associated from the start with the freeze-frame; it incarnates stillness, not only another dominion, but a refusal to accept the logic, or the absence of logic, of the relationship. Before further discussion of the machine we must now focus on animals, because it is they who, in many respects, come first.

When one underlines their importance in the work of Peckinpah, it is usual to point out the extent to which animal cruelty – their cruelty to each other and man's cruelty to them – echoes the violence that these films have become associated with. It is true that the scorpions being offered to an ant colony by the children prefigures the blood-bath at San Rafael at the beginning of *The Wild Bunch*. The link between one massacre and the other is indisputable: the scene of the children setting the insects alight dissolves into the victims that Pike Thornton's men and the railway company are going to strip like scavengers. It is true that at the beginning of *The Ballad of Cable Hogue*, Hogue stumbles on an iguana in the desert, which, famished, he prepares to make a meal of before being stopped by the gunfire of his two associates, who reduce the lizard to mincemeat. And it is true that at the beginning of *Pat Garrett & Billy the Kid*, the hens that the Kid and his buddies shoot at to relieve their boredom explode in a horrible vision clearly anticipating deaths to come.

The enumeration of so many animals however is insufficient, nor is it enough to point out their close link with the motif of violence. One has to start with what is most basic and most crucial: the animal comes before anything else,

before any other creature; they open the films, often if not always. The beginnings of *The Getaway* and *The Wild Bunch*, *The Ballad of Cable Hogue* and *Pat Garrett & Billy the Kid*. And the beginning of *Straw Dogs*: in a cemetery in Cornwall, children form a circle around a dog. And finally the beginning of *Junior Bonner*, allowing us to admire the bulls and horses of the rodeo where the title character works.

The animal is readily associated with childhood; it appears before the setting-in-motion of the grand apparatus of linkages of which the first minutes of *The Getaway* are a prime example. The animal comes before enchainment – before all enchainments, the good and the bad. The doe is followed by deer and horses, but its transformation in a freeze-frame gives it a special significance. It may be that the animal is essentially that, for Peckinpah: a logo, a mascot. A pure sign that means nothing beyond what it is. If not quite a signature then the expression of the idea that it might be possible to sign off with a snout or a pair of wings. Denied language and communication, the animal is in a position to protest, silently, against tyrannies and expedients, impatience and misunderstandings. The animal is alone; its image is at liberty, it belongs only to itself, (a) still not requiring manipulation. Its apparition carries something – momentarily, forever – that the rest of the film can only contradict.

Two timings, at once irreconcilable and profoundly intertwined, dominate Peckinpah's work. Both are present in the opening minutes of *The Getaway*: the tempo or era before the violence and the tempo or era when violence reigns. His œuvre is the story of forces which work together to overturn one time for another; it is also, one tends to forget, the story of the forces which fight to the bitter end against the direction of the swing. Before that – before the invention of the cinema – an equilibrium could be found, thanks to the animal, between the free and the enmeshed, between the sovereignty of those who stay outside of language and those who are enlisted in games of crusader cruelty, in which nothing limits recourse to, or the fatal necessity of, enchainment and its consequences. The animal doesn't represent anything and yet it is the object of all associations and every metaphor. The animal is outgunned in every way, something which always fascinates Peckinpah. It is primary, in such a way that one can consider the propensity of Peckinpah's cinema to violent relationships, and to violence itself, to be secondary.

MAJOR AND MINOR /
THE MONTAGES

The title sequence of *The Getaway* isn't the only one of its kind in Peckinpah's filmography. *The Wild Bunch* and *Pat Garrett & Billy the Kid* also each open with one. In both of them, the initial scenes feature transitions: in one, from movement to immobility, and in the other, from colour to a solarised black and white. In *The Wild Bunch*, the members of the gang making their approach along the main street of San Rafael to attack the railway company office, disguised as Texas Rangers, are outlined in freeze-frames for the opening credits. In *Pat Garrett & Billy the Kid*, the elderly Pat Garrett is likewise fixed in a moment of time, falling from his horse under a hail of bullets in 1909, a scene transported nearly thirty years from the drama of the original event in 1881.

The Wild Bunch and *Pat Garrett & Billy the Kid* also feature similar chase scenes. In the first, the gang led by Deke Thornton (Robert Ryan) goes after that of Pike Bishop (William Holden). In the second, the "Kid" (Kris Kristofferson) is pursued by the Sheriff (James Coburn). These two pursuits have in common a combat between old friends and brothers-in-arms for whom the passage of time, different careers, treason and compromise have not quite broken the ties between them. Each of these pursuits seems to go on endlessly, as though the hunters were actually in no hurry to catch their prey. As though the goal were not so much the confrontation itself as the delay in arriving at it. For Peckinpah it is always the moment of contact that is most sensitive: the moment both the most desirable and the most dangerous. Just as the opening moments of *The Getaway* confront imprisonment with freedom, *The Wild Bunch* and *Pat Garrett & Billy the Kid* both seem to contain – by way of changes of pace and cross-cuts, missed opportunities and chance meetings, momentary set-backs and sudden leaps – a hidden desire for an interstitial rupture to create a void broad enough that the characters on both sides may fall in and never again emerge. What other way to escape the carnage? If Deke Thornton and Pike Bishop, Pat Garrett and Billy the Kid were all to disappear into the limbo of a splice between two scenes, we could conclude they had reached the goal that they had always sought, not separately or in competition, but in a blessed unity.

The aim of this text is to reflect on how the sequences and edits of Peckinpah's cinema yield up their truth. Where is that truth to be found? In what relationship between the story as reported and that unreported, between transitions and breaks in continuity? My hypothesis is as follows. That if this cinema has a place, then that place is in the strange interval between the singularity of images and the product of their assembly; between lonely (story-) lines advancing in parallel and those that meet; between separation from old friends and inevitably

meeting up with them again; between the free use of film-editing techniques –
even unto the bizarre, the nonsensical, the ecstatic – and the need for the scenes
– linked together, or perhaps colliding – to nevertheless make sense.

Particularly in these middle years when his compositional skill was at its
height, it seems that Peckinpah wanted to keep to the creative high ground,
a place where a cinema "deconstructed" into fragments – or in tatters – had
the possibility of linking up with another kind of cinema, one enamoured of
rhyme, music and History. To sum up: on one hand the structure, on the other
its negation. One hasn't got a chance of understanding the representation of
violence in Peckinpah's work without taking into account this constant
dichotomy of inspiration. No doubt this also provides an explanation for several
of the filmmaker's problems: chaotic shooting, budget overruns, an increasingly
bad reputation, movies massacred by the studios... Thus the intent of Peckinpah's
oeuvre was in effect towards the destruction of the cinema, even if it put his
own ability to work seriously at risk. How did these two opposing forces
function together, against and beyond their limitations? By what effort, or
contrariwise, by what accommodation, does one pass between them? How
does the cinema speak to the question of destruction, while itself seemingly
torn between discourse and destruction? Those are my questions.

The system which has been described at the beginning of *The Getaway*
applies at the start of other films: the self-sufficiency of the animal and the
great mechanism of montage interlinking everything, the stillness of the beast
and the work already in progress, if not already done... I have mentioned the
connection made in *The Wild Bunch* between the scorpions and the ants on
one hand and the killing at San Rafael on the other; it is also a connection
between childhood and adulthood, which wouldn't be so cruel if there weren't
in Thornton's gang a particularly unkempt simpleton, the aptly named Clarence
"Crazy" Lee. Another connection occurs later which briefly brings together
two old friends against all odds. One evening out on the trail, Pike Bishop
recalls wistfully his escapades with Deke Thornton, their last moments together,
the recklessness that almost cost the life of his partner. Several brief flashbacks
follow. On the other side, once back in the present, the viewer finds not Pike
but Deke, in a similar position, also thoughtful and as though emerging from
the same reverie. A link still therefore exists between the two men, between
the past and the present, but only in the imagination, a strictly mental
connection with no reality other than a hallucination shared between them
by the cutting of the film.

At the beginning of *Pat Garrett & Billy the Kid*, as mentioned, the Kid and his
buddies kill time by shooting at hens. Then there's more: an unexpected jump
and the shots are being fired at Pat Garrett riding his horse thirty years later.
A recreational moment morphs into murder, or even suicide, Pat soon joining

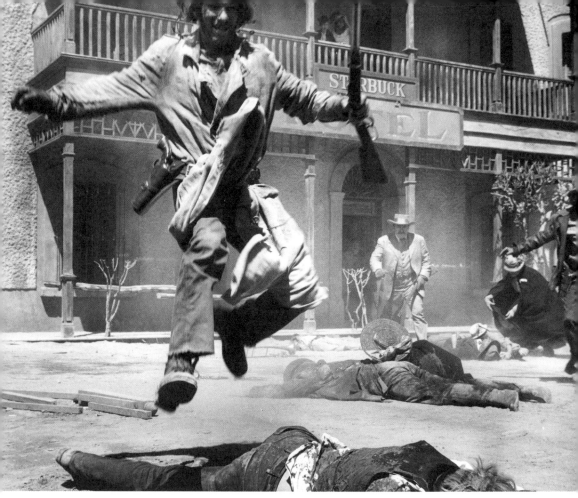

The Wild Bunch

the gunmen. 1881 has infected 1909. Everything is mixed up. One seems to recognise Kris Kristofferson beside James Coburn, looking older and more lined than he'll look seven years later in the epilogue to *Heaven's Gate* by Michael Cimino. The Kid's been dead for ages, but his ghost endures to ride alongside Pat Garrett. The future is in the present: that's the significance of these bullets, fired at the hens and hitting the old man. And the past is in the present: that's the meaning of the ghostly rider, this glimpse of a spectre seen again. Of course one can talk of obsession. The word has its place, but it should be balanced against another, less poetic: confusion. There is confusion in Peckinpah. It is pointless to deny it: this is the price of the power of his cinema.

It's done as though in error, from one shot and one edit, from one scene and one date – 1881/1909 – to the other. Like a wrong turning that's both joyful and dire and which ends the drama before it begins. This short-circuit is no less typical of Peckinpah than the mechanical complexity of *The Getaway*. I have introduced the idea that mathematical intelligence is one thing, but it's not everything; only by adding a measure of disorder to the mix can a filmmaker find the freedom they need. Film editing must be elevated to the

status of a major art form, but it is just as important that it be practised as a minor art, or even practised as an insult to its claim to the status of an art. To show the truth in images, there must be some where stray bullets fly: they hit the target too, and sometimes more surely.

The study of Peckinpah's work can't be captured in a single motif. Its manifestations are protean and asymmetrical. Some of his films are in a major key, a cut that is structured and clear: the opening of *The Getaway*, most of *Straw Dogs*... In others, *The Wild Bunch* and *Pat Garrett & Billy the Kid*, there's an alternation between clarity and confusion, major and minor keys. Finally there are the films in which a minor key predominates: *The Ballad of Cable Hogue* and *Junior Bonner*, to name only those in the period under discussion. The importance of *The Ballad of Cable Hogue* and *Junior Bonner* is certainly no match for that reached in the history of modern cinema by *The Wild Bunch*, *Straw Dogs* and *Pat Garrett & Billy the Kid*. Between the animal and the montage, the movement that flows in these two films doesn't achieve the admirable rigour of the opening of *The Getaway*. But that is precisely their interest: *Cable Hogue* and *Junior Bonner* bring into the open a happy nonchalance that is always potentially present in the work of Peckinpah, but is generally hard to spot.

These two films do not begin with clever craftsmanship. The split-screens are so whimsical that they border on parody. The screen is divided into two, three or four parts – of varying sizes – opening and closing like shutters, in one a close-up showing Cable Hogue wandering through the desert, as well as his appeals, imploring or angry, directed at God. The opening of *Junior Bonner*, the first of two films made in 1972 with Steve McQueen, looks for its part like a cheap version of that of *The Getaway*. The same cobbled-together effects as before – almost exactly – mixing sepia and colour, images of the rodeo and those of the hero returning disappointed to his caravan. Junior sticks his hat on one last time, the timer set in motion, the eye of the bull, a hand releases the gate, the sound of the bells on the beast's neck, and, in alternation, JR returning exhausted to the stables, still the sound of the bells and of his spurs, and he sets off again...

A series of comic situations confront Cable Hogue (Jason Robards) with the plunging neckline and bosom of Hildy, the prostitute played by Stella Stevens. As if it were itself also moved, the face engraved on the banknote he has in his hand gives a smile which is enough to convince Hogue to treat himself to a little pleasure. And in the desert where he has miraculously found a spring, fast motion accompanied by music evocative of that of a Benny Hill Show provides further evidence that Peckinpah can use the manipulation of images to deliver cartoon-like gags very different from the constructivism he practices elsewhere.

As for Junior Bonner, there are of course freeze-frames, but also fast motion and a huge saloon brawl on the margins of which Bonner and Charmane share a first kiss. The film evokes a pastiche of a Western transposed into the America of the 1960s. Other jingles, also worthy of Benny Hill; shots that zoom in on a competitor's blood-stained boot or adjustment of a glove; the buzzer that launches them into the arena: all raise – or lower – the tone of Cable Hogue's lesson. The weirdness of Peckinpah lies not in the peals of loud laughter (those of *The Wild Bunch* are unforgettable) of its heroes, whose faces are ravaged by the sun and by adversity; it is also in the rhythm, the sound and the content of the scenes themselves, where there is no reluctance to grimace and play the fool.

From refined to rustic, his staging and montage cover the whole spectrum. From one extreme to the other there is in his work both the subtle and the antithesis of subtlety. Peckinpah shows us more than one face. Sometimes he composes his films in the guise of a baton-wielding orchestral conductor. On other occasions he appears, less rehearsed, as a straightforward singer, brother of those he likes to film: Bob Dylan in *Pat Garrett & Billy the Kid*, Kris Kristofferson in that film, then in *Bring Me the Head of Alfredo Garcia* and in *The Convoy*. Here one could say that his films are improvised like a fireside ballad, like that of Cable Hogue, and again, that of the "Rubber Duck" (Kristofferson) in *The Convoy*, which is composed by his admirers along the course of his journey.

Peckinpah at times evokes an American offspring of the formalists of the 1920s, a kind of Eisenstein soaked in tequila. He is undoubtedly one of the most brilliant filmmakers/film editors of history. But sometimes on the contrary his films seem so laid-back that one feels inclined to see him as a director who is all "zoom-zoom" on the cutting table and is thinking of other things while he directs. One has to keep in mind that Peckinpah began his career in television and that's where he ended, in a way, with *The Osterman Weekend*, which deals with surveillance and the new ubiquity of images.

And so one has to weigh one's words carefully when talking about Sam Peckinpah as a great filmmaker. One must pay attention to what that means: the term is appropriate for the first few minutes of *The Getaway* and for the bravura segments of *The Wild Bunch* and *Pat Garrett & Billy the Kid*. But is it appropriate for the amusing ventures *The Ballad of Cable Hogue* and *Junior Bonner*? Peckinpah needed these zooms and artifices, these comic effects and straight-out comedy, to give him access to further possibilities for filmic creation, alongside the more sensational ones which he knew how to formulate so well. Should one judge him less great to have agreed from time to time to descend a few steps on the scale of his pretensions? One would have to say yes if one considers greatness the ability to choose one's standards and then

stick to them. And one would say no if one chooses to ignore the second-rate Peckinpah and retain only the other: the first, the flamboyant, the Soviet.

One can also say no without having to make that choice. Some filmmakers are great in their differentiation, others by that which they work to reveal. Peckinpah's greatness lies in his openness and in his dissolution. There is no exclusivity in his work. His art tolerates, if not pettiness, that which others would quickly reject as being too easy. His greatness is inseparable, as we shall see with *Straw Dogs*, from a hazardousness directed at everything including itself, to which he applies method as much as, sometimes, blind fury.

STRAW DOGS / PECKINPAH'S DIDACTICS

Straw Dogs is the film that most keenly addresses the formal but also moral relationship between linking and explosion, between discourse and destruction, between the discourse of destruction and the destruction of discourse. It therefore calls for special attention. The passage of time, as is well known, has imposed a certain reading of this film so strongly that it has come to seem irrefutable. This is the story of an American mathematician who relocates to Cornwall with his wife, and slowly degenerates into violence. The conventional interpretation is of the impotence of scientific reason when it is confronted with man's innate savagery. *Straw Dogs* is thus a justification for self-defence. The history of the Sumner household takes on a broader significance, its message extending to the totality of his œuvre: if Peckinpah filmed so much violence, then he must believe that it is a fundamental force in history and in man, and that by reason of its inevitability, conclude that it is necessary in certain circumstances.

The filmmaker's characters are usually veterans of brutality. One of the surprises of *Ride the High Country* in the genre of the dying Western was the presence of Randolph Scott and Joel McCrea in the role of two cowboys making a comeback, looking stylish but in reality just as ruthless. He who was violent can take a break, but he is condemned to return to it sooner or later. The David Sumner character played by Dustin Hoffman has nothing to do with the aforesaid. The likeable researcher has fled the United States, one is lead to understand, due to his inability to deal with the troubles facing that country. Violence has never been his business. Thus what Peckinpah portrays in *Straw Dogs* is the Genesis of his world, not a return to violence, but an introduction to it. David believed that he was sensible enough to deal

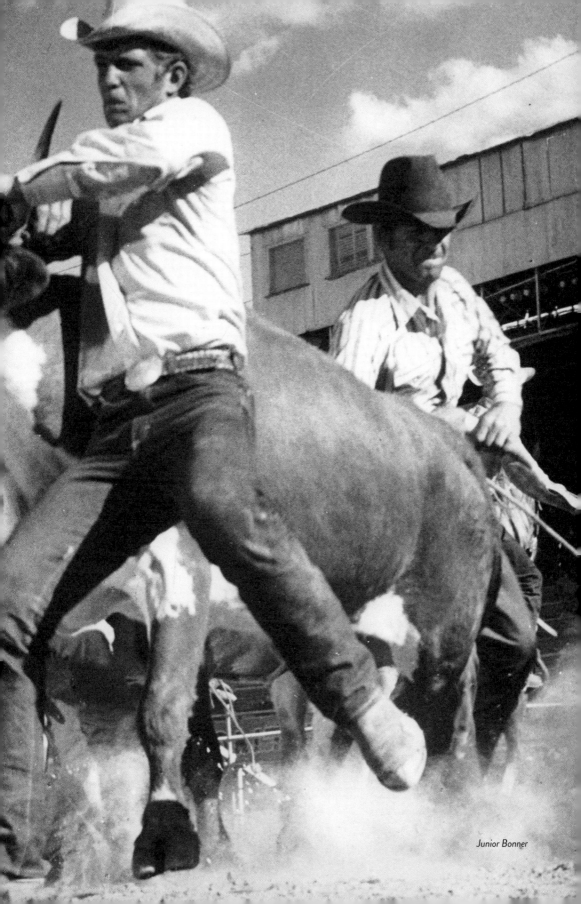

Junior Bonner

diplomatically with the hooligans who provoke him, covet his wife and eventually storm their home. He must learn that sometimes only violence works against violence. Considered thus, the film could bear the subtitle: "Welcome to Sam Peckinpah's World."

When it came out, the famous American critic Pauline Kael published a landmark article in *The New Yorker*. Kael, who had done much to defend Peckinpah, described *Straw Dogs* as the "the first American film that is a fascist work of art" before conceding that "I realize that it's a terrible thing to say of someone whose gifts you admire that he has made a fascist classic." Having seen the film several times and knowing that the accusation of fascism in the 1970s meant something different from what it does today does not diminish the difficulty of challenging such statements. Even in retrospect, especially in retrospect, here as elsewhere, the crowd of followers obstructs a clear evaluation of the master's intention (this is written without having seen Rod Lurie's 2011 remake of *Straw Dogs*). As for recent work on Peckinpah, most quote Kael, more or less, at least with regard to the "fascism".

The Paulinian approach is, however, inadequate. Not that it is wrong; in fact there is a lot of evidence for it. That is why it must be contended. Peckinpah is the first to resist, with all his strength. Until the massacre, his approach consists in measuring the capacity of the situation to resist destruction. That he gives up in the end, and allows the bloodbath, does not diminish his efforts, nor those of his protagonist. Contrary to widespread opinion, Sam Peckinpah does not sentence David Sumner for cowardice or irresponsibility. He pursues a path parallel to that of his character, from discourse to destruction, from relationship to relationship breakdown.

Straw Dogs is perhaps the most powerful film that Peckinpah directed. First, it is his most precise. And second, his most brutal. His montage the best assembled, and the best disassembled. *The Wild Bunch* was more novel. *Pat Garrett & Billy the Kid* remains more lyrical. But *Straw Dogs* is stronger and harder. And if so, it is by virtue of a rupture which Kael does not dwell on but which she sensed. About the director's "intuitions", Kael wrote that they are "infinitely superior to his reasoning". After watching *The Killer Elite* – which demonstrates Peckinpah's merciful side rather than the opposite she added. "Whether consciously or, as I think, part unconsciously, he's been destroying the surface content."

The idea of a dissociation between intuition and reflection, awareness and the subconscious in Peckinpah cannot fail to interest. And the remark about sabotaging the readability of the plot is so cogent that it might be good advice.

Straw Dogs

When you watch *Straw Dogs*, I recommended you disregard the "first reading level" and, as for the opening of *The Getaway*, concentrate on the images and their relationships. One then discovers, if not another film, something other than a binary antagonism between science and savagery, between an American sure of his rights and coarse brutes who become murderous.

First scene: a village in Cornwall, children in a cemetery. Some play around a dog, others around a grave. Amy Sumner's breasts bounce under her flimsy white sweater as she approaches along the street. This enchanting vision is brought about by one of those "errors" of visual editing already noted. Should we attribute the beginning to the children, or to the supposedly lustful village idiot played by David Warner, whose role will be crucial in accelerating the pace of the story? Where is innocence, where is guilt, and where the means to decide between them: *Straw Dogs* immediately raises the question, and from the start it raises it by the means of the montage, as always with Peckinpah.

A few minutes later, David and Amy play the fool in the convertible that brings them back to their cottage. Then David amuses himself pulling childish faces at Amy before throwing grapefruit at the cat. The locals have just begun to direct their sneers at the couple's deteriorating manners, or rather their pretence of it. So it seems that comedy and farce or perversity are not only on one side here.

The first hour or the first hour and a half of *Straw Dogs* is composed of thousands of incidents of this nature. It's a concert of little things which are both slight and shrill, their resonances discernable but camouflaged. The magnets of a mobile posed on a desktop attract and repel. The idiot in the street pushes a matchbox with his stick. A cigarette lighter is activated, a package is displaced, a huge trap is set up on the fireplace. David puts back the alarm clock and jumps rope whistling the Marseillaise. David and Amy play chess in bed. David, very playful, pretends to look for a chess piece under the bedclothes, etc.

All these minor observations place *Straw Dogs* under the sign of the game. Lightness and ambiguity of motivation, innocence and trickery are important. *The Wild Bunch* opens with play: children, ants and scorpions... Games permeate *The Getaway*, chess and the mock debate of "Doc" and Carol on the serious or playful nature of their association. They are present throughout *Pat Garrett & Billy the Kid*, with card games that lead up to a shoot-out, and the smiling bravado that the "Kid" displays at all times. The game represents a state which is both stable and unstable, a relationship which is in balance, perhaps about to collapse, but which attests to a universal harmony. For a while at least, *Straw Dogs* does not contemplate doing anything other than playing, including playing with the imminence of danger.

The contrast is certainly demonstrated early on between the mathematician's refinement and the grunts of Charlie, Norman & Co., employed by him for roofing work and fascinated by Amy's return. It is not however, or not yet, the opposition between the savage and the civilized, the violent and the non-violent. David and Amy have from the beginning many flaws and foibles, even if they are nothing compared to what is to come. Looking out for the coincidences to which Peckinpah is attached, one may note the following interesting quid-pro-quo. In the first minutes of the film, while Amy and David are preparing to load up the boot of their car, Charlie Venner asks the latter what he hopes to catch with the aforementioned trap. "Peace and quiet," says David, thinking that he is answering another question posed at the same moment, concerning the reason for his exile. This telescoping cannot be insignificant. It suggests that calm and peace are – here as elsewhere? – no more than a trap, a continuation of hunting and of war by other means.

This is not to say that the Sumners are also violent from the start, or that Peckinpah sees no distinction between the civilised and the barbarian. If that were the case, the accusation of fascism would only be strengthened. This concerns something else.

Let's take another example: when she enters her husband's office, Amy changes the "minus" into a "plus" on one of the equations written in chalk on his blackboard. David does not appreciate the joke. Does Amy think that he wants to have fun instead of working? Such childishness, he thinks, is hardly dignified enough for the schoolyard. Yet the couple do come to enjoy such puerile games. Should we be led to believe that for David there is a clear difference between good and bad regression?

Peckinpah returns to the blackboard. Another filmmaker, no less than Jean-Luc Godard, got there before him, in the beginning of the 1970s. As Serge Daney analysed it in a definitive text, "*Le thérrorisé (Pédagogie godardienne)*" ("The Theorrorised (Godardian pedagogy)"), Godard sees – generally in the classroom but more specifically in the blackboard – a substitute for a cinema screen, which is experienced by the spectator as an evil place, as it is one where they are fated to regress. Regression, but also the good and bad places for images and thoughts, are at the heart of *Straw Dogs*. Let's take this link seriously: *Straw Dogs* is, in its own way, Peckinpah's pedagogy. It's thus suitable to leave no details out.

So this is what we think: if Amy had erased a line of the equation from the board, the gesture would have been a way of foreshadowing the ultimate destruction. But the young woman only changes the "plus" to a "minus". So she doesn't deny science. She seems more convinced of its indifference, or at least of the indifference of its results; that's to say the absence of discrimination

Straw Dogs

between what is revealed and what isn't. The plus is as good as a minus, she thinks. And for a long time in *Straw Dogs*, every little thing is as good as the other, even if it's little, even if it's little enough not to be noticed.

Although annoyed by his wife's prank, David will also pretend that there's no real difference between him and others. He'll offer Charlie and his friends a drink, he'll accept their invitation to go hunting, he'll even claim to understand them: "I know how they feel," he says when he hears them banging on his door. David will soon forget these noble thoughts to pour boiling water onto his attackers and shut the head of the most violent into a trap. Until this final stroke, the illusion of a whole world governed by play could have been preserved. Play as in both amusement and difference held up by limits that are not only acceptable but pleasant or even exciting.

So David did not commit the mistake of believing himself innocent of any violence. He believed instead that violence belonged to everyone, and as such it was harmless, just another inevitable human activity. In both work and play, David sees a universal and unifying principle which is solid enough to include all that dry mathematical research, the silly games of a couple, and the infamous excesses of the locals. He believed in a certain viewpoint from which nothing could be separated or destroyed, but rather that everything was positively connected. His wife's rape, which takes place while he is out

hunting, is shown by a crosscut which, although it displays his naivety, includes him once more in the situation. The relationship starts to go wrong; David will never know that Amy has been raped, and so there is an outside too, the blackboard doesn't cover the whole world... But this is only the beginning: the worst is yet to come. David will believe this for a long time. And how could it be otherwise since, far from trying to set him straight, Peckinpah doesn't stop setting up mirrors around him?

You must bear this in mind when you see the last twenty minutes of *Straw Dogs*. The structure will collapse to make way for dissolution and outright destruction. Slow motion and screams, windows that shatter, a foot in shreds, hands tied with wire, the trap detached from the wall to close with a snap... Pauline Kael wrote that Peckinpah transforms "the households defense into an orgy of destruction, as if it were determined to destroy everything and every human being on the screen. Fury overtakes his desire to prove anything; it almost seems like its directed against flesh itself." Kael was right: the brutal ending of *Straw Dogs* proves nothing, not even the virtues of self-defence. It only proves that once things have reached this point, it's impossible to prove anything.

This finale is built as climax, a definite bravery, but also, to some extent, an ultimate defeat. This is reason defeated by barbarism, and with it comes the

Straw Dogs

defeat of editing, leaving behind all mathematics, all music, showing only the crudity of the ripped and the tattered. There are two ways to undo editing with Peckinpah. The light-hearted one of *Cable Hogue* and *Junior Bonner* and the dreadful one of *Straw Dogs* are wholly unalike. The first could be considered a minor inspiration. The second one, despite its grandness, might be seen as Peckinpah's own undoing.

That *Straw Dogs* doesn't concede to a fascist ideology is not because it tries to avoid indecency, or because a political alternative is formulated. It is primarily built on the belief that the world organises itself in harmony, as a unit, within which opposites are confronted with not much more trouble than two magnets on a mobile, and antagonists are as similar as a "plus" and a "minus" on a blackboard. This unity would probably be observed only in abstraction, but the directing confers it a certain materiality for a while. *Straw Dogs* succeeds in avoiding fascism because Peckinpah, not satisfied with showing his hero's initiation into violence, turns the nihilism and the blindness, the "orgy of destruction", against his own cinema. The two forces that coexist in him, the doing and undoing, share a relationship in *Straw Dogs* that they don't have in any of his other films. The undoing follows the doing in a way that, despite being chronological, signals the abandonment of all logic in favour for what ends up being pure destruction. This is worth repeating: the ending of *Straw Dogs* doesn't fully define it. The outcome may have been an Apocalypse, but this doesn't affect the exploration that came before it.

HOW TO TAKE A DIVE / THE DRAMA OF THE FALL

Everything stops at the end of *Straw Dogs*, images as well as sounds. The tinkling of crystal turns to screams of terror. The record that continues to rotate expresses it clearly: the music has stopped, only a quiet scratching sound continues, the slight crackling of the end of the world.

There is a cyclicality in Peckinpah's work, both in the sound and in the image; high season and low season, take-off and forced landing. The threat that Pat Garrett represents can be heard in the spurs on his heels, and in the noise they make when Pat walks at his slow, heavy pace: a veritable leitmotiv, at once a pleasant chiming – like the bells around the necks of Junior Bonner's beasts – and a sombre tocsin. The melody of Bob Dylan's soundtrack is inspired by this carillon – a soft clanking of chains – and it is again this ambiguous music we hear as the sheriff advances onto the porch to deliver his friend the coup-de-grâce.

Our years 1969–1973 finish here, with that strange tolling sound. What finality? What fall? And what reprieve before it? Can one fall without loss? These questions do not only apply to *Straw Dogs*. Another film with spurs, *Junior Bonner*, depicts a traditional art, that of the rodeo, which consists of knowing how to fall as late as possible, and by preference in the most elegant way possible: around twenty seconds of perilous balancing are enough to establish a record. In one episode of *The Wild Bunch* horses tumble and roll, in slow motion, in the dunes, and disappear among clouds of sand.

The most significant fall takes place half an hour before the end of *The Getaway*. Pursued by the police, "Doc" and Carol take refuge in a garbage truck where they spend the night until in the morning the truck throws them, along with its cargo, into a landfill. Steve McQueen and Ali McGraw then fall, in slow motion again, into the middle of a vile, messy waste-pit. The scene inspires even more disgust because shortly afterwards is a shot that shows the ugly Rudy, played by Al Letteri, quietly sitting on the bog, ignoring the veterinarian's body hanging beside him: the stench of sewerage from these locations makes us realise how far the story has come since the immaculate opening sequence of *The Getaway*.

In this scene we see another joystick, after that in the prison workshop, the one that the rubbish truck driver pushes to empty his skip and thus bring us the image of "Doc" and Carol falling with the rubbish in another roly-poly. So there is a link between the machine and waste, between the beginning and end of the cycle, as there is between machine and editing. Noticing this link is only a way of asking one last time what relationship in Peckinpah's work connects science and violence, relationships and the breakdown of relationships. We're getting close to the heart of the problem: in effect what we're dealing with at present is the intimacy of the industry of images with the scrapheap of images, art and death, or, to speak frankly, art and shit.

Peckinpah readily associates the fall with slow motion. This association creates ambivalence. It makes it easier for the viewer to see dust or sand, the tiny fragments that come after the fall. Paradoxical as this may seem, that is also part of its grace. The meaning of falling and of slow-motion underline how the latter is at once a way of drawing out and a way of termination: image-future of the dust and dust-future of the image, the beginning and the ending meet in a vertigo of opposites that nothing can stop.

In Peckinpah's work, the fall has several values; it even has every possible value. It must be understood as the most basic thing, the act of falling. It must be understood with the meaning of an ending, like how a joke requires a punch line, and the comic isn't something to be forgotten in this cinema. It must be understood by what's left or by scraps. And it must finally be understood by

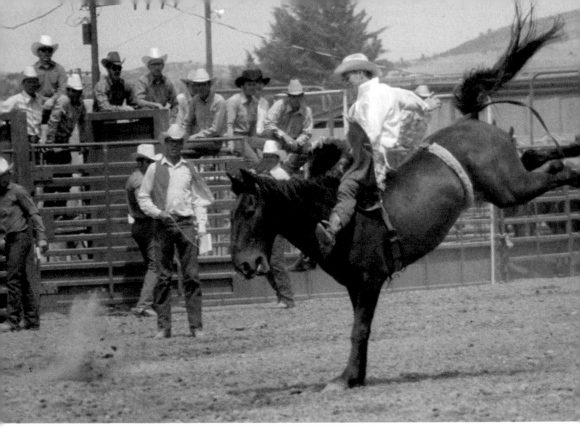

Junior Bonner

the meaning that the word has in cinematographic language, where "falls" also means the outtakes and the images left out in the filming process.

The heroes of Peckinpah, except David Sumner, belong to a bygone era. It makes sense to see Carol and "Doc" as just additions to the scrapheap. Something is always already completed with Peckinpah and at each fall something else finishes. In the scene from *The Getaway* one can also notice, in a hardly metaphorical way, the idea of cinema itself as rubbish, a form that's taken over by its own fall or its own disaster, hardly distinct from an editing bin or a rough-cut of rushes. To get back to Jean-Luc Godard, we know that he presented his *Week-End* (1967) as a film that was "found in the trash, lost in the cosmos". Peckinpah could use the same formula for this scene, where the repulsion of not only the characters but also the director is palpable, and in the end of *Straw Dogs*, where "unloading" also means the liberation of energy. In these two films, a regression occurs that is not only moral but material, and the bit of valour goes with the increase of images ahead of their being put onto film. There is a clear difference between Godard and Peckinpah's projects: the sexual significance of the word "discharge" leads the latter to self-destructing savagery – an unavoidable event: Lyle Gorch (Warren Oates) seizing the machine gun at the end of *The Wild Bunch* with his spasms of pain and pleasure – while the former has always stayed away from this.

In Peckinpah's work there is, if not quite a desire to get everything finished with, a grudging desire for a splendid ending that never comes until the last few minutes. The motif and the leitmotif of the spurs tell us the same thing: man drags his earthly condition around with him like a millstone, and only an overpowering jingle can make him confuse this damnation with mercy.

The great land film comes just after the studied time period. It's *Bring Me the Head of Alfredo Garcia*: that unforgettable moment when Benny (played by Warren Oates), is "resurrected" early in the morning in the cemetery. When he vacates the tomb where he's spent the night, his face is covered in stones. Even before this, Peckinpah had tried to summarise his art, which is at once ethereal and fallen into dust and rubble, images of material impurities suddenly blocking the sight and overwhelming all hope of successful linkage. The nocturnal ending of *Straw Dogs* wades through an astonishing darkness: we can't see anything outside the Sumner house, and soon we can't see much more inside. A wind blows in *Pat Garrett & Billy the Kid*, so thick that it is said with a smile that only several swigs of whiskey would allow one to pass through. Grime sticks to bandits and drunkards' faces in *The Wild Bunch*, as if to disguise them even further, and Cable Hogue nearly dies in a sand storm at the beginning of his adventure. The destruction of the father's house by bulldozers in *Junior Bonner* is a special case. Like in a vision of horror, it presents a ballet of machines and dust which is an obvious echo in opposition to that other ballet, the rodeo: it is the animal that is civilized, one would think, and civilisation that is not. After these comes *Bring Me the Head of Alfredo Garcia*, and even further heavyweights in *The Convoy*, raising huge clouds in their wake.

Peckinpah likes to organise meetings between earth and machine, between the world of dust and that which man and his machinery create. Between cinema-the-animal and cinema-the-machine, this meeting can only be fatal. This is the anti-rodeo of Junior Bonner's bulldozers. And it's in *Straw Dogs* that David discovers the cat hanging by the electric wire in the closet: this short circuit between those who reign can't bring any good.

The films that open with images of animals also meet technical progress along the way. Starting from *Ride the High Country*, every Western by Peckinpah repeats the idea of the surprise of the invention of the car, this "horseless carriage", welcomed with equal suspicion and enthusiasm. Conversely, *Junior Bonner* and *The Convoy* are Westerns from a specific time, America of the 1960s and 1970s, when horses were no longer a sure sign of virility.

This is how *Cable Hogue* will end, in a smash-up of eras and devices. And this is how we will finish. Hogue became a sage. He gave up on taking revenge

on those who had abandoned him in the desert. He even resolved that Bowen (Strother Martin) would succeed him once he left Cable Springs to go and live a quiet life with Hildy. It's at this moment that Hogue throws himself in front of a car that's sliding down a slope to save his friend. The car runs over his legs and leaves him paralysed. His bed is taken outside and Joshua, the facetious, lascivious Reverend played by David Warner, begins his eulogy. Hogue doesn't want him to wait until he's dead: he wants to have the great privilege of hearing the tribute that will be given him before his time. While the speech is in progresses, a jump cut makes him pass from life to death, from the bed to the ground where he will lay from now on. The ballad ends with Joshua's peroration, while one by one, now dressed in black, the people return to their occupations.

The whole distance has been travelled in a few seconds and, for once, smoothly and naturally. From the car to bed, and the bed to the ground – one vehicle to another – from the machine to the land and from life to death. This cinema goes willingly to look for truth in the church organs and in the outbursts of the editing. But, as if by chance, he manages to find this truth in a subtle and almost indifferent game of upscaling and downscaling. The balance between enchainment and "disenchainment" is so subtle and happy that it's as if Peckinpah too would have wanted to have the pleasure – and not only the nightmare – of being a living witness to his own end, and to hear the words of admiration that would surely be pronounced upon this occasion.

Translated from French by Colette de Castro.

The Wild Bunch

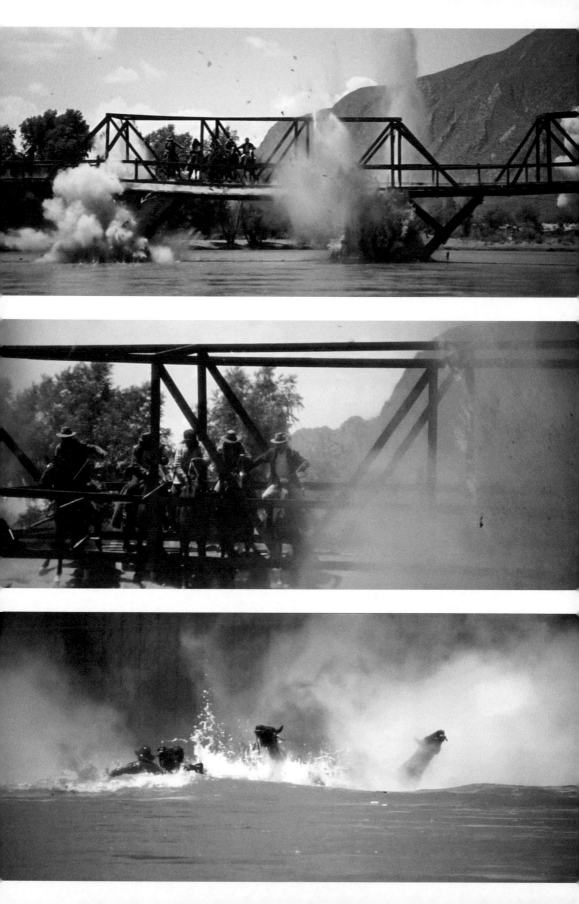

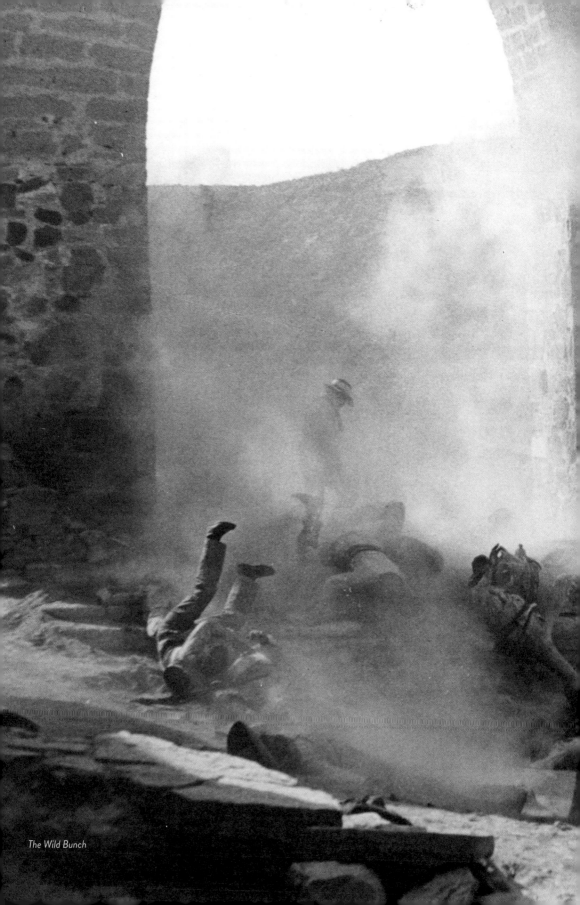

The Wild Bunch

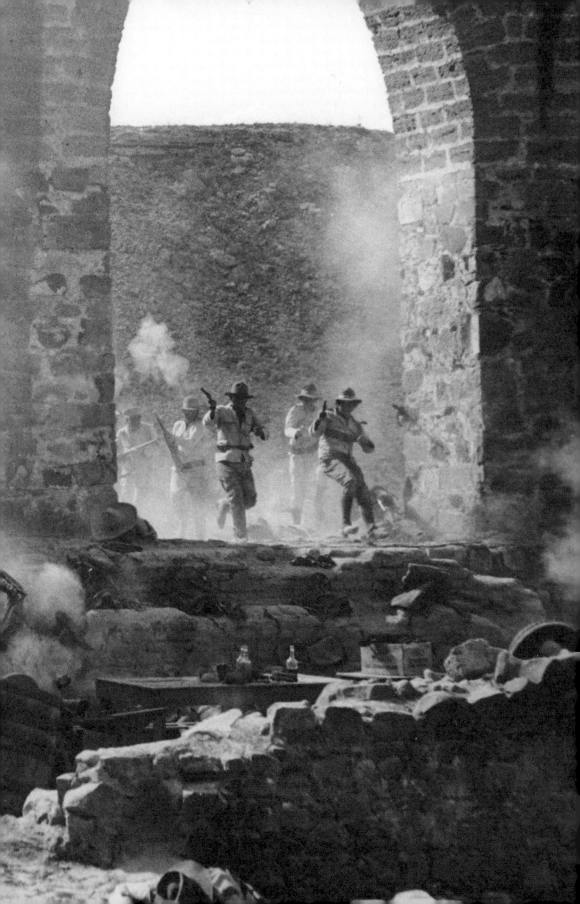

1969-1973

FILM SHOOT STORIES

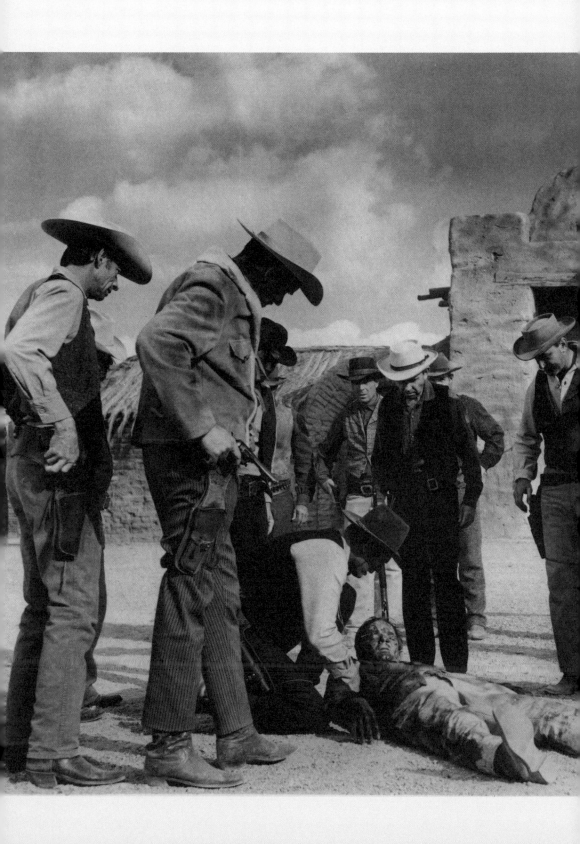

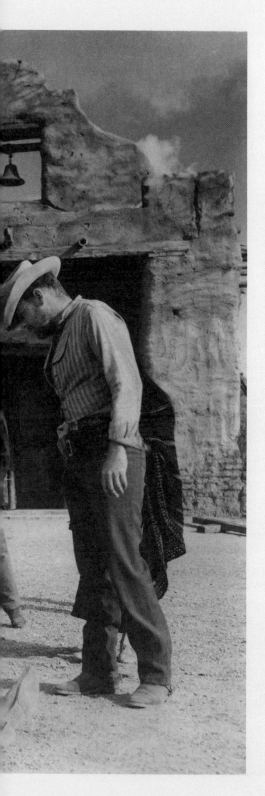

The Wild Bunch
(1969)

In an unusual twist of fate, for this film Sam Peckinpah managed to find a producer who shared his artistic vision: Phil Feldman, who had produced Coppola's *You're a Big Boy Now*. But that wasn't to say that filming would be plain sailing, thanks particularly to the fact that the filmmaker-martyr suffered an enormous haemorrhoid. Worried, Feldman called in a specialist from Los Angeles, who suggested that the filmmaker take two days sick leave, and have it operated on. "If you can get rid of it here and now in the kitchen with a kerosene lamp, like they did with my grandpa, and I can be back to work on Monday morning, then fine, but if not, then it's out of the question." He decided to stay that way for the rest of the shoot, barely sleeping and drunk most of the time. Over the course of filming, he'd fired one third of the team. William Holden, the lead actor, had begun to get fed up of it all. But alcohol brings people together, and Holden took inspiration from Peckinpah in his portrayal of Pike Bishop, leading his gang like Peckinpah led his team. The film's ultimate carnage, a frenzy of physical violence, will forever be the symbol of his era, before being immortalised in the Neil Young song "My, My, Hey, Hey": "It's better to burn out than to fade away."

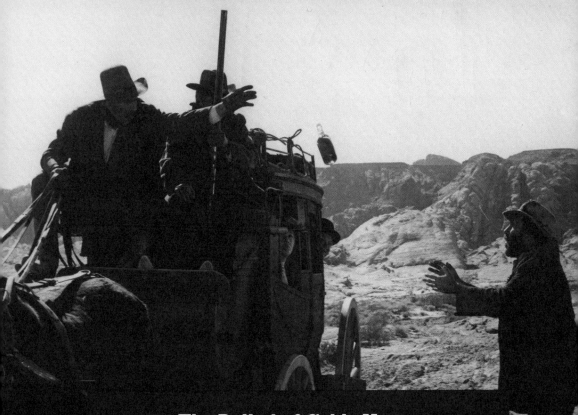

The Ballad of Cable Hogue
(1970)

Filming *The Ballad* was, first and foremost, a revenge project. Whilst preparing for *The Deadly Companions*, Michelangelo Antonioni hadn't allowed Peckinpah to contact Richard Brooks. So when an emissary from *Zabriskie Point* contacted Peckinpah to obtain permission to visit the set of *The Ballad of Cable Hogue*, the Californian responded that Antonioni would have to come and speak to him in person. When the Italian arrived, Peckinpah was busy filming a scene. "Hello, I'm Michelangelo Antonioni, it's a pleasure to make your acquaintance..." Peckinpah let him speak, continuing to play with the camera. In the end, his only response would be: "No, sorry." "He didn't know that you should never go to see someone yourself when you have a problem," he would later say. At the same time, Peckinpah was happy: this film was a chance for a reunion with his old drinking buddy, Jason Robards. Their debauchery caused uproar in the hotel. One night, production got a call from reception, who feared the worst: Peckinpah and Robards were drunk, throwing bottles from one side of the lobby to the other, stopping only to urinate in the plants. This festive spirit spread throughout the team, to the point that the women working in the hotel had slept with so many team members that a VD epidemic broke out. Peckinpah was forced to bring in prostitutes to quell the situation. In the end, a band of armed pimps stormed the production offices, looking for a certain Sam Peckinpah.

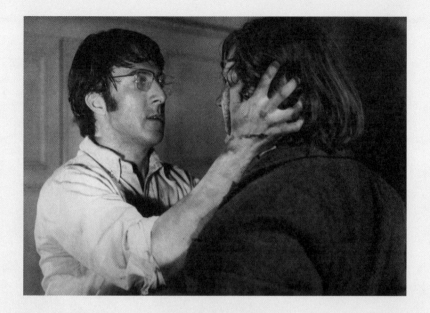

Straw Dogs
(1971)

Peckinpah decided to shoot this film in England, seeing it as the application of the writer Robert Ardrey's theory: "Man is violent by nature, and we have to learn to live with that". When the studio saw the first takes, the worry was palpable: "What is this shit? Is this guy sick or what?" And it was true, Peckinpah was ill. Not being used to the Cornish winter, he fought it off with whiskey-spiked coffees and fruit juice topped off with vodka. He was shooting in the grip of pneumonia, whilst shooting up penicillin. Forced to halt filming in order to go to hospital, he insisted on first drinking a few whiskeys with the crew, who bid him farewell as if he were going to a certain death. But he returned, and adopted a new rhythm: filming in the day, drinking in the evening, and all whilst working on the future script for *Bring Me The Head of Alfredo Garcia*. What's more, the filmmaker was using every means possible to unsettle the actress Susan George, whose character goes from the joy of returning to her home country, to the horror of a gang rape. It got to the point that Susan George, no longer trusting Peckinpah, demanded a body double. "I haven't got a single lecherous intention. There won't be an ounce of porno – you know I don't care about that," he wrote in defence of himself to the producer. To which the producer responded: "It's not me who's lost trust in you, but she has and, frankly, I think you are capable of asking your actors to have sex for real." Peckinpah: "Only if it were really necessary." When filming wrapped, the director would send a gift to Susan George, by way of apology: a bouquet of leeks and lollipops. Dustin Hoffman would go on to say about the director: "He was a gunfighter at a time when we were putting a man on the moon."

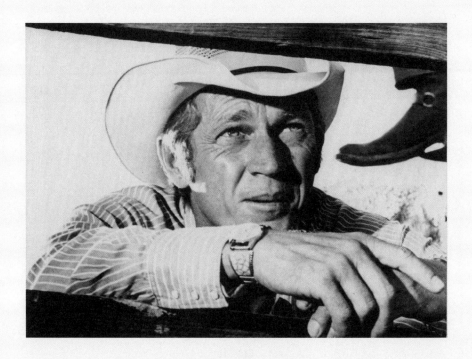

Junior Bonner
(1972)

Peckinpah was happy to work with Steve McQueen again, despite still being slightly bitter that the actor hadn't supported him when, five years earlier, he'd been fired as the director of *The Cincinnati Kid*. Miraculously, Peckinpah managed to agree to McQueen rewriting the dialogue. Perhaps this calm had something to do with the fact that Peckinpah had hired his daughter, Sharon, to help with the second team. The filmmaker was able to manage a messy set, as well as several love interests. In addition, he would often bring waitresses up to his room to sniff Amyl nitrate. An excellent director of actors, Peckinpah drew unforgettable performances out of the great Robert Preston and Ida Lupino. In the strange mélange of alcohol, sex and family, Peckinpah was able to pacify Lupino. The actress, wanting to hide her age, had been adding years to her face with layers of make-up. Sam exploded with rage and made her take it all off. Ida went into a sulk, saying to him: "You know who you should've got for this role? Shelley Winters. Go get her for the close-ups, I'll only do wide shots." That evening, a boy knocked at the actress' door, holding a bouquet of flowers with a note penned by Peckinpah: "Dear Shelley. We apologise. We know how interested you are in the role, but we have already fallen in love with Ida Lupino. Signed: Darryl Zanuck."

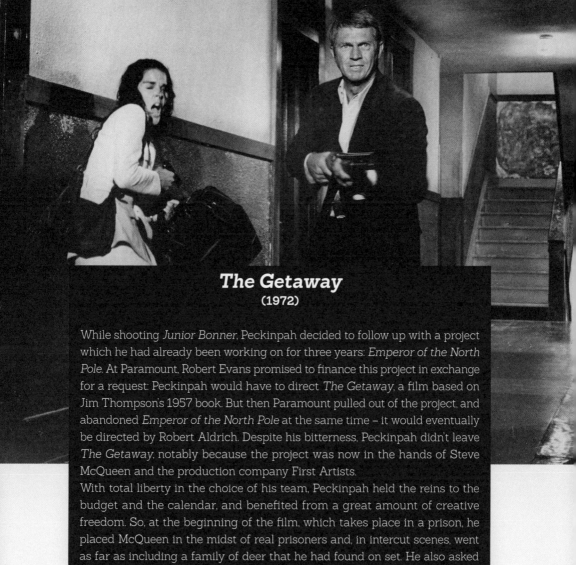

The Getaway
(1972)

While shooting *Junior Bonner*, Peckinpah decided to follow up with a project which he had already been working on for three years: *Emperor of the North Pole*. At Paramount, Robert Evans promised to finance this project in exchange for a request: Peckinpah would have to direct *The Getaway*, a film based on Jim Thompson's 1957 book. But then Paramount pulled out of the project, and abandoned *Emperor of the North Pole* at the same time – it would eventually be directed by Robert Aldrich. Despite his bitterness, Peckinpah didn't leave *The Getaway*, notably because the project was now in the hands of Steve McQueen and the production company First Artists.

With total liberty in the choice of his team, Peckinpah held the reins to the budget and the calendar, and benefited from a great amount of creative freedom. So, at the beginning of the film, which takes place in a prison, he placed McQueen in the midst of real prisoners and, in intercut scenes, went as far as including a family of deer that he had found on set. He also asked one of his actors, the loyal Slim Pickens, to try a bit of improvisation: "Throw something at McQueen to see if he can act". Backstage, Peckinpah was dealing with the stress of a fifth marriage, this time to British Joie Gould (fifteen years his junior), who he had married in Jaurez in case he wanted to divorce quickly afterwards. This was soon, and expensively, the case. From then on, his contracts included a clause prohibiting him from getting married during film shoots. Unfortunately, this second and last collaboration with McQueen ended on a sour note. The actor re-edited the film on his own in order to add certain sound effects and, above all, to replace the soundtrack of the director's regular composer, Larry Fielding, with the more modern Quincy Jones. Peckinpah publically denounced this decision, but it did not ruin the film's release, which was the greatest success of his career. Still, Peckinpah did get to experience a small taste of revenge: Robert Evans and Ali MacGraw's marriage fell apart due to the romance that had developed between the actress and McQueen during shooting. The director celebrated this, stating: "Nobody messes with Sam Peckinpah".

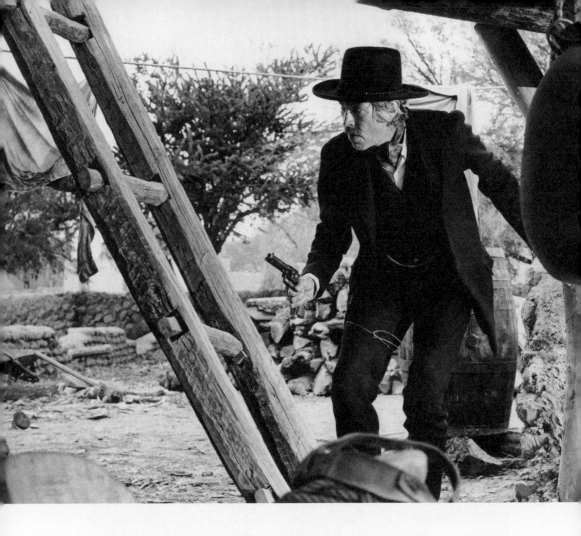

Pat Garrett & Billy the Kid
(1973)

Peckinpah was preparing to start what could be his most personal project ever. It was the story of Billy the Kid, killed by his old friend and now sheriff, Pat Garrett. It's a death that signifies the end of a certain idea of America, and of the personal freedom that it represents. The film was shot in the middle of the Nixon era, in a country filled with disillusionment. "The inevitability of the resolution between Billy and Garrett fascinates me. More precisely, the inevitability of Billy's death. (...) The same guys who hired Garret to kill Billy assassinated him few years later, and one of them, Albert Fall, went on to become United States Secretary of the Interior, which could be a commentary on the current government," he said of the film. Peckinpah had just seen and adored *Two-Lane Blacktop* by Monte Hellman. When James Aubrey, the head of MGM, read the script and noticed sequences such as Garrett reclining by a river and exchanging fire with a family approaching by boat, he became hysterical. The following reasoning came from Peckinpah: "It's a moment of existential violence." To which Aubrey replied: "Existential fucking violence?

I never want to hear that again!" In spite of such conflict, Peckinpah managed to get his way and have the singer Kris Kristofferson take the role of the Kid, rather than Peter Fonda or Jon Voight. Bob Dylan, a friend of the screenwriter Rudy Wurlitzer, was also interested in the project, but Peckinpah saw him as a fashionable singer forced on him by MGM so that the project would sell amongst teenagers. They had to meet in person for Dylan to get Peckinpah to listen to a few pieces inspired by the script so that he could give them his approval. "Cocksucking son-of-a-bitch," Peckinpah said, by way of recognising Dylan – before asking him to play the role of Alias, one of the Kid's friends. Peckinpah's nearest and dearest completed the mythical cast: James Coburn, Emilio Fernández, L.Q. Jones, Slim Pickens, R.G. Armstrong. However, the shoot would prove to be Peckinpah's most difficult since *Major Dundee*. "Whose fault was it? All of those retards at MGM. Who else?" Peckinpah would justify, shooting useless scenes just to waste the producers' money. Rumours of a catastrophic film set abounded, and the director chose to send a photo to *Variety* magazine, which showed his assistant (and lover) Katy Haber, dressed as a nurse, injecting him with alcohol. In the end, he suggested two different edits, but MGM decided to destroy both and entirely change the film. "Rudy Wurlitzer is a poet. He writes very well. His script would have made the film five hours long. It would have been an epic battle, with great lyrical qualities. I took him back onto my film, in order to preserve his poetry, and I was happy with it. But MGM's emotional castration in their edit stole all of the personality – they tried to just keep in the fighting. It wouldn't have worked." When the film was released, it was a total flop. Peckinpah received $2 million from the studios for their incompetence. It was only in 1998, when the filmmaker died, that we were able to see the film as the director had wanted it, proving that it is one of the most beautiful westerns in the history of cinema.

THE DANCE OF PAT GARRETT

BY CARLO CHATRIAN

The scene resembles a ballet. The momentum of James Coburn's perfectly extended right leg which meets the vertical axis of his left arm, does not only emphasize the actor's elasticity, but bears witness to the highly controlled composition of the scene. The emotional impact of this sequence is so strong that Coburn's figure, just like a dancer's, is practically overlooked when one sees the film.

By arbitrarily arresting the flow of the narrative, photography reveals the choreographic quality of Sam Peckinpah's films, as well as that of the extraordinary actors entrusted with realizing them. This quality existed well before his famous montaging. Indeed, I would also say that it existed in the movement itself, before it was captured by the camera, which is, here again, admirably precise. The shot is characterized by the predominance of vertical lines – those of the pillar, those of the shutters that frame the door, and those of the standing man – all of which underline two parallel diagonal lines – that of the kick, enacted like a gunshot, and that of the beaten body. Curiously, these two diagonals define a space which, like a frame, emphasizes a secondary character; this character symbolizes the spectator with his fear of the pistol's threat and of the sheriff's strikingly fast and violent gesture. A large part of the profundity of the film resides in this very incredulity.

Above all, before being an excellent shot, the image is the record of a physical act. I insist on this point because it reveals the centrality of the set as the space where Peckinpah's cinema is created. The set embodies the moment when a story meets a body, when a mental space becomes a physical one, or, otherwise said, when Peckinpah's action begins. For me, this gesture is not solely violent – although, indeed, it is very violent: it suffices just to look at the expression on the sheriff's face. In Coburn's gesture I can also discern the corporality of classical cinema, the importance given to recording an action which is unique

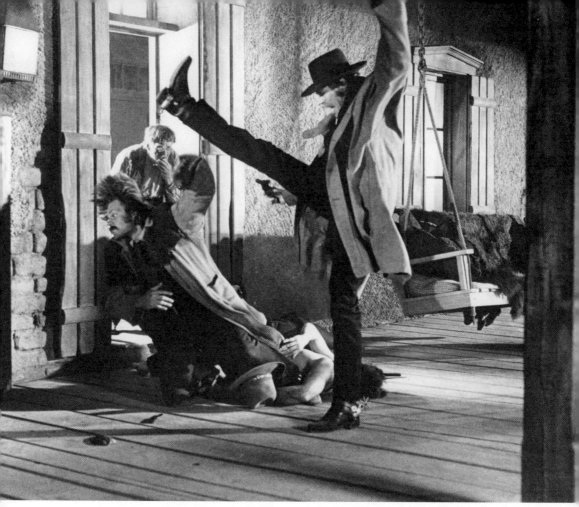

Pat Garrett & Billy the Kid

due to the talent of its actor. Whereas modern cinema has moved the focus to the gaze, reducing itself to an image, classic cinema offers itself as the record of an action. Despite his deconstructed writing (sometimes) and montages (always), Peckinpah remains a classic: he sees the cinema as the reproduction of a gesture, of an action, of movement expressed by a body in space. These roots, which – beyond the numerous superimposed filters – still remain visible in almost all of his shots, may explain why his films, despite their provocations, exaggerations, and harshness, remain so appreciated and have such an influence on the directors of today. Each of Peckinpah's shots is like an "ersatz" way of making cinema that has disappeared forever, but for which we still remain nostalgic.

Translated from French by Patricia Bass.

SAM PECKINPAH BY SAM FULLER

About *The Ballad of Cable Hogue*

When he was in Cologne, Germany scouting locations for his 1972 film *Dead Pigeon on Beethovenstrasse*, lifelong newsman Samuel Fuller was invited by a local journal to review any recent picture that had caught his fancy.

"Water is where you find it, and you won't find it there! "

With that simple springboard, Sam Peckinpah's superb film of man versus men (in this case the contradictory strands of weakness and determination within Cable Hogue) is a must-see movie from WB now playing at the El Dorado, a new moviehouse in Koln named after Howard Hawks' sagebrush success. Unlike the lusty Hawks film or any other Western, Peckinpah's *Ballad of Cable Hogue* is a sensitive, emotional, surgical job on an American desert hermit without familiar sagebrush stuffing. At times Cable Hogue's story gnaws at one's memories of Von Stroheim's *Greed* to Huston's *Treasure of Sierra Madre* – but the gnawing is short-lived because of Peckinpah's reconstruction of the West with fiendish authenticity.

Cable Hogue is a classic because in his passion for the counter-make-believe West, its humans and inhumans, Peckinpah never varies from his obsessive desire to show you how it really was and yet never to lose that cinematic touch that makes a movie a really entertaining movie. The animal behavior of Cable Hogue, brought to primate heights by Jason Robards, is quiet claw

and unbared teeth – a difficult role sensitively conquered by one of the finest actors around these days.

Hildy, the blonde plaintively brought to life by Stella Stevens, segues from independent whore to simpleminded sex thorn in Robards' isolated desert bed. With authoritative and extravagant brush Peckinpah paints the comedic, fatal love story of Cable and Hildy, accentuated by Lucien Ballard's always exciting photography. Peckinpah's camera is spiced with Cable Hogue's bizarre accomplishment of life and bizarre accomplishment of death.

The strange mournful sound of the changing West and of the lone desert rat's fist of sand fighting against all odds, is mirrored in dry tears of humor: bearded, body broken but spirit still soaring, the bedridden Hogue under an open sky listening to his own funeral sermon coming from the cracked lips of gaunt Joshua, a scabrous, libertine preacher brilliantly played by David Warner. The character of this hypocritical preacher is right out of Molière's *Tartuffe* but Peckinpah evades the familiar and guides his preacher to originality. In one of the best and funniest scenes in the film, the preacher's macabre gift of using God as a procurer to lure to bed a grief-stricken young lady explodes with captivating honesty. Peckinpah strikes home to the heart the falsity of God's roving cactus messenger with reversible collar. In this scene the preacher's determination to mount the girl, mournfully and gently played by Susan O'Connell, is as meaningful as Cable Hogue's determination to make his watery El Dorado a grim reality.

The plot, on its barren face, is simple: Cable Hogue, abandoned in the desert by two friends because of lack of water, is plagued by an idea that is physically impossible and that is to operate a nonexistent waterhole as a stagecoach way station. His lunatic dream pays off, even to the extent that he kills a thirst-crazed man for refusing to pay ten cents for a drink of water. and with that payoff the ballad of Cable Hogue ends, for he was put on earth for the unchronicled act of finding water "where it wasn't."

An eagerness for profit and love for the whore become his heroin, but when he discovers the emptiness of his accomplishment, it is too late and he is ungloriously run down by a four-footed spectre of the changing West – a damned automobile!

The El Dorado cinema promises more movies of the calibre of *Cable Hogue*. A worthy thing to look forward to.

First published in *Movietone News*, n° 60-61, February 1979.

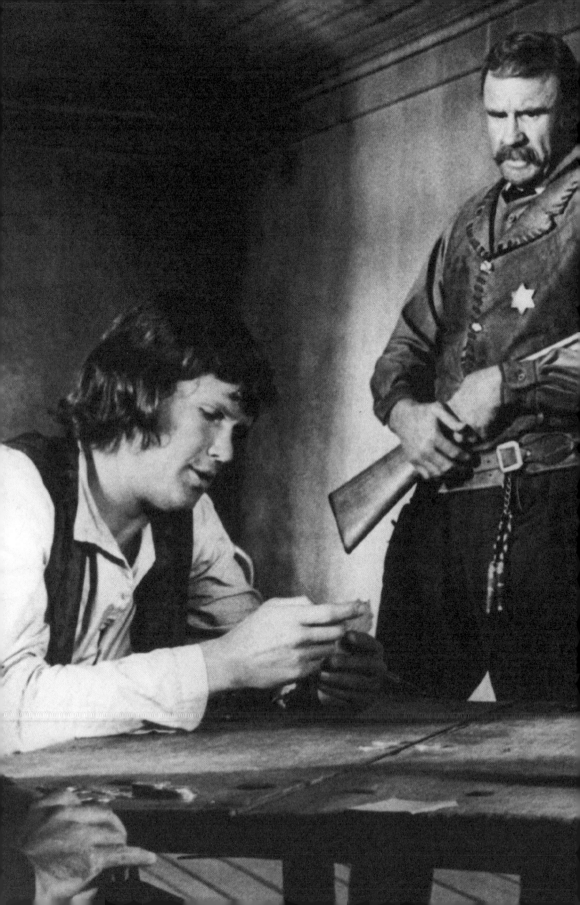

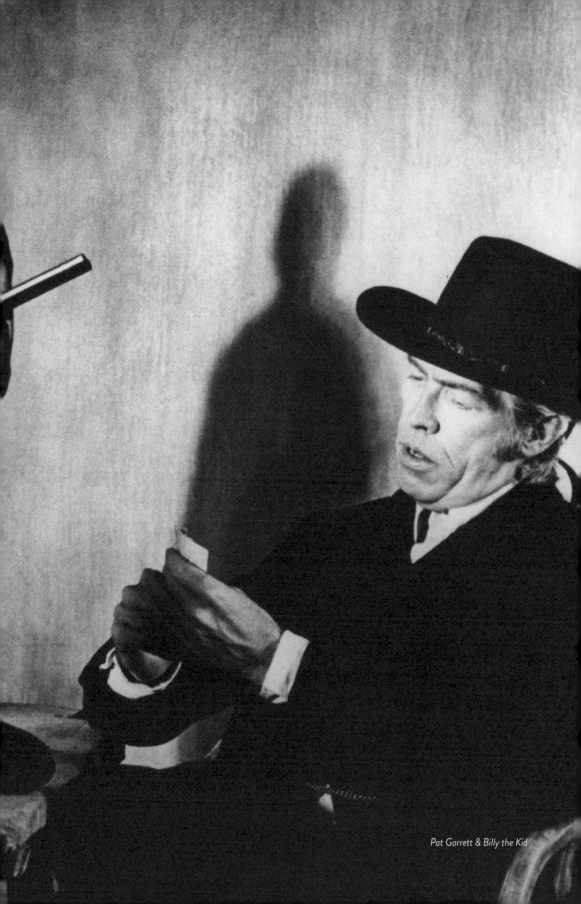

Pat Garrett & Billy the Kid

1974-1983

WHEN LEGENDS DIE

BY CHRISTOPH HUBER

BRING ME THE HEAD OF ALFREDO GARCIA (1974)

THE KILLER ELITE (1975)

CROSS OF IRON (1977)

CONVOY (1978)

THE OSTERMAN WEEKEND (1983)

"A drunk man dreams, a sober man doesn't."
Sam Peckinpah

THE LATE WORK OF SAM PECKINPAH: AN OVERVIEW

Almost universally reviled on its initial release, *Bring Me the Head of Alfredo Garcia* marks a crucial turning point in Sam Peckinpah's short and brilliant career, at least in the mainstream view of things: like Peckinpah's previous film, *Pat Garrett & Billy the Kid*, it was a box office flop. But this time critics had no notorious, embattled and highly publicized production history (culminating in another butchered studio cut of a Peckinpah film) to fall back on. They simply hated *Alfredo Garcia* for what it was – pure Peckinpah. One of his few productions that went smoothly, at least by Peckinpah's standards, it was later declared by the director as the only work "I did exactly the way I wanted to. Good or bad, like it or not, that was my film."

For that reason alone, *Alfredo Garcia* remains divisive by nature, probably even more so than any other of Peckinpah's films. But despite being initially greeted with revulsion, this modern and masterful Mexican nightmare has been rightfully reevaluated since. Unsurprisingly, it has gained considerable reputation as a cult movie, bolstered by such iconic supporters as Quentin Tarantino and David Lynch, both clearly influenced by Peckinpah's penchant for grotesque, even disgusting details and a (self-)destructive streak that – taken to its logical extremes in *Alfredo Garcia* – borders on the surreal. Although this can be easily justified as pop-culture appreciation of a truly unique work, it is still faintly reminiscent of *Alfredo Garcia*'s initial, surface-level reception as some sort of sick shocker, only in reverse; with the passage of time, the film has come to be considered a success rather than a failure for its disturbing qualities. However, a more thoughtful strain of recognition has also developed in tandem and arguably achieved wider traction. Seen not just as Peckinpah's most personal work, but also as one of his best by many admirers, it has become clear that *Alfredo Garcia* is the culmination point of Peckinpah's most celebrated phase, inaugurated by his stunning rebound with *The Wild Bunch*. This film catapulted him into the spotlight as a controversial talent; his bold and contentious pronouncements and difficult, booze-fueled behavior (on and off set) were as welcome material to the mass media as the somewhat misleading "master of

violence" label. This label is a simplification that has spread the false image of Peckinpah as an artist whose visionary approach to montage both extended and celebrated the violent content of his pictures. Rather than this celebration, the director was seeking to express a complex and ambivalent stance towards violence – a stance that (undoubtedly intensified by his reductive reputation) became increasingly more tortured throughout his career.

With its striking mixture of a macabre lyricism and its desperate consequences, *Alfredo Garcia* remains the most extreme example of Peckinpah's tendency to transmit positive values via demonstrations of the opposite: in this film, the whole universe is sucked into a vortex of negativity. *Alfredo Garcia* remains one of the most glorious refutations of Peckinpah's official and superficial image, which likely contributed to its dismal reception: critics were probably disappointed that its philosophy did not translate simply as more brutality in what had been established as Peckinpah's signature style of balletic mayhem. As so often, the director may not have done himself any favors by setting up false expectations when he described *Alfredo Garcia* as a film in which "somebody gets pissed off with all this bull, and takes a gun and shoots a lot of people and gets killed."

In retrospect, it seems rather obvious that *Alfredo Garcia* was more than a direct expression of the personal demons plaguing Peckinpah, including his constant conflicts with producers and studios. Consider, for instance, the pronounced parallels of the criminal syndicate in the movie to the world of movie production: in Peckinpah's pissed-off-with-all-this-bull view, both are enterprises represented by unscrupulous, greedy business guys in clean suits. *Alfredo Garcia* represents the ultimate point of investigation for several of his major concerns, from vengeance to male-female relationships to the nature of an increasingly corrupted world and, most pronouncedly, the nature of human barbarism itself. Stephen Prince has noted the trend, drawing a line from *The Wild Bunch* via *Straw Dogs* and *Pat Garrett* to this film, which deliberately and definitely reveals nothing but a pitch-black void at the center of the (vicious) cycle of violence. As such, *Alfredo Garcia* – at least aesthetically – actually still belongs to the previous, and most venerated Peckinpah period; in fact, it can be seen as its period in the grammatical sense. Still, it also makes a lot of sense to consider it as the entry point into Peckinpah's much-contested later work. For one, Peckinpah's fame and notoriety had quickly become so strong that the public image always overshadowed his true artistic achievements; the disgust and disinterest that greeted *Alfredo Garcia* came to be seen as emblematic for his alleged downfall over the course of the next decade, which was its own kind of vicious cycle, pulling Peckinpah down further, even as he lashed out with the same passion as before.

But unlike his *Wild Bunch*, Peckinpah would not be allowed to go out in a blaze of glory. Starting with the so-so spy movie *The Killer Elite* (which was hardly

Burt Lancaster and Sam Peckinpah on the film set of *The Osterman Weekend*

a disaster, but surely nowhere near a Peckinpah triumph), alienation is no longer just a subject, but also an attitude for Peckinpah. Disappointed with work-for-hire material, Peckinpah took a satiric stance towards a script that seemed an unexceptional saga of betrayal amongst agents, elaborating on his idea already voiced vis-a-vis the standard action template of *The Getaway*, but this time angling for full-scale absurdity. He even shot an ending in which a character who has just been shot simply reappears, to be laughingly thrown overboard by his colleagues. Of course that finale was not used (although a few other fanciful touches remain), and Peckinpah's lessening influence would be felt similarly on all his remaining films. Starting at the script stage, they remained troubled productions and ultimately were considered disappointments by the critics – and, more painfully, in one way or another also by the director himself, who may have felt the loosening of his grip concerning the moral questions that are at the heart of his work (and his unmistakable montage style). But to really wrestle with the principles of humanity and its ethics, you also have to be fully involved emotionally – which is hard to maintain once you consider

your material completely beneath you. Peckinpah made stern pronouncements about the quality of what he had to work with throughout his career, so that was always part of his combative character – but his commentaries on most of his late work are downright devastating.

If one looks for a (downwards) turning point in his career, it must be located somewhere during the making of *The Killer Elite*, where things *really* started to get out of hand. Allegedly, it was his star James Caan who introduced Peckinpah to big-time cocaine consumption during that shoot, and the publicity surrounding Peckinpah's drug intake makes it impossible to ignore the issue. Like his drinking and his openly combative stance, cocaine contributed to the troubles he had in getting projects off the ground – a factor that cannot be disregarded, as it shaped his final decade as a director even more decisively than the earlier years. It also added a new touch to his controversial public persona, helpfully summarized by a source whose objectivity may otherwise be hampered: none other than *The Drunkard Magazine*. When publishing an admiring profile of Peckinpah as an "exemplary drunkard", the magazine declared him an alcoholic director thus able to truthfully portray constant drinking in his movies as something unexceptional, but concluded simply that after years of successful inebriated filmmaking "the drugs ruined Sam Peckinpah, not the hooch." Take it or leave it, but from that perspective, *Alfredo Garcia* is also the correct starting point for a consideration of Peckinpah's late career. "When I came to make *Alfredo Garcia*, the studio doctor told me I'd be dead in a couple of months if I didn't change my habits. So I did what I was told – I quit the booze, I quit the coke – and started smoking marijuana instead," Peckinpah later remarked. Regardless, it must be noted that Peckinpah did never fully abandon alcohol. Most famously, on the Yugoslavian set of *Cross of Iron*, he would drink four bottles of 120-proof (others even claim 180-proof) Slivovitz or Vodka, starting at 6 a.m. and, according to actor Roger Fritz, hitting the third bottle around 9 a.m., when the actual shooting started, before opening the fourth at noon for the afternoon delight, "making no secret of it whatsoever".

However flawed Peckinpah's four final films may be as a result, none can be dismissed out of hand (as often happened upon their release); they show his signature in style and spirit, although slackening to various degrees, as with Peckinpah's health. Nevertheless, some of these films' blemishes only add to their fascination as a whole. If *Alfredo Garcia* is seen as Peckinpah's most unflinching gaze into the abyss, it is logically unavoidable that the darkness at its bottom could never be forgotten, even in ostensibly lighter works as *The Killer Elite* and *Convoy*. More frequent lapses (in script logic, strained dialogues, uneven direction) and other inconsistencies partially translate as productive irritations not so far from those a montage artist like Peckinpah sought consciously through dialectical juxtaposition of images and sounds. Although all the flaws in the late films are usually and summarily attributed to Peckinpah's

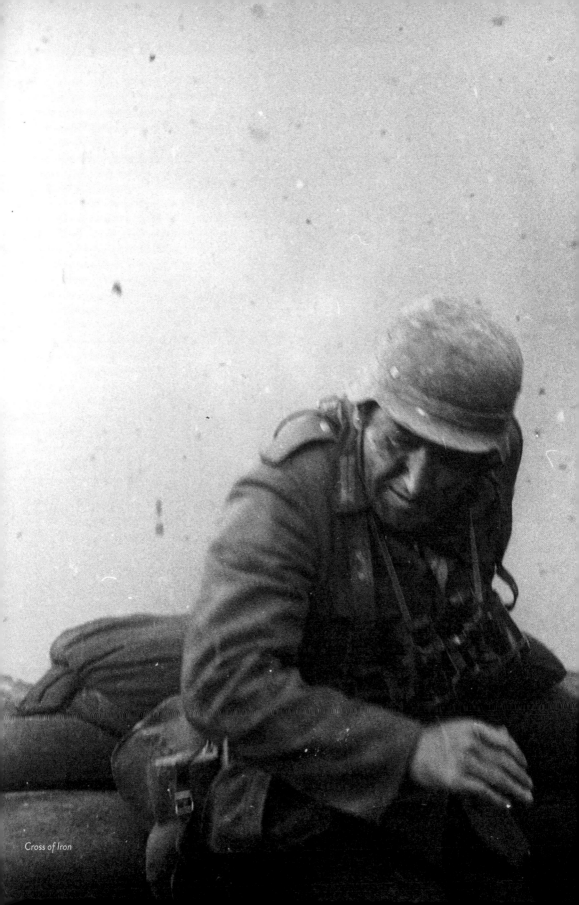

Cross of Iron

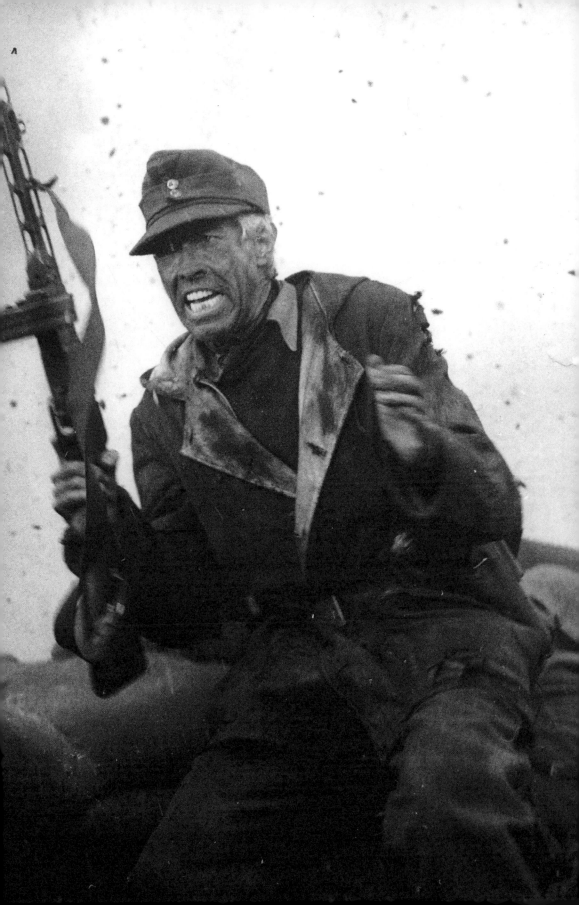

decline due to alcohol and drugs, they also serve (in a supreme irony worthy of the great ironist, Peckinpah) to "unify" this unruly body of late work, whose increasingly sinister view of modern society seems to demand an increasingly fragmented approach as the renegade's last stand. It is as if the films themselves were torn apart by their rebellion against the suffocating, all-enveloping grip of a corrupt, commercialized universe, which the director experienced as continually expanding, and rightly so as the years since have shown.

The films may be unwieldy mostly because of circumstance, but to a certain degree they are so by necessity as well. They were marked by Peckinpah's growing disillusionment, which fueled both his self-destructive tendencies and his Brechtian streak. This latter added to the alienation that had become his defining theme. Little wonder he put a Brecht quote at the end of *Cross of Iron*, the only full-fledged war film in a filmography strongly associated with fighting, and at first glance the odd one out amongst his last five films. Whereas the others have contemporary settings, *Cross of Iron* is a nihilist evocation of WWII, as experienced exclusively from the German side. Its coda however, capped by Brecht's famous words from *The Resistible Rise of Arturo Ui* ("Do not rejoice in his defeat, you men. For though the world has stood up and stopped the bastard, the bitch that bore him is in heat again."), presents a series of still photographs of atrocities from later conflicts (Belfast, Biafra, the Arab-Israeli war, Vietnam…), insisting on the universal continuation of war into the present. Praised upon release by none other than Orson Welles as "the best war film I have seen about the ordinary enlisted man since *All Quiet on the Western Front*", *Cross of Iron* was one of several notable US box office casualties in the wake of *Star Wars* in 1977. It was quite successful elsewhere however, and has since proven itself as another major Peckinpah production to be somewhat rehabilitated over time – whereas the follow-up *Convoy* still cannot shake the faintly ridiculous aura of its frankly impossible attempt to combine the antithetical approaches of *Smokey and the Bandit* and *The Wild Bunch*.

This truck-driver-as-cowboy update additionally suffers from a certain vagueness in how to transmit its central idea: here Peckinpah's rebels just rebel, but exactly why – apart from a dissatisfaction with the way things are, clearly shared by the director – is anybody's guess. Which is probably one reason it turned out Peckinpah's biggest financial success – the vagueness makes it more palatable than Peckinpah's previous, pointed interventions. Overall, it remains a most entertaining, sometimes silly, sometimes illuminating demonstration of the principle of noble failure, not at all what you would expect from a film about which its director declared on the last day of shooting: "I haven't done one good day's work on this whole picture – not one day that I really felt I'd put it all together." A heart attack in 1979 further hurt Peckinpah's already dubious employability – it was well known that collaborators had shot scenes for the frequently incapacitated director on the last films. On *Convoy*,

Peckinpah's condition was regularly in such a sorry state that second unit director James Coburn, on board to earn his DGA credit, had to take over on more than one occasion.

But Peckinpah did not falter – he even took a second-unit job himself, on the last film of his one-time mentor Don Siegel: *Jinxed!* (1981). Though the film, like much of Peckinpah's late work, is better than its reputation suggests, it lived up to its title as far as grosses were concerned. Despite this, Peckinpah's contribution – most notably, a well-executed nighttime action scene of a trailer going over a cliff and crashing in flames – was appreciated, and certainly helped in securing what would be Peckinpah's last job as a feature director on *The Osterman Weekend*. Although saddled with a script he hated (and was not allowed to rewrite), Peckinpah was more successful in combining commercial concessions with the absurdist exaggerations demanded by his personal involvement than in his previous contract work, the spy thriller *The Killer Elite*. He fashioned a narratively messy, but convincingly cold and aloof attack on a dehumanized society steered by reactionary forces, and habitually manipulated by television and other media producing homogenization and alienation. This is crucial in a Peckinpah context, where even violence can no longer register as real in a world desensitized by constant mediated spectacle. It is impossible not to be reminded of Fritz Lang's last film, *Die 1,000 Augen des Dr. Mabuse* (*The Thousand Eyes of Dr. Mabuse*, 1960) considering both the emphasis on surveillance mechanisms and the distant perspective, regarding the characters as if they were aliens rather than (alienated) human beings. Once again, doubts whether this was fully on purpose are more than warranted – there is a memo from Peckinpah to his editors in which he bemoaned the lack of rooting interest for the viewer: "Bottom line: This is not a great flick. I appreciate the efforts to make it so but it really is not. 1) give me somebody to hate. 2) give me somebody to love." Peckinpah himself sounds alienated from his work here: was he really disappointed that his compelling vision was hampered by substandard elements? Or was he also playing good boy to remain in the studios' graces after finally getting assignments again, offering an argument (though emotional) whose terms translate to a kind of commercial logic the suits would surely understand? With late Peckinpah, it's sometimes hard to tell.

In a way, that is the struggle made most manifest in Peckinpah's last five films: his own emotional bond to the characters and the material is wavering. Not so much perhaps in *Alfredo Garcia*, where he purposefully dismantles the film's structure by going all the way with his self-sacrificing loser-hero. But after having reached that point, where to go? The lamentably compromised satiric streak of *The Killer Elite* and the resolute, if apolitical, nihilism in *Cross of Iron* feel like valiant attempts despite some misgivings. The desperation can be most distinctly felt in *Convoy*, which for all its clueless striving still emerges as the director's most audience-friendly film, guaranteeing a place of pride in

the rich universe of Peckinpah's paradoxes. But this impression is to be paradoxically turned on its head, as the filmmaker recedes fully into a cool, corrosive tone with *The Osterman Weekend*, providing a fitting finale for a career that was challenging in every sense. And yet, when it ends with a direct, probably naïve, but forthright plea to turn off television, that delivery mechanism for social control, it is hard not to be moved by this final message. "I want that said," Peckinpah had insisted, "that's the only reason I'm going to make that fucking picture."

Struggling with his own problems, as well as with ethical quandaries and the forces he felt were corrupting the modern world, Peckinpah stayed true to himself until the very end. Surely that is part of the reason why his late work, once simply regarded as a series of letdowns, has never vanished from view. Whether misunderstood or just not living up to expectations, including those of their creator, they still bear his touch, especially the need to communicate something of relevance – something that remains meaningful to this day. With Peckinpah dead, the legend surrounding him has lost some of its force, but his legacy is still powerfully alive, down to its legendary – and, as shall be demonstrated below, actually only alleged – nadir.

BRING ME THE HEAD OF ALFREDO GARCIA

For a film that used to be customarily characterized as obscene, disgusting, sadistic, misogynistic or awful (the list of negative adjectives could continue for some time, but to no point...), *Bring Me the Head of Alfredo Garcia* does indeed have a shocking beginning. A female idyll in fertile nature is introduced with relaxed guitar music and a peaceful freeze frame of swimming ducks, which gives way to the no-less-soothing sight of a pregnant young woman by the waterside, bathed in warm sunlight, looking at the ducks passing by and stroking her belly, lovingly attended to by another woman.

Then the first couple of men arrive and the terror starts. The girl is summoned away from this feminized Mexican Eden towards the path of desecration, which is paved with a characteristic Peckinpah montage: shots of the young women being led by the two men (the constant clangor of their spurs a linking element on the soundtrack) are intercut with people ceremoniously gathered in a huge

Convoy

hacienda listening to a mass read in Latin. As is typical of Peckinpah's cutting, the details accumulate until we get the full picture, finally realizing that "El Jefe", the hacienda's owner (the great Mexican actor and director Emilio Fernández, familiar to Peckinpah devotees from previous Mexico excursions in *The Wild Bunch* and *Pat Garrett*) who is reading the mass, is also the girl's father, about to demand the name of the man who impregnated her. At first she refuses, silently and proudly, even after her dress is torn, but upon a cue from El Jefe the two men bring the girl down to her knees, as she winces in pain. The quiet stoicism of the onlookers (the Latin mass reinforcing the notion they are here to witness an unchangeable ritual) is suddenly shattered when the girl's arm is broken and the hitherto stone-faced mother exclaims "Nooo!" Meanwhile, Peckinpah discreetly cuts to the outside, instead of showing the act of violence itself, a strategy he will repeat during several crucial moments of the film, as if he couldn't bear to make himself and his camera complicit in the most immoral acts in a film that most of all wants to demonstrate how corruption – both monetary and spiritual – manifests itself as an inescapable downward spiral leading to violence and humiliation of the most amoral kind.

Still, the violating force is felt no less harshly for Peckinpah's elision. As the culprit's name resounds through the hall, El Jefe declares both in Spanish and English that he will give a million dollars to whoever brings him the head of this Alfredo Garcia, causing a first commotion. One of the well-dressed gringos standing among the Mexicans approaches the young woman to tear off her locket. Inside is Alfredo Garcia's picture – the only time the audience will ever see the face of our titular "hero" (another void) – and a manhunt begins, illustrated by brief flashes of airplanes taking off and landing, cars careening through backwater towns and bounty hunters emerging to ask the locals questions.

Actually, it takes almost exactly ten minutes until the actual "hero" of the film is introduced, and in such a way as to clarify within seconds that he is an anti-hero par excellence. Leading a "Guantanamera" chorus – as well as trying any way other to get perambulating tourists to give him a tip – Bennie (Warren Oates) makes ends meet as a pianist in a rundown Mexican bar. He is the quintessential loser, angling for the proverbial last straw, when he hears about the money put on Alfredo's head, offered by another male couple, two henchmen in business suits (Robert Webber and Gig Young), who are clearly homosexual partners. One of them knocks down not only his tequila, toasting with Bennie, but also one of the local *putas* when she tries to fondle his thigh. Like the repeated suppression of certain brutish acts in a movie still chock-full of killing and mayhem, the recurrence of male pairs as gatekeepers to violence hints at how carefully Peckinpah has set up his film's structure already in the short opening stretch. Like the girl (who will become his unlikely ally at the very end), on his upcoming nightmare journey Bennie will be pulled

from an Edenic idyll towards the loss of all he cherished and believed in, leaving him stranded and vengeful in a wasteland of enforced brutality.

Not that anyone might mistake Bennie for an idealist, even early on. He starts at a low point, picking up his girlfriend Elita (Isela Vega) and chiding her as a "lying, cheating, no-good two-bit bitch." His plan will give her the creeps: Alfredo Garcia was one of her former lovers, who died drunk in an accident, and Bennie wants her to take him to the burial site, which should make for easy grave-robbing. "I want to enter my house justified", goes the most famous line from Peckinpah's *Ride the High Country*, but here the values have changed: true to his time (and the film made to describe it, in which justification is eroded and only rot remains), Bennie declares that he's not interested in Alfredo Garcia's house, but "his grave will tell me more". First, however, he is granted *his* glimpse of Eden, with a roadside picnic in the overripe Mexican landscape that leads to one of Peckinpah's most moving relationships. Elita has had her share of experiences and is accordingly hardened, but within her still blossoms the soft hope of settling down with a man she can love – both states touchingly conveyed by Vega. But her later pleas to go back to how it was before and pretend nothing has happened ("Isn't being together enough?") curry little favor with the male drive to make it big, even though Bennie, loser that he is, has only been promised a share of $10,000 for the head – victim of a typical Peckinpah-suit tactic.

It adds to Bennie's pathetic stature, brilliantly captured by Peckinpah stalwart Oates, who crowns his under-sung career with one of the great self-effacing performances of the 1970s. It's based on Peckinpah himself, including the director's very own sunglasses, which are a major element of the characterization. Bennie's macho swagger can be perforated easily, and whenever he takes off the glasses, he becomes especially vulnerable. (Like many strong Peckinpah women, Elita does not respond to his machismo, but he can't help trying to act according to type.) A named star might have given Bennie the pathos of his gravitas, but it's precisely Oates' unglamorous appearance and effortless manner that makes his character unforgettable. Played and photographed with the unsentimental signature that is key to *Alfred Garcia*, Bennie's pathetic core is much more keenly felt. You notice how he tries never to be aware of it, and yet it floods out unconsciously in the tender moments he has with his beloved, their apparent ordinariness betraying a staggering depth of feeling – like the scene in which he impulsively, but sincerely, asks Elita to marry him, simply because she finally brings up the topic. But like the title hero of Peckinpah other's great labor of love, *The Ballad of Cable Hogue* (a part for which Oates was considered), he sacrifices his love for his false pride and a corresponding urge, mistaken for justness. For Cable: revenge, for Bennie: the dream of a better life. That is, until that dream is shattered, and then he too is spurred by revenge. As per the recurring

pattern, this destruction of dreams is anticipated, when another male pair enters the paradise of Bennie and Elita, and the setting is turned from day into night. Two bikers overpower them: one wants to rape Elita (and is played by Kris Kristofferson, perhaps cast by Peckinpah as a reminder that reviewers erred when they interpreted Kristofferson's Billy the Kid in *Pat Garret* as an outlaw-hero instead of just an outlaw). In the end, the couple manages to overcome the bikers, but even as Bennie fires the deadly shots, it is important to note that it's an act of Elita that breaks the spell – throughout *Alfredo Garcia*, the women (Alfredo's grandmother, El Jefe's daughter at the end) ignite the truly decisive actions. Peckinpah himself stated that in *Alfredo Garcia* he tried to show that he adores women: "They represent the positive pole of the film, the life force and instinct."

Nowhere is this brought out more beautifully that in the shower scene following the rape attempt, in which Bennie lets down his guard and is rewarded with the hope of a future in marriage. But then he insists on having his way, and they move on, fatally, but perhaps inexorably. About midway through the film, when he is standing above Alfredo's grave, machete in hand for the unspeakable act (which again, is not shown), the film completely turns into a nightmare. Out of nowhere, Bennie is hit slo-mo with a shovel, and when he awakes half-buried with the corpse next morning, he finds Elita dead in the grave. If Peckinpah's films can be defined as tragedies brought on by the destruction of utopia, the exceptional lyricism granted to the ballad of Bennie and Elita seems to demand an equally ghoulish descent. The second half of *Alfredo Garcia* sees the betrayed Bennie on a revenge spree that first leads him to relatively regular confrontations, spiced with touches that amplify the surreal element of his descent. A shoot-out with Alfredo's family and the two gay henchmen (one introduced as Fred C. Dobbs from John Huston's Peckinpah-beloved greed-destruction saga *The Treasure of the Sierra Madre*, 1948) leaves only Bennie and, somewhat absurdly, one old Mexican (another notable director-actor, Chano Urueta) standing. The scene surprises the viewer with a concluding outburst of emotion from one killer, mortally wounded, for his already-deceased lover – a moment of grace not expected from a suit . Then Bennie goes on the lam at suits' headquarters, a parody of a Hollywood studio outpost, where two manager types sit behind desks, and another enjoys a pedicure by two ladies, while reading a *Time* magazine issue with Richard Nixon on the cover. The systemic implication is unmistakable: although accused of fascism for his violent movies, Peckinpah always considered himself a liberal democrat, and saw Nixon as his bête noire: when Bennie is first seen in the bar, behind his piano there is a parodistic dollar bill with a caricature of Nixon in its center.

Obviously, *Alfredo Garcia* turns most prejudices against Peckinpah on their head when studied closely. Near the end, even the male-bonding aspect implodes, with the most unlikely pair of buddies in cinema history preparing for

the showdown. The green-brown palette of overripe Mexico around them is ever more arid – the color of plants which have never known succulence, the brown dustier and muddier, just like Bennie's once-white suit, which has become a soiled rag under his unshaven chin. In a kind of pulp version of Hamlet, much of the film's second half is filled by a deranged version of buddy-movie banter inflicted by the crazed, desperate Bennie on his partner: Alfredo's decaying head, stuffed in a bag circled by flies. Typical of the black humor perfectly in sync with the blackness at the heart of the entire film, these scenes also nail the exaggerated emotionality and self-awareness, not to mention the battered grandeur and existential design, which make *Alfredo Garcia* such a special experience. As Paul Seydor, writer of the authoritative study *Peckinpah: The Western Films*, has pointed out: "Fifty or a hundred years from now people will be looking back on that film the way we look back on Faulkner today. Professors used to get fired or denied tenure for arguing that Faulkner was a great writer; today he's recognized as one of the greatest American writers. People will look back on us and wonder why we failed to understand *Alfredo Garcia*."

Ultimately, *Alfredo Garcia*'s bitter deconstruction of the mostly regressive male buddy movies so popular during the era (and beyond) fits perfectly well with its final stroke of genius. Although Peckinpah, due to the influence of his action-direction and his pronounced break with tradition (cf. his ambivalent relationship to John Ford, whose legacy he clearly tried to critique and expand on in his westerns) is often considered a precursor of that elusive entity called postmodernism, he is actually a modernist, and nothing exemplifies this as impressively as the self-immolating structure of *Alfredo Garcia*. The film's anti-hero is not only made to suffer, but has the rug yanked out completely from under him. More precisely: he yanks it out himself when he transcends his character profile, unexpectedly struck by awareness. Whereas in a typical loser story the protagonist may redeem himself either through winning or, like in *Rocky* (1976), by losing but still proving his worth, here the whole value system (and thus the foundation for any possibility of success) is brought crashing down, once Bennie, Hamlet-like, starts to question the whole enterprise instead of pragmatically fulfilling his mission according to tradition. Killing his way to the top of the chain of arbitrary law, he finally snuffs out El Jefe himself, metaphorically destroying the foundations of his entire story, proving himself a modern hero: still a loser, but redeemed by losing his life.

Bennie's final act and the ensuing havoc reiterate that this is a film about chaos engulfing the world, leaving its protagonist no way out – a flash of martyred Bennie, bullet-riddled in his car, cannot compete with the iconic final shot, underscored by the director's credit, given to the close-up of a firing machine gun. A signature gesture, an image of the deadly void, before one of Peckinpah's still montages conjures paradise lost over the end credits. It is worth noting that Peckinpah, always adapting during the shoot (for instance, the

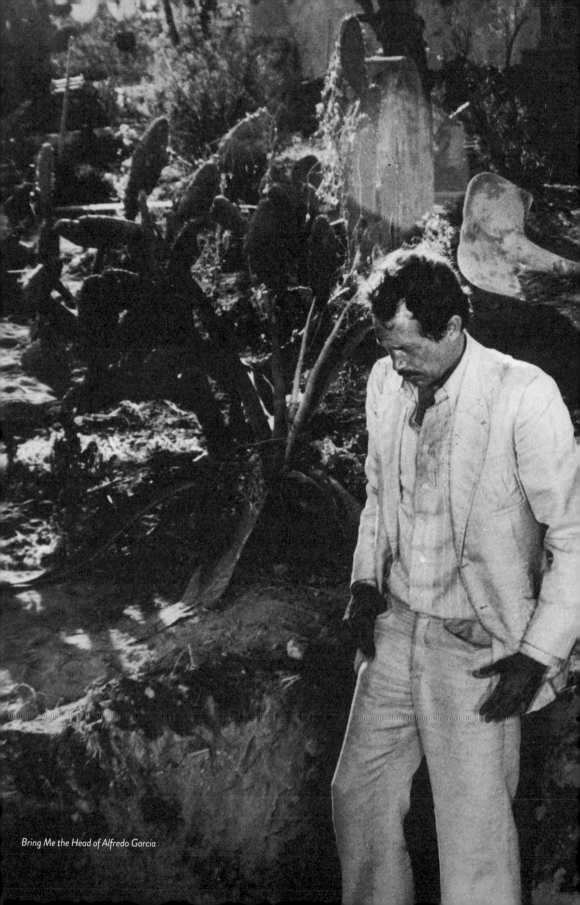

Bring Me the Head of Alfredo Garcia

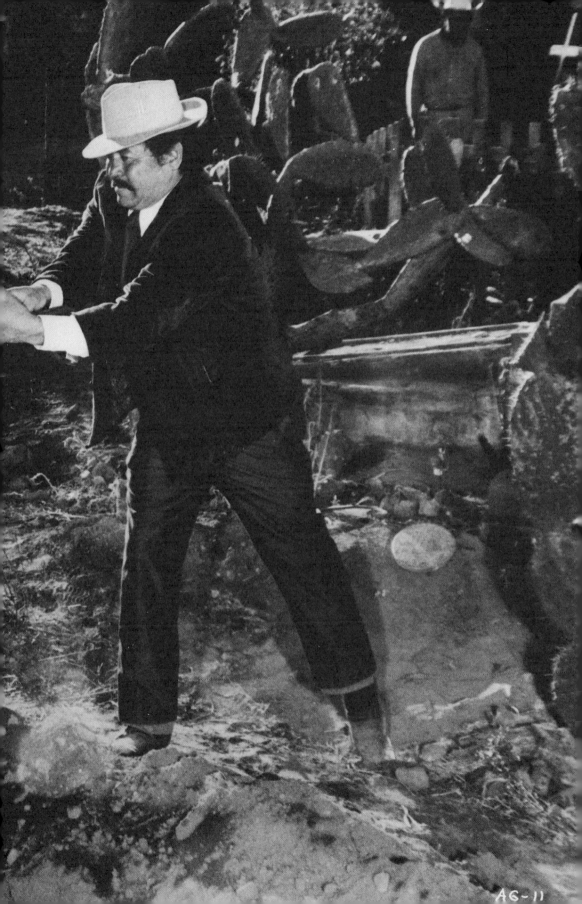

AG-11

superb touch of the Latin mass in the opening, down to El Jefe being handed his cigar box, was made up on set), originally had an ending in which Bennie got away. Only during production did he realize that Bennie had to die – not least because he took the money. If his vision later clouded, here both Peckinpah's moral and aesthetic awareness were still fully functioning, leading him to a high point that also proved to be a point of no return.

THE KILLER ELITE

Having learned his lesson about unemployment in the 1960s, Peckinpah had already signed up for *The Killer Elite* when he started to get doubts. Star James Caan was hired on the basis of his superb performance in *The Gambler* (1973), so the script Peckinpah wanted to make went out the window – like the original novel, which was quite a different spy story, set in England. But Caan refused to shoot abroad. The director hated the new script, and renowned writer Stirling Silliphant was brought in, who indulged his newfound love for martial arts (and snuck in a part for his brown-belt wife, Tiana Alexandra). Silliphant was eventually trapped during the revision process by conflicting input from the producer, who wanted straight action, and Peckinpah, who favored the satirical route[1]. Ultimately, the result excels in neither way, with leftover absurdities (an unexplained "flasher" appearance next to an assassin's body at an airport conveyor belt) and self-mocking dialogue (depreciating jokes about the MGM studio, almost giving credence to the po-mo Peckinpah fallacy) not nearly enough to turn an efficiently filmed, convoluted routine story into something personal, let alone consistently self-critical – although enough sinister suits are traversing the modernized wastelands to suspect another movie-biz allegory.

There is the minor problem of second-billed star Robert Duvall – a pleasure to watch, as always – only having been given something like a glorified cameo, but the main issue lies elsewhere. The story of betrayal seems tailor-made for Peckinpah's sensibilities – the promising opening leads up to Duvall's agent killing the man he and Caan should protect, then sparing his partner by "retiring" him via select hits in arm and leg. Caan's subsequent regeneration, evoked in detail (and with some good ideas), makes for an interesting contrast to *Alfredo Garcia*'s all-out destruction, but like many plot strands and supporting characters the theme remains too spottily developed. Standout moments include some successful set pieces, like the defusing of a car bomb on a bridge. With

1-Like the film's opening, in which a series of text inserts from an interview (with the high-ranking co-vert-ops character played by Gig Young) about covert agencies employed by the intelligence networks, is impossibly dated September 31st, 1975, and capped by the ironic notice that the mere thought the CIA might use such an organization is "of course, preposterous".

corrupted characters trampling over Peckinpah's ideals, *The Killer Elite*'s half-serious, half-mocking tone causes uncertainty about the commitment behind Peckinpah's once-heartfelt ironies. Despite director Aoyama Shinji's assertion that "no other film has taught me as much about human dignity", the intentions within the film seem to waver enigmatically – maybe like Peckinpah himself wavered, saddled with a genre that encompasses both low potboilers and the heights of John le Carré and in which his kind of moral investigation seems commonplace. The film is still worth seeing at least once, which is a pretty sorry thing to say about a Peckinpah film.

CROSS OF IRON

Again, the details of the plot are of secondary importance, but *Cross of Iron* rectifies two of *The Killer Elite*'s most problematic aspects: instead of near-interchangeable opponents, an actual battle of characters (and their wills) is at its core, and it may be Peckinpah's most nakedly emotional film. The German Wehrmacht's retreat from Russia in 1943, as restaged in Yugoslavia with an international cast, serves as explosive background for the ongoing confrontation between the "mythically indestructible", battle-steeled Sergeant Steiner (James Coburn) and a Prussian officer (Maximilian Schell) scheming for the

titular decoration despite his cowardice. In many ways, *Cross of Iron* suggests an updated inversion of *Major Dundee*, designed to offer an abundance of the apocalyptic vision to which the earlier, mangled film built in vain. If *The Wild Bunch* provided an idea of how *Dundee's* climax should have looked, *Cross of Iron* is a constant climax of agony, to which Peckinpah's lyrical interludes offer a contrasting counterpoint, but no real relief. The pressure-cooker atmosphere of constant battle – shown through a tour-de-force Peckinpah montage – does not even let up in the dialogue scenes, which set up their own trench lines. As the director's designated war film, it is not about WWII or the world at war in general, but a reflection of the world as war.

Coburn has recounted how he and Peckinpah prepared by touring film archives to watch war footage, including two films "cut from the same stock", one German propaganda, the other Russian: "It was very interesting to see what amounted to the same shots edited differently to be used by two so totally different ideologies for their own purposes. So what we realized – and this really hit Sam – was that they were both liars. The truth, if there is a truth, has to be somewhere else." Accordingly, *Cross of Iron* aims for a universal statement, with ideology having long gone to pieces and drying in the bloody mud tat piled up around the survivors. Instead of cliché Nazis – the arrogant aristocratic officer played by Schell comes close, but is the film's quasi-villain for other reasons – Peckinpah's Germans are simply soldiers (it is worth noting that the film was especially successful in Germany and Austria) caught in front-line crossfire, the impending defeat a given. However, with typical off-beat brilliance, Peckinpah has already established an idea of German duality during the impressive opening credits, by scoring them with "Hänschen klein" and the Horst-Wessel-Lied – Germany's most popular children's song and the most notorious Nazi anthem. Not everything worked as successfully in this production, which constantly threatened to come apart at the seams; the local way of doing things lacked the professional Hollywood standards to which Peckinpah was accustomed, and the German producer repeatedly ran out of funds (Peckinpah once had a suitcase of his own money delivered to keep the gig going).

This may also have added to the nihilist fervor of the whole enterprise. Reportedly, the rather remarkable finale was improvised on the spot in a few hours thanks to the clout of the stars, after Peckinpah broke down when being told to stop filming before his ending was in the can. Originally, Steiner was to blow up himself and his nemesis with a hand grenade; the finished version captures the spirit of this conclusion, but adds a convincing touch of roaring madness: Steiner forces the cowardly Prussian officer to join him in the undoubtedly fatal last stand "where the Iron Crosses grow." In a furious demonstration of Peckinpah's space-time-shattering montage – including a return of the dead – the world is taken to the brink of total collapse, with Steiner's hysterical

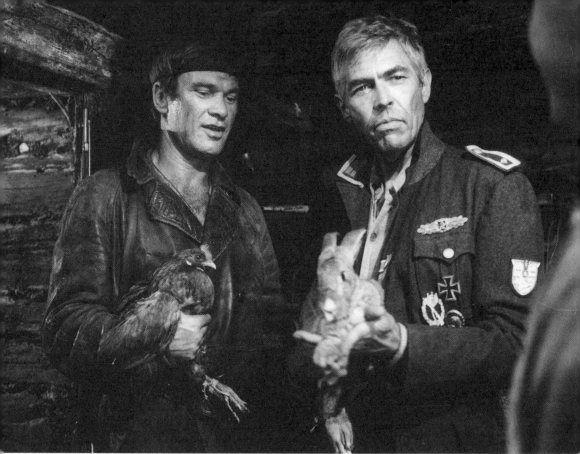

Cross of Iron

laughter (reappearing over the concluding montage of stills of atrocity and beyond) the perfect endnote. This is perhaps the most successful demonstration of Peckinpah's absurdist streak, in a film that for all its ironies is clearly a serious, committed piece of work, full of unsettling turns and unexpected grace notes (as when the Russian woman cries about all this waste, as she dutifully, almost tenderly kills a young German soldier) in its evocation of all-engulfing chaos. Nobody who has ever seen its centerpiece is able to shake it: after being wounded, Steiner enters a hallucinatory state, and the film with him. Strobes flashing and time collapsing, contradictory visions continue throughout his hospital stay, which is crowned by a haunting image of an unsympathetic General's visit; the General dutifully extends his arm to shake a wounded soldier's hand, which turns out to be a stump, as does his other hand when the embarrassed officer goes for that. The soldier finally raises his left foot in a mock salute instead. While most films on the subject fall back on simply illustrating the absurdity of war – a truism that has become a dubious genre stereotype for self-justification, without yielding deeper insights – Peckinpah manages to evoke this notion in passing, condensing it into a single painfully (sur)real scene.

CONVOY

Kris Kristofferson once declared Peckinpah "a songwriter more than anything else", so it seems only just that they made a film together based on a song: C.W. McCall's eponymous CB-fad anthem (rewritten to fit Peckinpah's feature, with the updated lyrics even including some of the film's text denoting time, date and place of action: "ARIZONA (noon), on the 7th of June..."). *Convoy* surely is one of the best features in this distinct category, but not for its direc- tor – for all its pleasures, it shows Peckinpah's struggle to compact his ideas in what remains a proposal for improvisation, trying to smuggle *Wild Bunch* gravitas into the recent trucker-comedy boom (there's even a character named Deke Thornton, and the actor Ernest Borgnine aboard to provide exagger- ated machine-gunning ecstasy for the showdown). Flippant jokes give way to the serious treatment of the *Convoy* rebelliously "trucking through the night" to stick it to the man in general, represented by an unholy suit alliance of politicos and journos, their enforcers a gallery of trucker-hating cop cari- catures. In its joyful, anti-authoritarian destruction of police property and vehicles, *Convoy* even anticipates the juvenile thrill of *The Blues Brothers* (1980), and there may be a hint of self-recognition in Peckinpah's portrait of Rubber Duck, the convoy-leader played by Kristofferson, who announces himself as a man in pursuit of "cheap thrills", but also grudgingly accepts his position as an icon of lofty anarchic ideals, which remain woefully fuzzy in this context, though that may be the point: "The purpose of the Convoy is to keep moving."

Notorious for shooting a lot of footage "with editing in the back of my mind", Peckinpah here simply let the camera run for reels on end in hope of getting nuggets from his actors. In trying to string them together, he ended up with a three-and-a-half-hour cut, walking off disappointed to leave the rest up to the studio. What remains still carries his signature – the action scenes work well, the crazy rhythm is infectious, and many shots of the trucks are nothing short of breathtaking – including an endless nightly procession, a line-up of mighty machines extending to both sides of the road like the gunmen going for the showdown in a western or a slo-mo ballet in the desert. All this is in the service of the preposterous proposal that cowboys of yore have become the steel riders of today, rejecting their manservant duties for outlaw glory – even the tragic finale is played for a joke. The non-sequitur last freeze-frame after the credits shows an old-timer couple in an old-timer kiss – an image that suggests Peckinpah's acceptance that he is out of time. But the urge to raise hell is not completely gone – just the belief in its purpose. The lunatic genius of *Convoy* can be summed up in one dialogue exchange – when Rub- ber Duck is told "They're all following you!", he simply replies: "No, I'm just driving in front of them."

Convoy

THE OSTERMAN WEEKEND

"You want something from me – I want something from you." This proposal of a corrupt deal, repeated almost verbatim from *Convoy*, underlines the cynical but still seditious attitude Peckinpah increasingly adopted throughout his late work, arriving in the Reagan era with *The Osterman Weekend*. As in all films after *Alfredo Garcia*, the storytelling is messy not just by convention-defying standards, and what is commonly regarded as the Peckinpah touch – his unmistakable, time- and speed-shifting style of (action) montage – only surfaces intermittently, such as in a prolonged siege-showdown faintly evoking *Straw Dogs*. Back then, Peckinpah's statement about the necessity of violence – reactionary, but hard-won and not without a measure of ambivalence (it is both liberating and destructive) – could still be anchored in archaic, *real* outskirts of the modern world. By the time of *The Osterman Weekend*, the world has become fake, a mediated brainwashing experience, in which even the murder of one's most beloved is just "another episode in the movie" continuously running on our screens. No wonder the bereaved agent (John Hurt) settles for a bonkers revenge scheme which, like many ingredients from Robert Ludlum's

The Osterman Weekend

novel, doesn't hold up to scrutiny. But what to scrutinize in a universe that is only a video game? Peckinpah's sometimes barely functioning visuals (shot by the great John Coquillon as a kind of antithesis to his work on *Cross of Iron*) deliver their own critique, as does the supremely alienated tone of the entire picture, distilling a decade of resentment into one of those stripped-down examinations of key themes that cap the ending of many great directorial careers.

The distant style does the actors – an impressive ensemble with stars from Burt Lancaster to Dennis Hopper rejoicing at a chance to work with the legendary director – no favors, although the old desperate jitteriness, the primal struggling so characteristic as a primary motivation in Peckinpah, is still in effect, however muted and warped. There is a profound sadness at the core of *The Osterman Weekend*, even as it revives Peckinpah's absurdist approach, which feels better integrated than in *The Killer Elite*, because the whole set-up is so absurd (it turns out to be fake as well, of course). One comedic highlight sees John Hurt's agent caught at the wrong end of his inescapable surveillance system – accidentally visible on a TV monitor to those he otherwise invisibly spies on, he pretends to be a weather newscaster and, remaining unnoticed, really gets into it, enthusiastically garbling on even after he has been "switched off". It's a jokey reversal of the film's nightmare idea that we're always literally on somebody's radar, but it is worth noting that Peckinpah's original cut, which has resurfaced on DVD, had an additional image after Rutger Hauer's investigative TV newsman admonishes the audience to "turn it off": a close-up of the plug being pulled. Even in the released cut, though streamlined, Peckinpah's goodbye seems a gloriously defiant gesture in the face of despair. The other changes made by the producers seem less dramatic this time, despite reducing further scenes in their complexity and eliminating the (test-audience-hated) video distortion Peckinpah used for the opening – ostensible surveillance-cam footage of a murder, yet edited like a conventional feature. The pseudo-hallucinatory video effect looks really weird, but this beginning might have amplified the Brechtian elements of the film, not least its considerations of the manipulation of images (and humans). *The Osterman Weekend* is also is a critical self-examination of Peckinpah, the great director of point of view. The bitterness may show, but Bloody Sam entered his house justified.

CODA

Peckinpah's last work was actually a music video commission in 1984: two modest affairs, centering on performer Julian Lennon in a recording studio as he sings his hits "Valotte" and "Too Late For Goodbyes". When Peckinpah died at the end of that year, it was still much too soon.

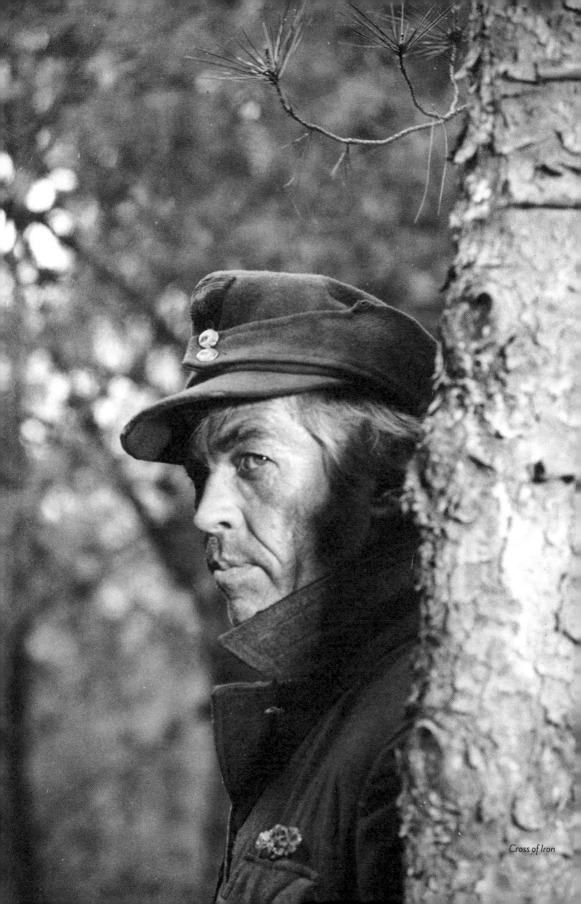

Cross of Iron

1974-1983

FILM SHOOT STORIES

Bring Me the Head of Alfredo Garcia
(1974)

Peckinpah's timetable in Mexico: wake at 4.30 a.m.; prepare for filming; then filming. Except for the days when they didn't film. On those days, the timetable was closer to the following: wake at 4.30 a.m.; try to go back to sleep; fail; take sleeping tablets; try to wake up; fail; a wasted day. In Mexico, the filmmaker styled himself as San (saint) Peckinpah. He became a Mexican; he was weary of the traumatic experience that was *Pat Garrett*, and disillusioned with a country capable of re-electing Nixon. Warren Oates, in the main role, saw that the film was entirely about Peckinpah himself, and that he would have to imitate him directly to create his character. Peckinpah had worked on the story for three years with his friend Fred Kowalski, who he'd fired during filming for *The Ballad of Cable Hogue*, and who once said to the director: "Keep your friends Sam, I hope they'll stick around long enough to carry you to the grave." In addition to Kowalski, the film afforded Peckinpah the opportunity to make amends with another collaborator with whom he was on bad terms: his daughter Sharon. Even better than that, he reconnected with his wife, and also his beloved Emilio Fernández, his Mexican alter ego. He was happy. So much so that he managed to stay sober during the week for the entirety of filming.

The Killer Elite
(1975)

For the sake of being an exile, Peckinpah had planned to film his new film in England, with James Caan. But the actor categorically refused to leave American soil, and the whole script had to be re-written so that it could be filmed in San Francisco. It was Stirling Silliphant, winner of the Oscar for best screenplay for *In the Heat of the Night*, who was given this task. An old student of Bruce Lee, and husband to a Vietnamese woman with a black belt in karate, Silliphant was mad about martial arts: it was he who made the decision to add ninjas to the equation. Peckinpah asked him to get rid of the satirical, even parody-like, tone that, in his opinion, existed in all action films. Silliphant even wanted one of the dead to get up again at the end and share a beer with the survivors, sending everything a bit Brechtian. In short, tensions ran high between the two. The following exchange ensued: "It would be good if we talked, I understand that you have a problem with alcohol..." "Which cocksucker told you that?" "It's enough just to see you drinking right now. And the fact that you're throwing daggers at me makes me believe you want me to understand something. In any case, if you want to attack me, make sure you knock me out with the first blow. I studied with Bruce Lee and if you don't kill me, I'll get up and destroy you – I'll break your nose, I'll wring your neck, and I'll pull out your kidneys." "Wow, you really are full of hostility." In the end, the film was a failure, of which Caan would say: "If Peckinpah hadn't been there, I would never have got involved in that crap." For the director, it was a period in which his drug habit had reached dangerous heights. "They should put his liver in a museum," Caan once said, "When we're all dead, that fucking liver will still be filtering alcohol and inhaling coke."

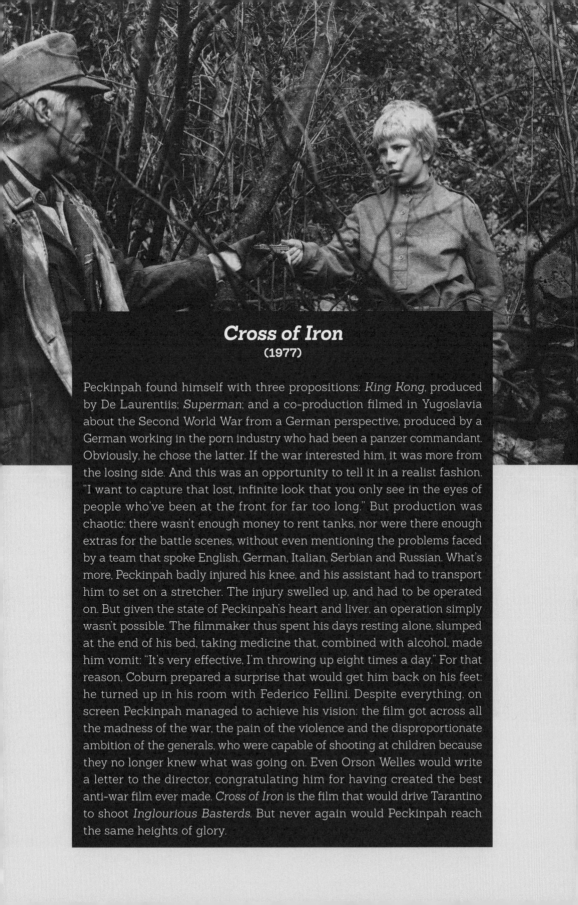

Cross of Iron
(1977)

Peckinpah found himself with three propositions: *King Kong*, produced by De Laurentiis; *Superman*; and a co-production filmed in Yugoslavia about the Second World War from a German perspective, produced by a German working in the porn industry who had been a panzer commandant. Obviously, he chose the latter. If the war interested him, it was more from the losing side. And this was an opportunity to tell it in a realist fashion. "I want to capture that lost, infinite look that you only see in the eyes of people who've been at the front for far too long." But production was chaotic: there wasn't enough money to rent tanks, nor were there enough extras for the battle scenes, without even mentioning the problems faced by a team that spoke English, German, Italian, Serbian and Russian. What's more, Peckinpah badly injured his knee, and his assistant had to transport him to set on a stretcher. The injury swelled up, and had to be operated on. But given the state of Peckinpah's heart and liver, an operation simply wasn't possible. The filmmaker thus spent his days resting alone, slumped at the end of his bed, taking medicine that, combined with alcohol, made him vomit: "It's very effective, I'm throwing up eight times a day." For that reason, Coburn prepared a surprise that would get him back on his feet: he turned up in his room with Federico Fellini. Despite everything, on screen Peckinpah managed to achieve his vision: the film got across all the madness of the war, the pain of the violence and the disproportionate ambition of the generals, who were capable of shooting at children because they no longer knew what was going on. Even Orson Welles would write a letter to the director, congratulating him for having created the best anti-war film ever made. *Cross of Iron* is the film that would drive Tarantino to shoot *Inglourious Basterds*. But never again would Peckinpah reach the same heights of glory.

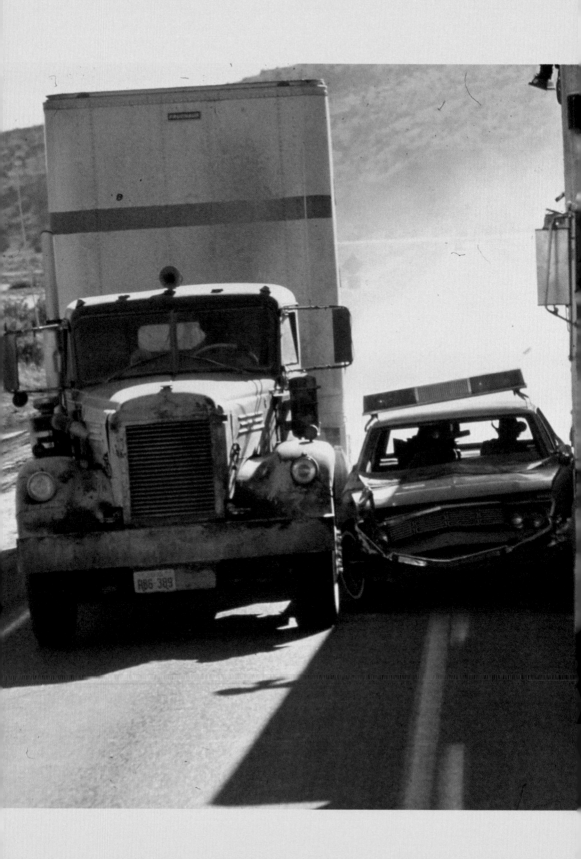

Convoy
(1978)

After a heart-attack, Peckinpah suggested that he film the trucking world in the same way that he'd filmed the West, surrounded by a team he knew: Kristofferson, Ali MacGraw, Ernest Borgnine... But he struggled to find the key to the film, and began to think that it was going to be a failure. He left to conduct research in the middle of filming, recording conversations between drivers, insisting on adding a philosophical tone, and improving the images by using numerous cameras and plenty of film rolls... The film went way beyond its $3 million budget. To film the funeral of one of the drivers, more than three thousand extras and 150 vans had to be ready at 7 a.m. Only Peckinpah was missing, having not yet left his trailer. The team of actors waited for the word "action", but it never came. Ten hours later, everyone was asked to leave. "Don't get angry," was all he said. After a month's interruption, spent in Italy with Monte Hellman and John Huston, Peckinpah returned to film new shots in a desperate attempt to save the film. Then, disillusioned, he embarked on an editing spree. In spite of all this, *The Convoy* would be the greatest success of his career, and all while *Star Wars* was steaming ahead in the box offices.

The Osterman Weekend
(1983)

After five years without filming, a fresh heart attack, a failed project penned by John Milius, and a reunion with Don Siegel, Peckinpah was not in a position to refuse a project. He led the film wearing an oxygen mask to ward off bacteria and fatigue. The lead actors were Rutger Hauer, John Hurt, Burt Lancaster and Dennis Hopper. As for the rest of the cast, it was made up of a band of youths and near-unknowns. Peckinpah presided over the set like a father: kind and attentive. He was weak, pale, and his hands trembled. Writing to his agent, he said: "I'm surrounded by memories, memories of laughter and rage, memories of despair and success, memories of being pushed to always do better, memories of what it means to be a professional." The producers tried to restrict the budget as much as possible, and Peckinpah decided to record all of their meetings in case of the eventuality of a trial. He fought for his film to be seen as a post-Watergate re-reading of *Blow-Up*, and as a treatise on a world where image had become greater than the world itself – an explosion of formats, mediums, and points of view intended to confuse the spectator. At the editing table, he tried to save the last third of the film, but it would all be in vain. One year after *The Osterman Weekend* was released, his heart would give up for good.

By Fernando Gonzo. All film shoot stories translated by Zizzy Lugg-Williams except *The Getaway* by Patricia Bass. All information has been gathered from the books: *Bloody Sam* by Marshall Fine (Donald I. Fine, 1991), *Peckinpah: A Portrait in Montage* by Garner Simmons (University of Texas Press, 1983), *Sam Peckinpah* by Francisco Javier Urkijo (Catedra, 1995), and the documentaries: *Remembering Peckinpah and Other Things, One for the Money: Sam's Song, A Justified Life: Sam Peckinpah and the High Country*, as well as from various contemporary articles and interviews.

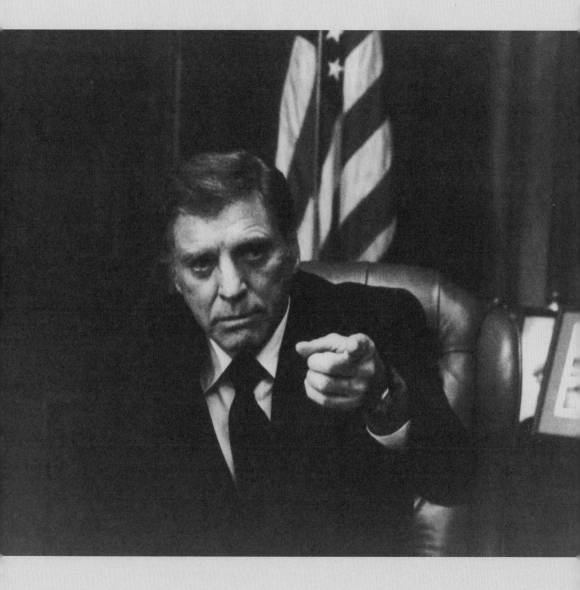

INTERVIEW WITH KRIS KRISTOFFERSON

* * *

BY FERNANDO GANZO

Ex-US Air Force pilot, close friend of Johnny Cash and member of the New Hollywood, the folk musician Kris Kristofferson was one of Sam Peckinpah's greatest friends, and played roles in *Pat Garrett & Billy the Kid* (1973), *Bring Me The Head of Alfredo Garcia* (1974) and *The Convoy* (1978). Here, he remembers the years of music, films and debauchery between Texas and Mexico.

Do you remember the first time you met Peckinpah?

Sam had wanted me to get involved in a project to do with music. But in the end, nothing was finalised until he gave me a role in *Pat Garrett & Billy the Kid.* I wasn't the only musician in the cast: my drummer had a role too, as well as my girlfriend at the time – she was a singer. And of course, Bob Dylan played Alias. I don't think Sam really liked his character, he didn't like *who* Bob Dylan was. Rock stars' lives, their aura – that wasn't his thing. There were some really tense moments. At one point, I went to see Peckinpah and I said to him: "Sam, I know you're a bit annoyed by Dylan, but that guy's the best singer-songwriter on the planet." Little by little, things

calmed down, and they even ended up being good friends. By the end of filming, you'd catch them together, Dylan with his guitar, Sam listening and drinking… On Sam's sets, he was usually drinking. Me, I drank quite a bit. Not always with him, though. Everyone has their vice.

You've worked with Scorsese, Michael Cimino, Dennis Hopper… How was Peckinpah different to the rest?

What stuck with me the most was seeing how he could lose his patience in useless arguments with studios and producers… He hated the people with money who ran the business, so he would get into impossible situations with them. It was getting worse and worse.

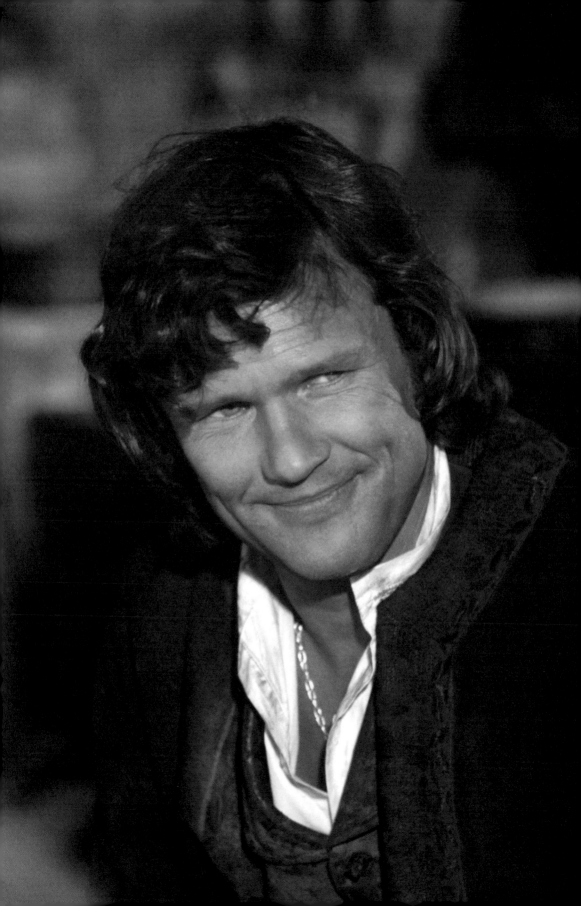

At some points it even started to harm the films. It stalled the whole process. In *Convoy*, everything blew up. The producers didn't want anything to do with him – at one point, they even fired him. I went to go see them and said: "Give the film to Sam, or I'm leaving." The next day, he was back. He came to see me straight away: "You bastard! I'd managed to get out of it!" I said to him: "You're the bastard! You're the one who made me come and be in this thing!" (He laughs). I'd saved him, but obviously he'd never wanted to be saved!

Had he changed much in the years between your first meeting and that last collaboration, six years before his death?

Like many talented people, Sam had the tendency to let himself get consumed by his dark side. He burned too brightly. I'm not in a position to judge though, because I've drunk enormously throughout my life. What we have in common, Sam and me, is a tendency towards self-destruction. Although he was better at self-destruction than me: I'm still here. But it's that urgency, and that desire to burn that make his films so powerful. At one time, he liked to always have a loaded gun on him. When your director is someone unstable and armed, who likes to push the limits, things could very easily get out of hand. I remember one time when he threw a knife in the direction of Harry Dean Stanton – right in the middle of a take as well. He was pretty angry with him. He never would've hurt anyone, but he was a very highly-strung character. His personal emotions, and the emotions he put into his films fed into each other. I loved Sam, but he was his own worst enemy. Cimino, Hopper, they had the same kind of problems, but I'd say that they had more control than Sam did. Scorsese, he was never like that: he's a fantastic creator, but he's not self-destructive.

Mexico left its mark on the both of you...

I love that country. I've just come back from Durango, where I played a few concerts. I was born in Brownsville, in the extreme South of Texas, almost at the border. Crossing the Rio Grande, and arriving back in that country was... I think it comes across in *Pat Garrett & Billy the Kid*. Mexico brought us much closer, Sam and me. I was brought up by a Mexican woman, and he was married to one [Begoña Palacios]... Both of us loved Mexican women, but to tell the truth, we loved all kinds of women. We felt like we were at home there. For us, that country represented something that we had in common: a love of freedom. I've always tried to express that in my creative work: needing to feel free, in order to become the person that you're destined to be. Sam loved music. Often, I'd take my guitar and I'd sing for him. You know that, with Peckinpah and me, it wasn't just a simple friendship. I remember having to look after him a lot of times – especially towards the end of his life.

Did he lose a lot of friends in that period?

I always quote what the boxer Willie Pep once said about the end of his career: "The first thing that leaves you are your legs. Then, it's your reflexes that go. And finally, it's your friends." But not with Sam. He had such a commanding personality that the people who loved him were ready to be there right until the end.

What's your last memory of him?

Him lying in his bath – sick and drunk. I had to go over there with my wife to help him. He couldn't even get out of his own bathtub. But as I say in my song, which I played last night in Durango actually: "You can ask any working girl south of the border/ Sam Peckinpah *era un hombre* for sure." ●

Adapted from French by Zizzy Lugg-Williams.

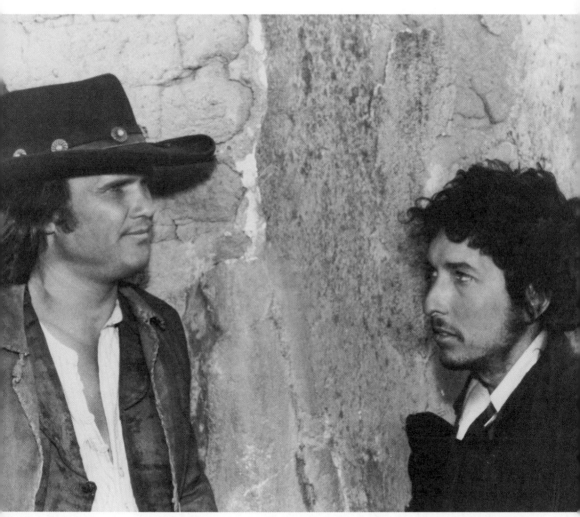

Pat Garrett & Billy the Kid

The Osterman Weekend

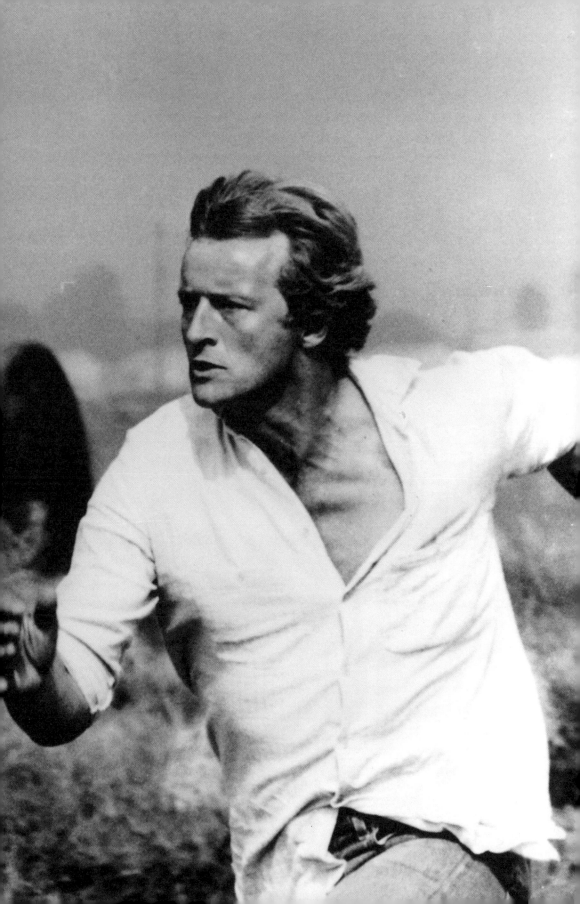

WILD WEST, DOMESTIC GAZE
Sam Peckinpah and television

BY JEAN-FRANÇOIS RAUGER

One of Sam Peckinpah's biographers writes, "if ever a man was in the right place at the right time, it was Sam Peckinpah."[1] Was he? And what were these right places and right times? Those which constructed the man's ever-authentic biographical experience, made in the image of classic, even archaic, Hollywood? Those which opened a new world for him, allowing him to invent a modern age, one in which the myths and narratives of American cinema were profoundly transformed? Television was an ideal vehicle for the young man, a way to warm up and to use the unique aspects of a new medium to invent a style and a way of thinking. His entry into the marines in 1943 and his experience with the end of the war in China (where he was stationed in 1945) may have provided him with a minimum of the "lived authenticity" that characterizes the work of this classic American artist. Not enough experience, however, to prevent the author of *The Wild Bunch* from embellishing the bare bones of his biography with heroic and improbable anecdotes during numerous interviews. Nevertheless, it was doubtlessly sufficient for him not to be later considered as just another gifted student at USC (University of South California), where he showed a certain talent for acting, directing amateur actors, writing, and staging.

American television experienced spectacular growth in the beginning of the 1950s. The new medium began a ruthless war with the film industry. The changing urban landscape gave birth to Eisenhower-era suburban houses, which were far from movie theatres but provided their own domesticized storytelling devices. While he was still a student, Peckinpah was hired as a sort of man-of-all-trades by a small Los Angeles television station, KLAC TV. There, he gained the reputation of being strong-headed, more concerned with screenwriting and theatrical issues than with performing the small tasks for which he had been hired. He managed to convince the station to broadcast the one-act piece *Portrait of a Madonna*, written by Tennessee Williams (1946), that he was supposed to stage for his USC degree. Afterwards, KLAC granted him petty directing tasks but refused his request for a film adaptation of a play written by Jack Garriss, a close friend that Peckinpah had met on the steps of the university. Peckinpah left the small television station.

The following years were devoted to the film industry and to collaborations with the producer Walter Wanger, Allied Artists, and the director Don Siegel. These collaborations led to Peckinpah's non-credited participation in screenwriting and to his short appearances as an actor (*An Annapolis Story, Invasion of the Body Snatchers*).

When Peckinpah returned to television, it had become the first mass media. In 1955, CBS decided to translate a radio series, *Gunsmoke*, for the small

1-David Weddle, *If They Move... Kill Them. The Life and Times of Sam Peckinpah*, Grove Press, 1994, p. 110.

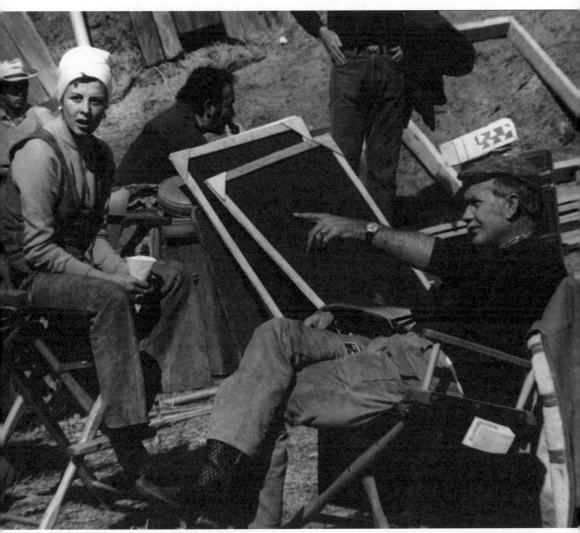

Sam Peckinpah on a film set with Begoña Palacios

Sam Peckinpah (centre) in Invasion of the Body Snatchers by Don Siegel

screen with great success. It was a Western, the most popular television genre of the time. Westerns promised the resilience of a bygone past, a past full of myths of the West, despite the fact that these very tropes were put into question in movie theatres by the films of Anthony Mann, Samuel Fuller, and John Ford, among others. The survival of an out-dated genre via a new medium? Perhaps. In any case, the Western ruled over all television shows. After a period of soap operas of singing cowboys (Gene Autry, Roy Rogers) and Robin Hood characters for children (Hopalong Cassidy) at the end of the 1940s, from 1955, television would allow the genre into the early evening time slot, which demanded a certain – although limited – maturity. The number of Western television shows rose significantly during this period (from seven to thirty between 1956 and 1959). During the 1957–1958 season, four of the five most popular shows were westerns.[2]

WESTERNS AND THE SMALL SCREEN

CBS first asked Don Siegel to produce the show *Gunsmoke*. He declined the offer and the station turned to Charles Marquis Warren (a director also under contract at Allied Artists), who accepted. Siegel had Peckinpah read several of the scripts written for the show in its radio version. Here, Peckinpah saw a thrilling opportunity to adapt the scripts of the show's creator, John Meston, for the small screen. Indeed, Sam Peckinpah would write the screenplays of eleven episodes of *Gunsmoke* between 1955 and 1958. The show focussed on

2-William Boddy, *Fifties Television. The Industry and Its Critics*. University of Illinois Press, 1993.

the character of the sheriff Matt Dillon, played by James Arness[3]. Matt Dillon was responsible for maintaining law and order in the town of Dodge City. Naturally on the side of the good guys and justice, the sheriff incarnated a sort of superego for the inhabitants of Dodge City, who were often intolerant and motivated by their lower instincts. "Stupidity and greed. I buried 'em both out here too many times. But they always show up again," declares the hero's voiceover during the recurring introductory scene filmed in a cemetery for the beginning of the "The Queue". This was the first screenplay written by Peckinpah for the show. Here, the vision of the "civilized West" is troubled, and this sort of latent, worrying pessimism can be detected in many of Peckinpah's *Gunsmoke* episodes. In "Cooter" (1956), Strother Martin (who would later be a part of the group of actors regularly used by the director for films) plays a simple-minded man manipulated by a poker-player, who gives him a gun with the obvious aim of wrecking havoc on the small town. The *Gunsmoke* producers had to soften the violence and pessimism of Peckinpah's screenplays on multiple occasions. The success of the series accelerated the popularity of television westerns and Sam Peckinpah became a screenwriter coveted by producers. The future author of *Pat Garrett & Billy the Kid* wrote certain episodes of the shows *Tales of West Fargo, Have Gun, Will Travel, Tombstone Territory, Man Without a Gun,* and *Broken Arrow.* His first directing gig for the small screen was the last episode of the show *Broken Arrow* in 1958.

Sam Peckinpah was hired by the producers Jules Levy, Arthur Gardner, and Arnold Laven to write a screenplay about Custer that wouldn't be filmed until 1965 under the title of *The Glory Guys,* directed by Arnold Laven. Peckinpah also wrote *The Sharpshooter* for the same producing trio. This story follows a sharpshooter haunted by guilt and remorse for a past cowardice. The producer and director Arnold Laven decided to accompany the hero's story with that of a small boy's, the sharpshooter's son. This became the pilot of a television show titled *The Rifleman* directed by Arnold Laven and centred around the sharpshooter-cum-ranch-owner, dedicated to giving a decent education to his son and characterized by his particular and ruthless skill with a rapid-fire Winchester rifle to eliminate troublemakers (and indeed, the character is defined by a certain interiorized violence). The leading role was played by Chuck Connors, a former baseball player. Sam Peckinpah actively participated in the first season of the show (1958–1959), signing six screenplays altogether. Arnold Laven even offered to let him direct several of the episodes himself. The four episodes of the series that he directed, between 1958 and 1959, constitute the true directorial debut of Sam Peckinpah – if we disregard the less-than-notable episode of *Broken Arrow.* Yet the atmosphere degraded after one year. The producers wanted the show to maintain appeal for families and

3-John Wayne was contacted to play this character, but he refused and suggested that NBC employ his friend James Arness.

they were frequently frightened by the ambiguous situations, violent scripts, nearly-insane protagonists, and other characters and events imagined by Sam Peckinpah. For Peckinpah, these producers prevented Johnny Crawford (who played the son of the hero) from ever growing up. "They refused to let it be the story of a boy who grows to manhood learning what it's all about."[4] Furthermore, Laven criticized the amount of time it took Peckinpah to finish his film shoots, notably when he performed complex camera movements, causing delays incompatible with the tight budget of the television show. Peckinpah quit the show and was then hired by Dick Powell, actor turned television producer, and his company Four Stars production to write and direct several episodes of *Zane Grey Theater*, a show comprised of independent narratives (for each episode), without recurring characters. Peckinpah wrote four episodes and directed three, establishing his own particular style and tone even more than he had done in *The Rifleman*.

"Trouble at Tres Cruces", broadcast as a part of *Zane Grey Theater*, would be the pilot of *The Westerner*, a show truly created by Peckinpah, its producer. It followed an errant cowboy (a "saddle tramp"), Dave Blassingame, played by Brian Keith, who was accompanied by his dog Brown. The first episode was broadcast on September 30th 1960, and the show made yet another step towards the sombre maturity of Peckinpah. The main character was not a superman but a vagabond of the West, often confronted with less than heroic situations. Peckinpah notably hired his former USC comrade Jack Gariss as a screenwriter, as well as Bruce Geller, who he had met during the production of *The Riflemen*. The quality of the show attracted talented collaborators from the film industry such as cinematographer Lucien Ballard. Tom Gries, Ted Post and Elliot Silverstein would also sign on as directors of certain episodes. The show only lasted several months, however, totalling a mere thirteen episodes. Robert Kintner, who was at the head of NBC, which broadcast *The Westerner*, did not appreciate the show and did his best to sabotage its run by placing it in a disadvantageous time slot and refusing to publicize it. The number of spectators was not sufficient and *The Westerner* was cancelled in the winter of 1960. Furthermore, during this period, television Westerns experienced a significant decline. As the genre lost popularity, the number of western shows diminished in the beginning of the 1960s.

Of course, when the number of television Westerns increased, television was doing no more than responding to the demands of the popular public, and more specifically, to a public represented by the Midwest: this population demonstrated an attachment to certain myths that the movies sometimes troubled and complicated. The presumed naiveté of the equivalent of "B movies" found an outlet on the small screen.

4-David Weddle. Op cit. p. 168.

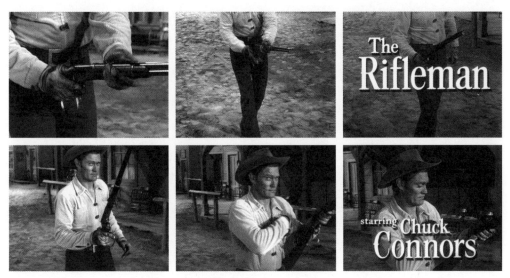

The Rifleman

The Westerner

It is doubtlessly necessary to remain aware of the radical difference between Western movies and their television equivalent. The technological developments and monumentalizing techniques used in the film industry (notably in order to battle against new competition from the younger emerging medium) radically changed Western films, as did the changing public that "became jaded" in the 1950s. The big screen, colour[5], and also the psychological complexity and the attraction of a greater realism created a taste for real landscapes and for nature as a crushing force that we find in the films of Anthony Mann, in neurotic characters (Mann, Ray, Fuller, Dmytryk) or in the mineralization of the human silhouette in the films of Bud Boetticher. The television western runs counter to these developments, both in form and in content. Condemned to black and white and determined by a skeletal budget, television westerns avoid wide natural spaces and must be filmed in studios. Therefore, in television, realism is replaced with abstraction both because of television's more primitive vision and their (modern) formal innovations. American television thus produces, with Westerns, *morality plays*. These moralizing fables or lessons delivered over twenty-four minutes were explicitly introduced during a presentation, given by either the producer or a famous actor, who announced the take-away moral at the start of the episode. *Gunsmoke* is a prime example of this format, since it is structured by the narrator's voice-over, which analyses the events shown. Of course certain figures, like Alfred Hitchcock in his show *Alfred Hitchock Presents*, aim to subvert this format to reverse the ideology. In a certain way, Peckinpah also manages to relativize the idea of an immanent moral suspended above the narratives of the far West – albeit sometimes with great difficulty and only implicitly. The stories and episodes that Peckinpah wrote are distinguishable by the subtle or explicit destruction of the eschatology of "how the West was won". From this moment on, Peckinpah's work focussed less on the conflict between savagery and civilisation than on the permanent savagery in the heart of civilisation itself, a savagery beyond all possible morals. Yet his television episodes (particularly those during and after *The Westerner*) functioned not only through the description of the western hero (or antihero)'s pathological deviance, but also through the suspension, or quasi-burlesque relaxation, of the tension created by the (always-central) question of domesticating an oft-irrepressible violence. Otherwise said, and in more Deleuzian terms, these episodes demonstrate a sort of precocious relaxation of the "sensory-motor links". The thirteen episodes of *The Westerner* also distance themselves from the conventions of the genre. Sometimes not a single shot would be fired, and the fundamental narrative of the social repression of primitive violence would be substituted by picturesque digressions: the two leading men, Dave Blassingame and Burgundy Smith – an elegant crook with a gift with words – would

5-See, for example, the trouble that John Ford had convincing Paramount to film *The Man who shot Liberty Valance* in black and white.

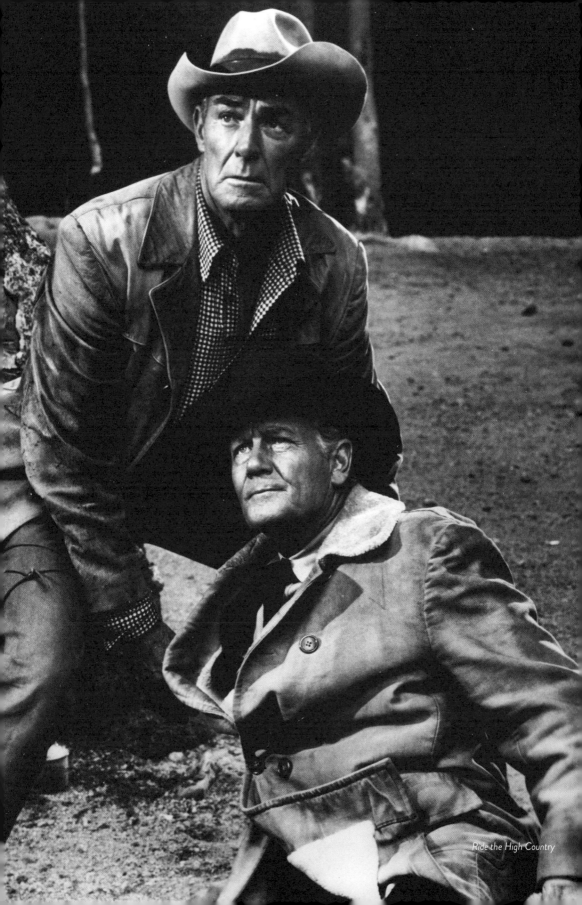

Ride the High Country

contend with one another to court the same woman ("The Courting of Libby", "The Painting") or master a dog ("Brown"), which presaged the sort of (fake) nonchalance of *Cable Hogue*. Given that Peckinpah's film work was (and is, even in this present book) abundantly analysed before his television work, one is obviously tempted to look for signs of his films to come in his television episodes, at the risk, of course, of falling into a teleology. It is doubtlessly Peckinpah's unique style and thought which radically distinguishes his episodes from the dominant television ideology of the time.

A PATHOLOGY OF
THE WEST

The sheriff of Dodge City, Matt Dillon (*Gunsmoke*), the sharp-shooter Lukas McClain of Fort Worth (*The Rifleman*), and, to a lesser degree, the errant cowboy of *The Westerner* all represent a type of superego dedicated to repressing, sometimes even with violence[6], the brutal instincts and prejudices of the town's inhabitants or travellers who disturb the uncertain peace. Their adversaries include individuals who exhibit not only greed and intolerance but true psychological degeneration – an allegory of an "American West" wiped clear of all idealism. The pathology that so characterizes Peckinpah's film characters, like the Hammond brothers in *Ride the High Country* and some protagonists from *The Wild Bunch* (whether they're on the side of the law or the outlaws, bounty hunters or bandits), might have originated in some of Peckinpah's television characters. Already "Cooter", the episode of *Gunsmoke* that was written by Peckinpah and directed by Robert Stevenson, showed, as mentioned above, a simple-minded man armed with a gun. Moreover, the antagonists portrayed by Warren Oates and Robert J. Wilke in "The Marshal" (an episode of *The Rifleman*) are not only destructive but self-destructive forces, and they regularly sack the saloon – a recurring gag and senseless expenditure of violence. Manipulated by the cynical and cold character played by James Drury, these two can be seen as the embryo of organic destruction. In "The Baby Sitter" (*The Rifleman*), a bigot chases after his wife, a saloon singer, to savagely whip her. "Lonesome Road" (*Zane Grey Theater*) shows a sheriff with all the symptoms of paranoia, while other characters, like the young greenhorn obsessed with gun tricks in "Hand on the Gun" (*The Westerner*), are led to their downfall by their own violent instincts. In "Miss Jenny" (*Zane Grey Theater*), a psychopath kidnaps a young woman (Vera Miles) after having murdered her husband, with the obsessional aim of marrying her. The West that Peckinpah represented on television is thus riddled with

6-*Gunsmoke*'s expositionary scenes all take place in a cemetery where we can only imagine how our hero's sharp-shooting skills have multiplied the graves.

"The Marshal"

"Lonesome Road"

"Miss Jenny"

instances of insanity that often break with the expectations made for what was supposed to be family entertainment. In his television episodes, chaos was represented as a pure autonomous force that threatened order and, later, in his films, even the idea of a historical determinism would be put into question – the very historicism of the West.

Often, as the title of *The Wild Bunch* implies, the difference between the adversaries, with the men of the law or protectors of civilisation on one side and the outlaws or brutal ne'er-do-wells on the other, was no longer perceivable as a distinct binary. Starting in his television episodes, the idea of an eventual role reversal or a potential confusion between good and evil insidiously imposed itself. At the end of "Trouble at Tres Cruces", it even seemed that the two mortal enemies (Dave Blassingame and the sadistic killer nicknamed "the Greek" played by Neville Brand) could have been brothers in arms, a potentially virile fusion that troubles the Manichaeism of television westerns.

MASOCHISM AND VIOLENCE

The first episode of *The Westerner* ("Jeff") is doubtlessly one of the strongest pieces of Peckinpah's television work. An extremely stark piece, the episode is almost a stifling and smoky huis-clos because the action takes place primarily in two spaces – a miniscule saloon and adjacent bedroom. It shows how Dave Blassingame, the errant cowboy, tries to win back the woman he loves, Jeff, who has become a saloon prostitute under the control of an ex-prize-fighter pimp. The pimp asserts his domination over her with a combination of humiliation and affection, promises and slaps. Blassingame seems to represent a second chance for the young woman – the possibility to restart her life far from the bad reputation in which she is entrenched. Therefore "Jeff" must be seen as a series of challenges which, in several minutes (the narrative is practically in real-time), the hero must overcome to win the woman and attain a form of salvation. The episode facilitates this point of view when it shows the hero arriving in the small town, where he is addressed by a talented palm-reader who asks if he is searching for salvation. The following events take place as if he was running a gauntlet (he must kill the dishonest Indian barman, for example) while risking death by the ex-boxer if he doesn't decide to use, *in extremis*, his gun – normally prohibited by the rules of the game. Against all expectations, the pimp accepts that Blassingame leaves with the young woman, with a mix of weariness and troubling indifference, but doubtlessly also with a consciousness of Jeff's true state of mind. The decision of the "bad guy" – and more specifically, its underlying cause so at odds with the pugnacity characteristic of his previous behaviour – mirrors

the strange detachment of the main characters in *The Wild Bunch*, as well as the lack of anxiety about their ability to reach their final goal that we find in the characters of *Pat Garret & Billy the Kid*. But the most surprising is to come. The young woman refuses to follow Blassingame, resigning herself to her formerly established fate as a prostitute, making the efforts and obstacles of the hero worthless. By accepting her place, Jeff overturns the idea of a clear relationship between men and women in narratives where gender roles are otherwise so established and straightforward. Here, Peckinpah introduces a radically masochistic dimension that could even be considered novel. The interactions of men and women are constructed both on violence and on the affirmation of a shameful enjoyment nourished by brutality itself. As we now know, this would also become one of the central themes of *Straw Dogs* and one of the questions provoked by a scene in *Bring Me the Head of Alfredo Garcia*. Furthermore, this narrative is mirrored by the episode "Miss Jenny" (*Zane Grey Theater*) in which a stranger threatens a pioneer couple out camping and tries to steal the woman from her husband in hopes of marrying her himself. This scene, with its underlying threat of rape, seems to predict the interaction between Bennie (Warren Oates) and Elita (Isela Vega) with motorcyclists in *Bring Me the Head of Alfredo Garcia*. "Women ain't built to know what they want," declares the stranger, "They need a strong man to teach them." Here, the suspense is strangely tempered by the fact that everything indicates that the young woman isn't, in any case, very happy with her husband, a stern and alcoholic man. Peckinpah clearly affirmed the idea that male-female interactions were not self-evident in his television work. This idea would later structure and determine a certain way that American cinema entered the modern age and is evident even in the director's first works for the small screen. In Peckinpah's representations, the woman is either out of reach ("The Courting of Libby"), promised to another, or lost ("Jeff"), even if one episode does address the difficult reinsertion of a former prostitute in a small Western town where intolerance and puritan prejudice still reign (Katy Jurado in "The Boarding House", an episode of *The Rifleman*). In "Jeff", it is the male character who is masochistic, as he is physically beaten and prisoner of an "inherited" idealized image which leads him to fabricate an absolute femininity ("My Dad used to tell me that women must be God's favourites, cause He made them finer than anything else in Creation"), although after his experience, he turns this into a derisive joke. A not only radical but "unsaveable" alterity is created, be it via fantasy or tragedy, which declines in Peckinpah's film work, where the interactions between the sexes are only constructed on violence, profit, and, above all – for the men – on what could only be considered the unknowable.

Bring Me the Head of Alfredo Garcia

TELEVISION AFTER
THE WESTERN

Thanks to Brian Keith, Sam Peckinpah was hired to direct a film. This would be his first feature-length piece, *New Mexico*, and the film shoot in January of 1961 would be riddled with tensions between the director and his producer, Charles Fitzsimons, who was also the brother of the leading lady, Maureen O'Hara. Next came *Ride the High Country* in 1962, which firmly established Peckinpah as a new talent in American cinema. Yet Peckinpah would not abandon television. In television, the time of the Western had passed, as had that of the twenty-four minute episode. From hereon out, Peckinpah would film longer pieces of around fifty minutes each as if to take an episodic break in the middle of his quickly-chaotic film career. These include "Mon Petit Chou" for the show *Route 66* in 1961, "Pericles on 31 Street" and "The Losers" for the *Dick Powell Show* in 1962 and 1963. Later, he made "Noon Wine" for *ABC Stage 67* in 1966 and "The Lady is My Wife" for *Bob Hope presents the Chrysler Theater* in 1967. These were stand-alone episodes without recurring characters, and three of them ("Mon petit Chou", "The Losers", "Noon Wine") number among the director's most successful. "Pericles on 31st Street" is the story of a poor peanut vendor from Greece who is snubbed by all but children until he manages to mobilize his neighbours against their half-demagogue, half-shark landlord. The film is a minor work and a bit too moralizing, but it is worthwhile for a strange moment when the hero, played by Theodore Bikel, describes the Greek origins of democracy as a persuasive argument.

The two episodes in which Lee Marvin stars are, on the other hand, small masterpieces. Broadcast on November 24th 1961, "Mon Petit Chou" is the story of a sentimental break-up. Filmed in Pittsburgh, the episode follows a young French cabaret singer (Macha Méril) who meets a young American sailor, Tod, and breaks up with the man who is simultaneously her lover, manager, and pianist, Ryan. The latter, played by Lee Marvin, seems to hide a profound melancholy behind his cynical and tough outward appearance. In the hesitations of the young woman who is simultaneously attached to Ryan and attracted to Tod, we can indeed find this neurotic tendency to look for a form of pleasure in macho domination, a tendency already explored in the episode "Jeff" of *The Westerner*. In two dialogue scenes, filmed with an exemplary precision, Peckinpah manages to express the sadness of the signs of a relationship dying by showing Macha Méril and Lee Marvin in the centre of a set in which all the elements (a door, a wooden grate) seem to determine or objectify the feelings of the protagonists. The dialogues are surprisingly poetic and precise, notably when Perrette (Macha Méril) evokes the age difference of the two lovers: "My mother used to say to me: a man is young as long as a woman can make him happy or unhappy. He is middle-aged if she can make

"Mon petit chou"

"The Losers"

him only happy". "The Losers", broadcast on January 15th 1963, shows two crooks, poker players, played by Lee Marvin and Keenan Wynn. The two characters are named Dave Blassingame and Burgundy Smith, like the protagonists of *The Westerner*, as if Sam Peckinpah had wanted to continue the picturesque saga of the television show by updating it in a new genre. Chased by Texans (led by Mike Mazurski) that they had swindled in a card game, Blassingame and Smith take refuge in a country farm. At the farm, they befriend a blind travelling musician and a young woman (played by singer Rosemary Clooney) who is mistreated by her father, a bigoted farmer. The episode culminates in a particularly moving scene where Rosemary Clooney sings a gospel before the two protagonists, who the Texan creditors have finally found, take to the road once again. The film could have been the basis of a new show with recurring characters, but it remained a stand-alone performance. Strongly tinged with burlesque (the "comic chase" is a recurring theme), "The Losers" is reminiscent of the late-career works of other great directors (*Hatari!* [1962] by Howard Hawks, *Donovan's Reef* [1963] by John Ford) from whom Peckinpah borrows a sort of fake light-heartedness. The film shows nostalgia for a primitive universe, which the two protagonists accidentally pass through, and the sadness of returning to an original and redeeming rural world which the contemporary age has made impossible. Like the aging cowboys of Peckinpah's feature-length works, Blassingame and Smith are like two children who want to continue playing even as modernity progressively sweeps away all possibility for them to do so. These figures presage later

characters developed by the author of *Ride the High Country* (released in the UK as *Guns in the Afternoon*) and, above all, his way of conceptualizing History. In "The Losers", the director uses slow motion for the first time, making it seem as if the main characters are floating during a high-speed chase, plunging the film into a dream-like stealth. The dream of childhood innocence disappears.

In "Noon Wine", this rural and childlike world is no longer a mnemic refuge. In 1966, young television producer Daniel Melnick, in search of quality programming, contacted Sam Peckinpah for the adaptation of a short story by Katherine Anne Porter, an important figure in Texan literature. Peckinpah's task was adapting her story, "Noon Wine", into an episode for the show *ABC Stage 67*, which would be filmed in video. The story follows a poor farmer, Royal Earle Thompson (Jason Robards), who hires and subsequently underpays a strange young man with a Scandinavian accent, Olaf Helton (Per Oscarsson). This strange young harmonica-player who seems to have appeared out of nowhere helps with the farm and eventually becomes a part of the family. Indeed, through his work, he even allows the ranch to prosper a bit. One day, a detective arrives and declares that the new farmhand is none other than a criminally-insane man who the police have been chasing for having attempted to kill his own brother. Trying to prevent Olaf's arrest, Thompson accidentally kills the detective and causes the young man – now accused of the detective's murder and hunted by the police – to take flight. A series of misunderstandings and unfortunate events follow, in which bad luck, guilt, and lies finally lead to murder and suicide. In this short, tragic tale, rural America no longer appears as the poor world of an untouched virgin past. It is a space that is criss-crossed with doubt, insanity, and despair, traits immanent in the human sort, inherent in History itself. Instead of original innocence, we find here a constant threat. For example, a scene where the young stranger is seen enraged at the family's children – children who are, in any case, cruel little brats who broke his harmonica – may lead one to question whether the stranger really is criminally insane. Yet this threat is tempered by priceless moments of sweetness. Indeed, the film contains certain moments of respite and familial harmony that intensify the pain of the tragedy to come. A certain feeling of absurdity reigns over "Noon Wine", as if it is a fatal and senseless chain of cause and effect. Later, the film was elected as one of the best television adaptations by the Writer's Guild and the Director's Guild, and Peckinpah himself considered it as one of his best. It would be unjust to dismiss Peckinpah's television work as a confused and unfinished workshopping of his films to come.

Translated from French by Patricia Bass.

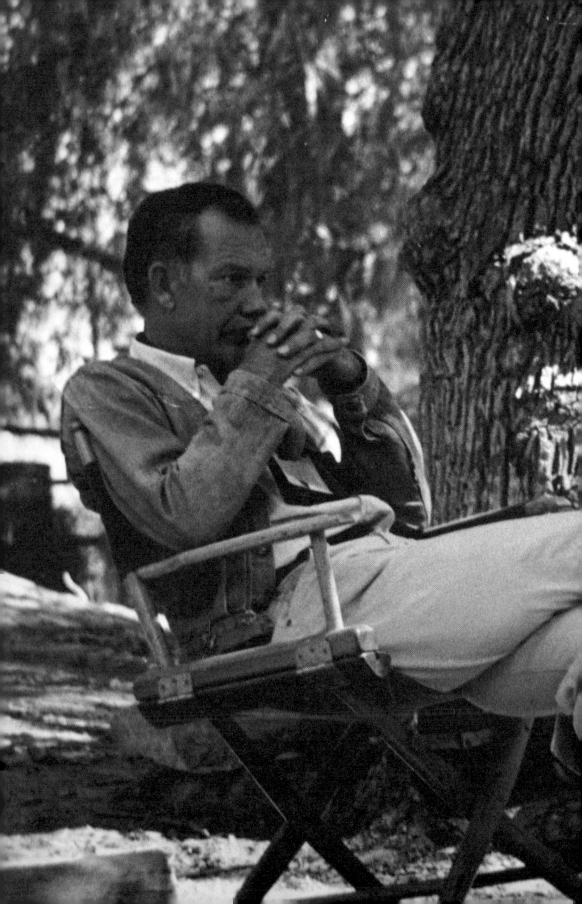

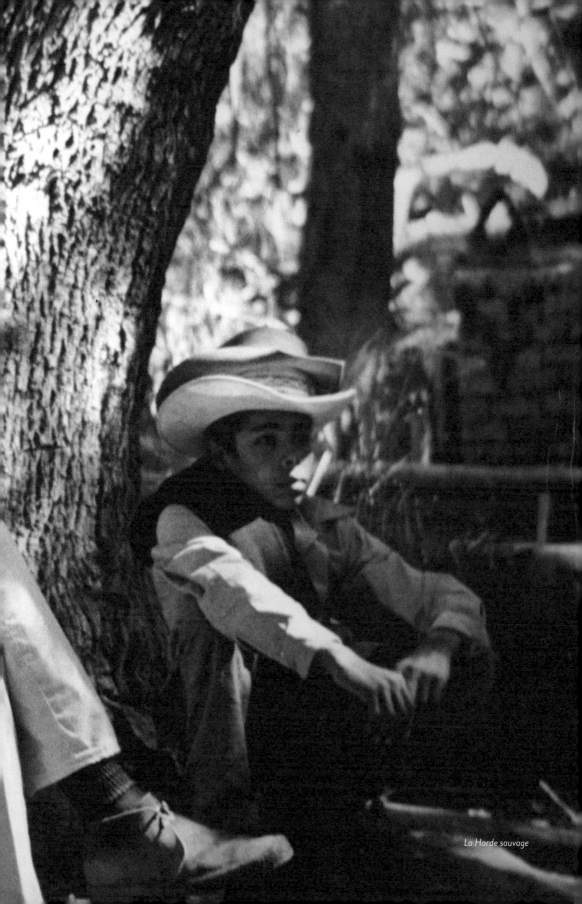

La Horde sauvage

CONTRIBUTING AUTHORS

Emmanuel Burdeau is a film critic. Publisher at the publishing house Prairies Ordinaires, he is also a contributing writer for *Mediapart*, *Trafic*, *Magazine Littéraire* and *ArtPress*. At Capricci, where he is the literary director, he has published books of interviews with figures such as Wernr Herzog, Judd Apatow, and Monte Hellman, and collections of essays such as *La Passion de Tony Soprano* and Vincente Minnelli. More recently, he has written *Comédie américaine, années 2000* (Prairies Ordinaires).

Carlo Chatrian is a writer, journalist, and film programmer. Since 2013, he has been the director of the Festival del Film Locarno.

Maroussia Dubreuil contributes to the magazine *Sofilm*, and, since 2012, regularly participates in the show "Le Cercle" on the television channel Canal+ Cinéma. With Alexandre Zeff, she codirected the documentary *Rencontres* (April 2014), and she has also contributed to the curation of two exhibitions on cinema (at the Hôtel de Ville in Paris and at the Cinémathèque française). She has acted in films directed by Alain Chabat, Jean-Claude Brisseau, and the Larrieu brothers. She is currently writing a book on fashion and cinema.

Chris Fujiwara is a film critic and film programmer. He has written books on Jerry Lewis, Otto Preminger, and Jacques Tourneur and has lectured on film aesthetics and film history at Tokyo University, Yale University, and elsewhere. From 2012 to 2014, he was Artistic Director of the Edinburgh International Film Festival.

Fernando Ganzo is the co-editor in chief of the magazine *Sofilm*. After much experience in the Basque country where he taught stage direction, he founded the journal *Lumière* in 2008. Since then, he has contributed to *Trafic*, *Cahiers du cinéma España* and *Comparative Cinema*, as well as to shows for the television channel Canal+ Cinéma. In 2013, he published the essay collection *George Cukor: On/Off Hollywood* for Capprici.

Christoph Huber is a Curator in the Program Department of the Austrian Film Museum. He was the main film critic of the Austrian daily *Die Presse* for over a decade and has published many articles for different publications, notably as a long-time contributing editor for the Canadian magazine *Cinema Scope*.

Jean-François Rauger is head of programming at the Cinémathèque française and regularly contributes to the newspaper *Le Monde*.

FILMOGRAPHY

1961

THE DEADLY COMPANIONS

Screenplay: Albert Sydney
Fleischman, based on his own
novel.
Producer: Charles B. Fitzsimons.
Production Company: Carousel
Productions.
Cast: Maureen O'Hara (Kit Tildon),
Brian Keith (Yellowleg), Steve
Cochran (Billy Keplinger), Chill
Wills (Turk).
Length: 1 h 33.
Released in the United States:
6 June 1961.

1962

RIDE THE HIGH COUNTRY

Screenplay: N.B. Stone Jr.
Producer: Richard E. Lyons.
Production Company: MGM.
Interprétation : Randolph Scott
(Gil Westrum), Joel McCrea (Steve
Judd), Mariette Hartley (Elsa
Knudsen), Ron Starr (Heck Todd
Longtree).
Length: 1 h 34
Released in the United States:
10 October 1962

1965

MAJOR DUNDEE

Screenplay: Harry Julian Fink,
Oscar Saul and Sam Peckinpah,
based on a story by Harry Julian
Fink.
Producer: Jerry Bresler.
Production Company: Colombia
Pictures.
Cast: Charlton Heston (Major Amos
Dundee), Richard Harris (Capitaine
Benjamin Tyreen), James Coburn
(Samuel Potts), Senta Berger
(Teresa Santiago).
Length: 2 h 03
Released in the United States:
7 April 1965

1969

THE WILD BUNCH

Screenplay: Walon Green and Sam
Peckinpah, based on a story by
Walon Green and Roy N. Sickner.
Producer: Phil Feldman.
Production Companies: Warner
Bros.- Seven Arts.
Cast: William Holden (Pike Bishop),
Ernest Borgnine (Dutch Engstrom),
Robert Ryan (Deke Thornton),
Edmond O'Brien (Freddie Sykes).
Length: 2 h 25.
Released in the United States:
18 June 1969.

1970

THE BALLAD OF CABLE HOGUE

Screenplay: John Crawford and
Edmund Penney.
Producer: Sam Peckinpah.
Production Company: Warner Bros.
Cast: Jason Robards (Cable
Hogue), Stella Stevens (Hildy),
David Warner (Joshua Sloane),
Strother Martin (Bowen).
Length: 2 h 01.
Released in the United States:
13 May 1970.

1971

STRAW DOGS

Screenplay: Sam Peckinpah and
David Zelag Goodman, based
on a novel by Gordon Williams,
The Siege of Trencher's Farm.
Producer: Daniel Melnick.
Production Companies: ABC
Pictures, Talent Associates,
Amerbroco.
Cast: Dustin Hoffman (David
Sumner), Susan George (Amy),
Peter Vaughan (Tom Hedden), Del
Henney (Charlie Venner).
Length: 1 h 53.
Released in the United States:
22 December 1971.

1972

JUNIOR BONNER

Screenplay: Jeb Rosebrook.
Producer: Joe Wizan.
Production Companies: ABC, Solar
Productions, Joe Wizan-Booth
Gardner Productions.
Cast: Steve McQueen (Junior
Bonner), Robert Preston (Ace
Bonner), Ida Lupino (Elvira
Bonner), Ben Johnson (Buck Roan).
Length: 1 h 43.
Released in the United States:
2 August 1972.

1972

THE GETAWAY

Screenplay: Walter Hill, based
on a novel by Jim Thompson:
The Getaway.
Producers: Mitchell Brower
and David Foster.
Production Companies: First

Artists, Solar Productions, Foster-Brower Productions.
Cast: Steve McQueen ("Doc" McCoy), Ali MacGraw (Carol McCoy), Ben Johnson (Jack Beynon), Sally Struthers (Fran Clinton).
Length: 2 h 02
Released in the United States: 13 December 1972.

1973

PAT GARRETT & BILLY THE KID

Screenplay: Rudy Wurlitzer.
Producer: Gordon Carroll.
Production Company: MGM.
Cast: James Coburn (Pat Garrett), Kris Kristofferson (Billy le Kid), Jason Robards (le gouverneur Lew Wallace), Bob Dylan (Alias).
Length: 1 h 46.
Released in the United States: 23 May 1973.

1974

BRING ME THE HEAD OF ALFREDO GARCIA

Screenplay: Gordon T. Dawson, Sam Peckinpah, based on a story by Frank Kowalski and Sam Peckinpah.
Producer: Martin Baum.
Production Companies: Estudios Churubusco Azteca S.A., Optimus Films.
Cast: Warren Oates (Bennie), Isela Vega (Élita), Robert Webber (Sappensly), Gig Young (Quill).
Length: 1 h 52.
Released in the United States: 14 August 1974.

1975

THE KILLER ELITE

Screenplay: Marc Norman and Stirling Silliphant based on a novel by Robert Syd Hopkins under the name of Robert Rostand: *Monkey in the Middle*.
Producers: Martin Baum and Arthur Lewis.
Production Companies: Exeter Associates, Persky-Bright Productions, Arthur Lewis Productions, Baum/Dantine Productions.
Cast: James Caan (Mike Locken), Robert Duvall (George Hansen), Arthur Hill (Cap Collis), Bo Hopkins (Jérôme Miller).
Length: 2 h 02.
Released in the United States: 19 December 1975.

1977

CROSS OF IRON

Screenplay: Julius J. Epstein, James Hamilton and Walter Kelley, based on the work of Willi Heinrich.
Producer: Wolf C. Hartwig.
Production Companies: Anglo-EMI Productions Ltd., Rapid Film, Terra-Filmkunst.
Cast: James Coburn (Sergent Rolf Steiner), Maximilian Schell (Capitaine Stransky), James Mason (Colonel Brandt), David Warner (Capitaine Kiesel).
Length: 2 h 12 / 1 h 59 (U.S.A.).
Released in the United States: 11 May 1977.

1978

CONVOY

Screenplay: Bill L. Norton, based on the song "Convoy", lyrics by C. W. McCall and music de Chip Davis, performed by C. W. McCall.
Producer: Robert M. Sherman.
Production Company: EMI Films.
Cast: Kris Kristofferson (Martin "Rubber Duck" Penwald), Ali MacGraw (Melissa), Ernest Borgnine (Sherif Lyle "Cottonmouth" Wallace), Burt Young (Bobby "Love Machine").
Length: 1 h 50.
Released in the United States: 28 June 1978.

1983

THE OSTERMAN WEEKEND

Screenplay: Alan Sharp and Ian Masters, based on a novel by Robert Ludlum.
Producers: Peter S. Davis and William N. Panzer.
Production Company: Davis-Panzer production.
Cast: Rutger Hauer (John Tanner), John Hurt (Lawrence Fassett), Craig T. Nelson (Bernard Osterman), Dennis Hopper (Richard Tremayne).
Length: 1 h 42.
Released in the United States: 14 October 1983.

TELEVISION

Here, we address the television shows and made-for-television films directed by Sam Peckinpah, and not those for which he acted merely as screenwriter or producer.

1958

BROKEN ARROW

Episode "The Transfer"
Screenplay: Sam Peckinpah, based on a novel by Elliott Arnold: *Blood Brothers*.
Producer: Mel Epstein.
Production Company: 20th Century Fox Television.
Cast: John Lupton (Tom Jeffords), Michael Ansara (Cochise), Regis Toomey (Thomas Bouchet).
Length: 30 min.
Released in the United States: 24 June 1958 on ABC (American Broadcasting Company).

1958-1959

THE RIFLEMAN

Episode "The Marshal" (1958)
Screenplay: Jack Garris and Sam Peckinpah.
Producers: Athur Gardner and Jules V. Levy.
Production Companies: Four Star Productions, Levy-Gardner-Leven, Sussex Productions.
Cast: Chuck Connors (Lucas McCain), Johnny Crawford (Mark McCain), Paul Fix (Marshal Micah Torrance), James Drury (Lloyd Carpenter).
Length: 30 min.
Released in the United States; 21 October 1958 on ABC.

Episode "The Boarding House" (1959)
Screenplay: Sam Peckinpah.
Producers: Athur Gardner and Jules V. Levy.
Production Companies: Four Star Productions, Levy-Gardner-Leven, Sussex Productions.
Interprétation : Chuck Connors (Lucas McCain), Johnny Crawford (Mark McCain), Paul Fix (Marshal Micah Torrance), Alan Baxter (Sid Fallon).
Length: 30 min.
Released in the United States: 24 February 1959 on ABC.

Episode "The Money Gun" (1959)
Screenplay: Bruce Geller and Sam Peckinpah.
Producers: Athur Gardner and Jules V. Levy.
Production Companies: Four Star Productions, Levy-Gardner-Leven, Sussex Productions.
Cast: Chuck Connors (Lucas McCain), Johnny Crawford (Mark McCain), Paul Fix (Marshal Micah Torrance), John Dehner (Tom King).
Length: 30 min.
Released in the United States: 12 May 1959 on ABC.

Episode "The Baby Sitter" (1959)
Screenplay: Sam Peckinpah and Jack Curtis.
Producers: Athur Gardner, Arnold Laven, Jules V. Levy and Arthur H. Nadel.
Production Companies: Four Star Productions, Sussex Productions.
Cast: Chuck Connors (Lucas McCain), Johnny Crawford (Mark McCain), Paul Fix (Marshal Micah Torrance), Lillian Bronson (Elizabeth Favor).
Length: 30 min.
Released in the United States: 15 December 1959 on ABC.

1959-1960

ZANE GREY THEATER

Episode "Trouble at Tres Cruces" (1959)
Screenplay: Sam Peckinpah.
Producer: Hal Hudson.
Production Companies: Four Stars Productions, Pamric Productions, Zane Grey Enterprises.
Cast: Brian Keith (Dave Blassingame), Nelville Brand (Nick Karafus), Frank Silveira (Ysidro).
Length: 30 min.
Released in the United States: 26 March 1959 on CBS (Columbia Broadcasting System).

Episode "Lonesome Road" (1959)
Screenplay: Jack Curtis and Sam Peckinpah.
Producer: Hal Hudson.
Production Companies: Four Stars Productions, Pamric Productions, Zane Grey Enterprises.
Cast: Edmond O'Brien (Marshal Ben Clark), Rita Lynn (Peggy), Tom Gilson (Wes Cooper).
Length: 30 min.
Released in the United States: 19 November 1959 on CBS.

Episode "Miss Jenny" (1960)
Screenplay: Robert Heverly and Sam Peckinpah.
Producer: Hal Hudson
Production Companies: Four Stars Productions, Pamric Productions, Zane Grey Enterprises.
Cast: Vera Miles (Jenny Breckenridge), Ben Cooper (Darryl Thompson), Adam WIlliams (Alan Breckenridge).
Length: 30 min.
Released in the United States: 7 January 1960 on CBS.

1960 ▰▰▰▰▰▰▰▰▰▰▰▰▰

KLONDIKE

Episode "Klondike Fever"
Screenplay: Sam Peckinpah and
Carey Wilber.
Producer: William Conrad.
Production Companies: ZIV
Television Programs, United Artists
Television.
Cast: Ralph Taeger (Michael
Halliday), James Coburn (Jefferson
Durain), Joy Lansing (Goldie).
Length: 30 min.
Released in the United States:
10 October 1960 on NBC (National
Broadcasting Company).

1960 ▰▰▰▰▰▰▰▰▰▰▰▰▰

THE WESTERNER

Episode "Jeff"
Screenplay: Robert Heverly
and Sam Peckinpah.
Producers: Sam Peckinpah, Jack
Gariss, Richard V. Heermance.
Production Companies: Four Stars
Productions, Free Star-Winchester.
Cast: Brian Keith (Dave
Blassingame), Geoffrey Toone
(Denny Lipp), Charles Horvath
(Crow).
Length: 30 min.
Released in the United States:
30 September 1960 on NBC.

Episode "Brown"
Screenplay: Bruce Geller.
Producers: Sam Peckinpah, Jack
Gariss, Hal Hudson.
Production Companies: Four Stars
Productions, Winchester.
Cast: Brian Keith (Dave
Blassingame), Harry Swoger
(Sherif Tom Lacette), Conlan

Carter (Mead).
Length: 30 min.
Released in the United States:
21 October 1960 on NBC.

Episode "The Courting of Libby"
Screenplay: Bruce Geller.
Producers: Sam Peckinpah, Jack
Gariss, Hal Hudson.
Production Companies: Four Stars
Productions, Winchester.
Cast: Brian Keith (Dave
Blassingame), John Dehner
(Burgundy Smith), John Apone
(Mark).
Length: 30 min.
Released in the United States:
11 November 1960 on NBC.

Episode "Hand on the Gun"
Screenplay: Bruce Geller.
Producers: Sam Peckinpah, Jack
Gariss, Richard V. Heermance.
Production Companies: Four Stars
Productions, Winchester.
Cast: Brian Keith (Dave
Blassingame), John Pickard (Mazo),
Wayne Tucker (Ned).
Length: 30 min.
Released in the United States:
23 December 1960 on NBC.

Episode "The Painting"
Screenplay: Bruce Geller.
Producers: Sam Peckinpah, Jack
Gariss, Richard V. Heermance.
Production Companies: Four Stars
Productions, Winchester.
Cast: Brian Keith (Dave
Blassingame), John Dehner
(Burgundy Smith), Madlyn Rhue
(Carla).
Length: 30 min.
Released in the United States:
30 December 1960 on NBC.

1961 ▰▰▰▰▰▰▰▰▰▰▰▰▰

ROUTE 66

Episode "Mon petit chou"
Screenplay: Stirling Silliphant.
Producers: Leonard Freeeman,
Herbert B. Leonard, Jerry Thomas.
Production Companies: Lancer-
Edling Productions, Screen Gems.
Cast: Martin Milner (Tom Stiles),
George Maharis (Buz Murdock),
Lee Marvin (John Ryan), Macha
Méril (Perette Dijon).
Length: 51 min.
Released in the United States:
24 November 1961 on CBS.

1962-1963 ▰▰▰▰▰▰▰▰▰▰

THE DICK POWELL SHOW

Episode "Pericles on 31st Street"
(1962)
Screenplay: Harry Mark Petrakis
and Sam Peckinpah.
Producers: Sam Peckinpah, Stanley
Kallis, Dick Powell.
Production Company: Four Star
Productions.
Cast: Theodor Bikel (Nicholas
Simonakis), Arthur O'Connell (Dan
Ryan), Carroll O'Connor (Leonard
Barsevick).
Length: 60 min.
Released in the United States:
12 April 1962 on NBC.

Episode "The Losers" (1963)
Screenplay: Bruce Geller et Sam
Peckinpah.
Producers: Sam Peckinpah, Bruce
Geller, Bernard L. Kowalski, Stanley
Kallis, Dick Powell.
Production Company: Four Star
Productions.
Cast: Lee Marvin (Dave

Blassingame), Keenan Wynn
(Burgundy Smith), Rosemary
Clooney (Melissa).
Length: 60 min.
Released in the United States:
15 January 1963 on NBC.

1966

ABC STAGE 67

Episode "Noon Wine"
Screenplay: Sam Peckinpah, based
on a short story by Katherine Anne
Porter.
Producers: Daniel Melnick, James
Clark, Lois O'Connor.
Production Companies: Rediffusion
Television, Talent Associates.
Cast: Jason Robards (Royale Earle
Thompson), Olivia de Havilland
(Ellie Thompson), Theodore Bikel
(Homer T. Hatch).
Length: 48 min.
Released in the United States:
23 November 1966 on ABC.

1967

BOB HOPE PRESENTS
THE CHRYSLER THEATRE

Episode "The Lady Is My Wife"
Screenplay: Halsted Welles and
Jack Laird.
Producer: Jack Laird.
Production Company: Hovue
Enterprises.
Cast: Jean Simmons (Ruth
Bannister), Alex Cord (Lucky
Paxton), Bradford Dillman
(Bannister), L. Q. Jones (Ernie
Packer).
Length: 60 min.
Released in the United States:
1 February 1967 on NBC.

capricci

3 rue de Clermont 44 000 Nantes, France
www.capricci.fr

Pierre Léon
JEAN-CLAUDE BIETTE,
LE SENS DU PARADOXE

Thomas Harlan
VEIT
d'un fils à son père, dans l'ombre
du *Juif Süss*

Marc Cerisuelo et Claire Debru
OH BROTHERS!
sur la piste des frères Coen

Pierre Perrault
ACTIVISTE POÉTIQUE
filmer le Québec
entretien avec Simone Suchet

Steve Martin
MA VIE DE COMIQUE
du stand-up au *Saturday Night
Live*

Linda Williams
SCREENING SEX
une histoire de la sexualité
sur les écrans américains

Buster Keaton et Charles Samuels
LA MÉCANIQUE DU RIRE
autobiographie d'un génie
comique

Collectif
FILMER DIT-ELLE
le cinéma de Marguerite Duras

Grover Lewis
LE CINÉMA INFILTRÉ
un Nouveau Journalisme

Bob Woodward
JOHN BELUSHI
la folle et tragique vie
d'un Blues Brother
(hors format)

William Castle
COMMENT J'AI TERRIFIÉ
L'AMÉRIQUE
40 ans de séries B à Hollywood

à paraître

Jérôme Momcilovic
PRODIGES D'ARNOLD
SCHWARZENEGGER

Thomas Harlan
UNE VIE APRÈS LE NAZISME
Entretien avec Jean-Pierre
Stephan

Hervé Aubron & Emmanuel
Burdeau
WERNER HERZOG, PAS À PAS

HORS COLLECTION

Frédéric de Towarnicki
LES AVENTURES DE HARRY
DICKSON
scénario pour un film
(non réalisé) par Alain Resnais

André S. Labarthe
LA SAGA "CINÉASTES,
DE NOTRE TEMPS"
une histoire du cinéma
en 100 films

Emmanuel Burdeau
VINCENTE MINNELLI

Collectif
THE WIRE
reconstitution collective
(en coédition avec
Les Prairies ordinaires)

Collectif
OTTO PREMINGER

Collectif
DANSE ET CINÉMA
(en coédition avec le Centre
national de la danse)

Collectif
GEORGE CUKOR
on /off Hollywood

C. L. Zois
LIFE GUARD

Joe Eszterhas
À LA CONQUÊTE
D'HOLLYWOOD
le Guide du scénariste qui valait
un milliard

Laurent Mauvignier
VISAGES D'UN RÉCIT
Variations autour d'une fiction

ACTUALITÉ CRITIQUE

Emmanuel Burdeau
LA PASSION DE TONY
SOPRANO

Philippe Azoury
À WERNER SCHROETER,
QUI N'AVAIT PAS PEUR
DE LA MORT

Hervé Aubron
GÉNIE DE PIXAR

Juan Branco
RÉPONSES À HADOPI
suivi d'un entretien
avec Jean-Luc Godard

Guillaume Orignac
DAVID FINCHER OU L'HEURE
NUMÉRIQUE

Jacques Rancière
BÉLA TARR, LE TEMPS
D'APRÈS

Stéphane Bouquet
CLINT FUCKING EASTWOOD

Louis Skorecki
D'OÙ VIENS-TU DYLAN?

Axel Cadieux
UNE SÉRIE DE TUEURS
les serial killers qui ont inspiré
le cinéma

First published in July 2015 by Imago in Slovenia.
Legal deposit: August 2015